STRUGGLE

STRUGGLE

The Art of

Szukalski

LAST GASP
SAN FRANCISCO

Last Gasp, 777 Florida Street, San Francisco, CA 94110 | *www.lastgasp.com*

Cover and Book Design by Piet Schreuders, Amsterdam
Edited by Glenn Bray and Lena Zwalve
Scans by Colortechniek, Amsterdam

Second Edition
ISBN 978-0-86719-479-1

Szukalski, Stanislav; Bray, Glenn; Zwalve, Lena;
DiCaprio, George; DiCaprio, Leonardo; Kirsch, Eva; Kirsch, Donat
1. Art; 2. Sculpture; 3. Polish culture.
Includes bibliography, index.

Official online source of all things Szukalski:
Archives Szukalski | *szukalski.com*

Art prints by Szukalski:
Varnish Fine Art Shop | *varnishfineartshop.bigcartel.com*

Szukalski bronzes foundry:
Decker Studios Fine Arts Foundry
Sanford Decker: *sdfinearts@gmail.com*

PRINTED IN CHINA

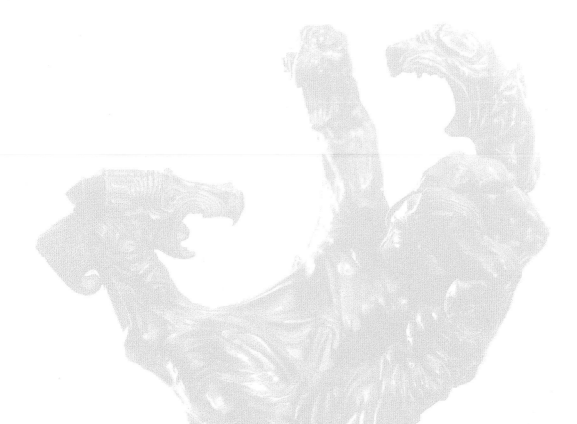

"I put Rodin in one pocket, Michelangelo in the other, and I walk towards the sun."

SZUKALSKI

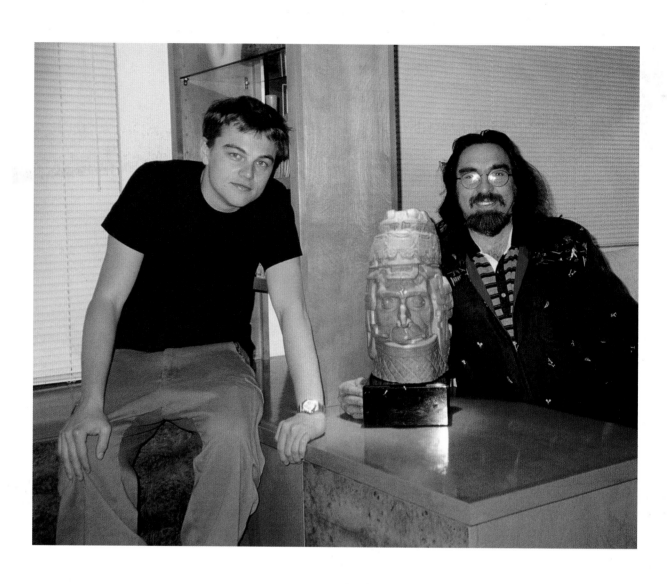

LEONARDO AND GEORGE DICAPRIO WITH SZUKALSKI'S *Cecora*, 1999

PHOTO BY GLENN BRAY

INSULTING PICASSO

■ *by* Leonardo *and* George DiCaprio ■

As we both look over the artful drawings, sculpture and idea-books passed down by Stas, we are astounded by the antic ellipses of cultural history that nearly succeeded in rubbing them out. Stas was like a caryatid struggling to keep his ideas above the surface of the rising deluge. A flood of political disaster, a capricious tide of artistic dogma almost overwhelmed his creations and submerged them in a sea of dark obscurity. The fact that he could not bear to re-create them from his perfect memory is the conceit of the genuine autodidact. His ideas almost died with him, nearly rode out on the horse they rode in on.

Stas loved to sculpt hands; his ingenuity can be measured in the manifold ways that he used them to express his ideas. His recently discovered *Imploration* is a perfect example (another lost bronze surfaced from

that sea of obscurity!). *Echo, Struggle, The Lost Tune,* and many other ones are dominated by hands that best represented his "deserved soul." The hands are the artist-creator passing ideas to us that glow and shimmer when compared to the dull, mordant concepts that have gained acceptance in the present day. He was a Polish mystic and a Promethean artist whose message, in a borrowed typeface from a dead language, would mean: "Help Yourself to the Sacred Fire." It is prankish that he is still so unknown.

This foreword would be incomplete if we did not spend a few lines insulting Picasso, or in Szukalski's terms, "Pick Asshole." Picasso, who sat idly by during the World War, abusing women while many of his friends suffered and died, is the same man who spent the last two thirds of his life doodling fawns, doves and peace signs for the commodity art machine. Picasso, who mechanically palmed off shopworn elements from the prop closet of classical Greek pedimental design to the public too numb to notice—that person is not the Picasso of the Twentieth Century.

—Leonardo and George DiCaprio

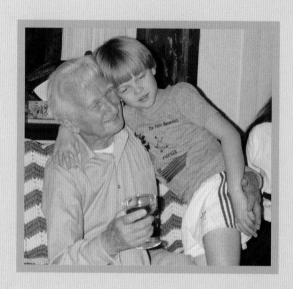

THE ARTIST WITH LEONARDO
JANUARY, 1983
PHOTO BY GLENN BRAY

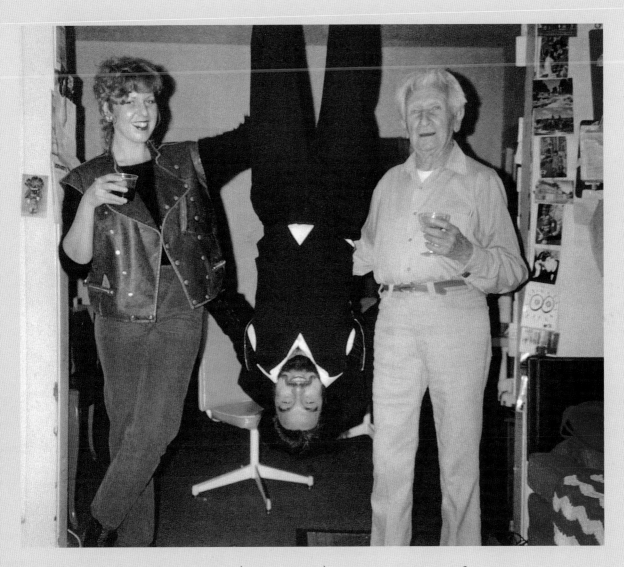

THE ARTIST WITH GEORGE DICAPRIO (UPSIDE-DOWN) AND LENA ZWALVE, 1983

PHOTO BY GLENN BRAY

STRUGGLE
—
■ *The Art of Szukalski* ■

TABLE of CONTENTS

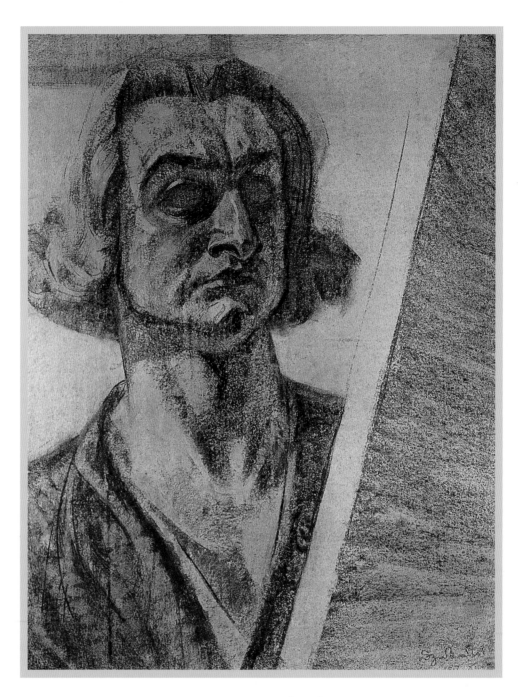

SELF PORTRAIT (1917)

ECHO *of a* PARALLEL CENTURY

The Art of Stanislav Szukalski

■ by Eva *and* Donat Kirsch ■

The geniuses of the first order are never known—not by anyone, not in life, not after death. For they are creators of truths so unprecedented, purveyors of proposals so revolutionary, that no soul is capable of making head or tail of them. Therefore, permanent obscurity constitutes the normal lot of the Geniuses of the Higher Class (…).

It is not that humanity has lost forever its geniuses of the first order—the geniuses, rather, have lost sight of humanity, for they have moved away from it. It is not that these geniuses simply do not exist: rather, with each passing year they do not exist *to a greater and greater degree*. The works of unrecognized geniuses of the second category can always be saved. All one needs to do is to dust them and hand them over to press or universities. But the works of the first order nothing can preserve, because these stand apart—outside the current of history.

—Stanisław Lem, "Odysseus of Ithaca by Kuno Mlatje," in: *A Perfect Vacuum* [1]

1 *The Paradox of Szukalski*

STANISLAV SZUKALSKI, a Polish-born sculptor who divided his life between Poland and the United States, may be one of those forgotten, forever lost geniuses of the 20th century. Today he is one of its best known officially undiscovered—or maybe officially forgotten—artists and, ironically, the words Ben Hecht wrote almost fifty years ago sound as brutally true now as when they were written: "His name is today unknown. His works are vanished. He is without public, without critics, so complete is the world's ignorance of him that he may as well never have existed." [2]

The finesse and technical perfection alone of the impressive sculptures completed between the two world wars should earn Szukalski a place among the greatest sculptors of the century. Instead, just memories of his eccentric personality and his art are today haunting not only the artistic world and storage spaces of several museums in Poland, but also the hearts and imaginations of a small circle of his dedicated friends in Southern California. [3]

In California, the patient efforts of Glenn Bray and Lena Zwalve, two faithful friends of Szukalski and the curators of Archives Szukalski, have made it possible to preserve and exhibit most of the artist's American work.

In Poland, his works have not been exhibited since 1939. They were either destroyed by the Nazis or stolen by Communists and ignominiously removed from the public view and artistic discourse. Many of them are still kept in the storage spaces of several cultural institutions, most notably the Municipal Museum in

Bytom.[4] Furthermore, the exquisite collection of world art once owned by Szukalski was renamed the "Collection of General Zając" and is now also in the possession of the Municipal Museum of Bytom.[5] Recently, some of the stolen pieces have been reaching the Polish black market in increasing quantities.[6] Since Poland, after Communism, is now—officially and traditionally—embracing Catholicism, the chances that Szukalski's work will ever be exhibited there are at best unpredictable—simply because the artist was as much anti-catholic as anti-Communist and anti-fascist. In practical terms, the Communists did so much damage to the property, contractual and tax laws of Poland that, in the best scenario, it will take years to unravel the fifty years of the "wealth redistribution" process imposed by them. Only one Polish art historian, Lechosław Lameński, has researched the life and art of Szukalski and published several in-depth essays on the subject.

While Szukalski's art contains elements that can be extremely familiar to a contemporary viewer, the manner in which those elements are pieced together may be puzzling and hard to decipher despite ample explanations provided by the artist. As a result, Szukalski cannot be fully fit into any standard art theory—which almost guarantees the capital penalty of certified disregard. He also does not fit because his views, often extreme in nature, do not follow the standard ideological fault lines between right and left, piety and agnosticism, racism and racial tolerance. Even worse, as much as he felt and lived the century, he did it in his unique way—as though his work echoed the vibrant life of a parallel Earth. So, while many talented artists with unruly personalities made it to the most renowned museums and their acts almost became the standard for middle class behavior, Szukalski has been awarded the status of being officially forgotten by the experts of both American and Polish 20th century art.

■ ■ ■

It is easier to write about Szukalski today simply because the number of people he managed to insult during his long life is naturally decreasing. Also, the perspective from the next millennium shows how closely his work and creativity actually followed the artistic and intellectual history of the century, if in an independent, parallel way.

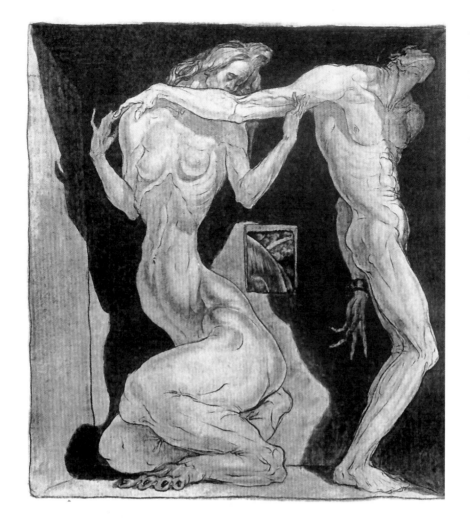

In the description of one of his early drawings, *In Bondage of One's Muse*, Szukalski wrote: "Art consumes life. The Muse presses upon and stops the artery of the artist's arm."[7] Indeed, art consumed Szukalski's personal life to the highest degree. This is why both his life and his art can be naturally divided into two major phases: the *avant-garde phase* (1910–1939) and the *postmodern phase* (1939–1987).

As an avant-garde artist, Szukalski was obsessed with the high artistic qualities of his work, mostly sculptures and designs. Already rebellious, highly critical and, in his own bizarre way, challenging the art of his time and society in both Poland and America, he committed himself to outlandish theories about art, race, politics and, above all, the Szukalskization of Polish culture.

During his postmodern years he produced sculptures and medallions, but mostly a large number (40,000) of drawings used

to reinterpret anthropology, archeology, geology, and linguistics in terms of *Zermatism*—a new, self-invented "scientific" discipline.[8] During this period, whenever he was free from reinterpreting the history of Earth, he managed to "lower" himself to producing masterpieces.

What unifies both periods is the artist's fierce rejection of the very concept of abstract art, as a matter of fact even of oil painting—the main medium of abstract art.

Avant-Garde (1910–1939)

During his avant-garde phase, Szukalski completed the most prominent of his works. His inborn obsession with the quality of his sculptures and designs led him naturally from the brilliance of analytical formalism to the detailed symbolism of decorative eclecticism he eventually developed. The major break in his art occurred around 1923, also the year of his return to Poland and marriage to Helen Walker.

The principles of the avant-garde philosophy and approach to life were well suited to the natural doctrinalism of Szukalski, who dedicated himself to the concept of alteration of yet undetermined values of tomorrow. Like many other self-assertive avant-garde artists, he chose radical dogmatism to express his views and attract attention. His dreams, career, and life were to be realized by way of perpetual conflict with all those who dared to disagree even on the smallest details of his art and views.

1. ANALYTICAL FORMALISM

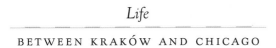

Life

BETWEEN KRAKÓW AND CHICAGO

Szukalski was born in 1893 in the small Polish city of Warta, which at that time was under Russian control—the worst option in a Poland divided between Russians, Germans and Austrians.[9] He always presumed that he was born in 1895, so he later claimed that he was admitted to the Academy of Fine Arts in Kraków at

the young age of 15. In the 1980s his original birth certificate, stating that he was born on December 13, 1893, was found in Warta by Marian Konarski, one of Szukalski's close friends and admirers.

Szukalski demonstrated interest in sculpture and drawing very early on, when he was about six years old. His father, a blacksmith, first emigrated to South Africa then to the United States where, in 1907, he was joined by his son. During the first years spent in Chicago, Szukalski continued to draw and sculpt, although there is very little known about those attempts. It is known that the earliest works of Szukalski were noticed by a Polish sculptor, Antoni Popiel, who also suggested that Szukalski should go back to Poland—a country then still divided between Austria, Germany and Russia—to study art in Kraków. The young prodigy went to Kraków in 1911.

At the end of *La Belle Époque* Kraków was one of the major cities of the Austro-Hungarian Monarchy. The ruling German upper class was managing the Austro-Hungarian empire through a carefully designed scheme of national domination: Germans dominated Czechs and Slovenes; Hungarians dominated Croats, Serbs, and Slovaks; and Poles dominated Ukrainians. As a result of this policy, Kraków was an entirely Polish city where—unlike in the Russian and German empires—Polish culture and colorful bohemian life flourished without much government disruption. Even more importantly, Kraków was one of the most vital European centers of Art Nouveau.

The beginning of Szukalski's studies at the Kraków Academy of Fine Arts is also the beginning of his early fascination—almost obsession—with form. After his admission to the academy, Szukalski vehemently refused to use models in creating his sculptures, and continually shocked his professors and peers with his experimental, but perfectly executed *études*. Naturally, these practices brought him into open conflict with his professors, who otherwise recognized his original talent and rewarded him with several prizes and medals. Instead of learning sculpture from models, Szukalski embarked on his own artistic search, which he understood as the process of perfecting different aspects of sculpting, first in his mind and then translating them into three-dimensional forms. This unorthodox method helped him to reach artistic maturity at a surprisingly young age and to regularly exhibit his *études* together with the most renowned Polish artists of his time.[10]

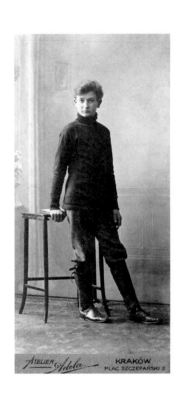

PORTRAIT PHOTO TAKEN IN KRAKÓW, C. 1911

SZUKALSKI AT KRAKÓW,

C. 1913 (OTHERS UNIDENTIFIED)

His works from that period, demonstrating unquestionable talent and individuality, were strongly influenced by elements of Impressionism, such as a roughly textured surface and snapshot-type poses and gestures. They were also exhibiting elements of Cubism.[11] Later on, Szukalski continued to develop Impressionism into the core of his art, mostly in the sculptures finished before 1923. Also during these years Szukalski completed one of the very few oil paintings of his life—*Self Portrait* (1911).

In 1913, after almost three years in Kraków, the artist returned to Chicago, where he sculpted a brilliant portrait of his father, the blacksmith, whom he supposedly didn't expect to live much longer.[12] Unfortunately, the artist was right in his predictions and his beloved father died some time after Szukalski's return. During the following years Szukalski lived in extreme poverty, frequently fainting from hunger and exhaustion.[13] Still, during this ten-year

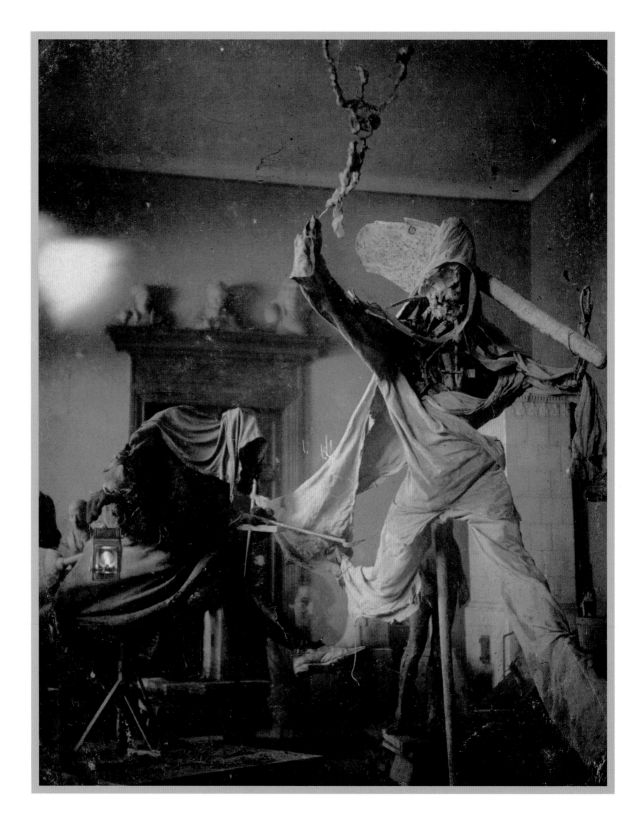

SZUKALSKI ATELIER, PRESUMABLY AT KRAKÓW ACADEMY, CIRCA 1913.
A 19-YEAR OLD SZUKALSKI, IN GHOST-SHADOW, IS SEATED BEHIND A MYSTERIOUS CONFIGURATION.

period in Chicago, he created numerous sculptures and graphics of great artistic value which were exhibited and left a strong mark on the artistic life of the city.[14]

The Chicago years gave Szukalski many chances to show his terrible temper and inability to deal with the official art world of that time, his competitors among fellow artists and, in particular, the art critics. The best known incident, described by his friend and admirer, Ben Hecht, involved throwing one of the most influential Chicago art critics, Count Monteglas, who had dared to poke Szukalski's statues with a cane while making a point, down the stairs.[15]

Art

THE TIME OF GREATNESS

The great art Szukalski created during his Chicago years was inconsistent. His drawings were fantastically visionary, highly symbolic, and incorporated influences of many styles. His sculptures of that time were much more disciplined and consistently followed the Impressionist approach with certain stylistic variations. Only later, during his decorative stage, was Szukalski able to synthesize these two movements into a consistent, unified style.

DRAWINGS: VISION

Before 1923, the artist was by far more formally oriented in his sculptures than in his drawings, which were already gravitating toward decorative symbolism, often heavily saturated with literary meanings. It is possible to distinguish three basic types of drawings characteristic of that period: experimental, symbolic, and early architectural projects—mostly fantasies.

The first type, experimental drawings, consists of works taking from Cubism, Futurism, early Expressionism, and even Polish Formism. In addition to using these influences, many of these works seem to be ahead of their time. In a portrait, *A Note* (before 1923), the artist used a wide and heavy black stroke, typical of German Expressionism. Another good example is *Experimental Drawing* (1917), a male face perfectly defined by a delicate, fancy, and rhythmically capricious sinuous line. *A Portrait of My Grandfather* (1915) is another of Szukalski's forays into Expressionism, or even Neo-

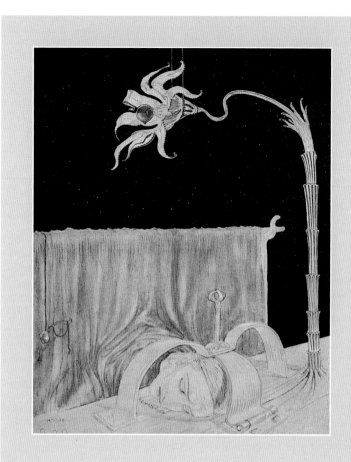

Flower of Dreams
"An idealist in his loneliness puts his head
into the vise which holds him in place,
while the roots of his flower-ideal enter his
brain and devour his blood... The stem of
this curious flower anxiously gives out its
bloom... This is the laboratory of the idea-
list. The bubble of blood in the blossom is a
trans-birth of his hapless love."
(*The Work of Szukalski*, 1923)

Expressionism. One cannot help but notice a striking similarity
between this work and the early paintings of German Neo-Express-
ionists, especially Georg Baselitz.

The second—and most frequent—type are black and white or
color drawings, rich in a literary symbolism that needs the art-
ist's explanation to be understood, such as *Escape* (1916), *Flower
of Dreams* (1917), *Man Following His Principle* (1917), or *Creation of
Man* (1918). A connecting element in many of these early draw-
ings is a mannerist echo of the Art Nouveau style, in the formal
as well as in the literary elements. However, some of the works
contain a more experimental approach in their formal and tech-
nical solutions. *Liberty and the Law of Gravity* and *Death Thought*
(both before 1923) could possibly be labeled surreal and, in a sense
of form, technique, and their witty humor, associated with some
works by the Dutch artist M. C. Escher. Of course, Szukalski did
not have Escher's interest in science or his playful approach to per-

VOL. LXXIII JUNE, 1921 No. 291

The
INTERNATIONAL
STUDIO

Reg. at U.S. Pat. Off.

PROPHET STANISLAW SZUKALSKI

Entered as second-class matter March 1, 1897 at the Post-Office at New York, N. Y., under the Act of March 3, 1879

JOHN LANE COMPANY
786 Sixth Avenue
Near 45th Street
NEW YORK

MAGAZINE COVER, 1921

The Prophet

spective and the latest theories in mathematics and physics; however, the association remains convincing, considering all the other components of their art.

In the same symbolic category there are also several intriguing drawings which use less literary symbolism versus some formal symbolism contained in spatial composition, definition of human interaction and, if present, color. In *Duel Between the Cynic and the Idealist* and *In Bondage of One's Muse* (both before 1923), *Self-Conference* (1917) and *Mood* (before 1923), Szukalski used the concepts of space and human figure surprisingly similar to those of later paintings by Francis Bacon. The space in Szukalski's works, similarly to Bacon's, is intensely claustrophobic, geometrically defined, self-contained, and stage-like; it is "a sacred space, the figure's self-protective aura, the membrane of its dignity, confirming the figure's character as a monad."[16] In this isolated space, Szukalski, like Bacon, placed either a single human figure (*Mood*) or two

ARCHITECTURAL SKETCHES,
C. 1922

figures (*Duel...*) "locked in a struggle or resting between the engagements."[17] The figures rendered by Szukalski relate to Bacon's figures as well. Elongated, manneristicaly contorted, and "mutedly muscular,"[18] they strongly evoke Michelangelo's sculptures, but at the same time only play with the concept. Even the colors, if applicable (for Szukalski preferred other than oil media), are similar to the cold, muted, and expressively emphatic hues of Bacon's compositions.

24

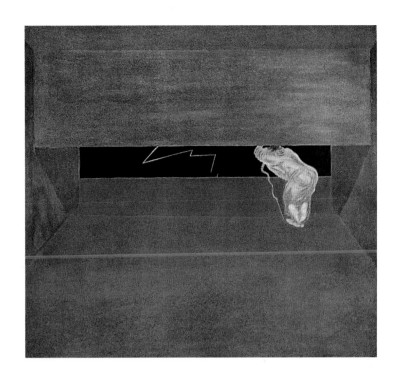

ADVERTISING FOR FIRST BOOK (1923)

Mood
(illustration from *The Work of Szukalski*, 1923)

Although the symbolic type of drawing is the most common for the early period of Szukalski's art, he also started his elaborate architectural drawings and projects prior to 1923, some of them as early as 1915. Mostly conceptual fantasies demonstrating the excellent rendering talent of the artist, they may be compared with similar attempts by earlier artists-visionaries, particularly with the theoretical projects by a French architect Étienne Louis Boulée (1728– '99). *Humming Tower* and *Pedestal for the Monument of Liberty* (both before 1923) were monuments with wind whistles designed to make sounds during windy weather. *A Memorial* (before 1923) shows a doorway under an elaborate figure of a woman holding a snake—stylistically combining the elements of Minoan and Meso-American art.

As *A Memorial*, other works from the time show the increasing tendency to incorporate the elements of Meso-American and Meditteranean (Minoan and Egyptian) art. In this unifying vision Szukalski was a precursor of Art Deco, one of the main design styles of the 1920s and '30s—which combined elements of European

modernism with motifs borrowed from recently excavated, previously unknown remains of ancient cultures from Egypt, Crete, Mexico and Mesopotamia. Later on, Szukalski's importance was recognized during the history-making Paris exhibition of decorative arts—*Exposition Internationale des Arts Décoratifs et Industriels Modernes* (1925), which later gave the name to the entire style.[19] Still, the formative role Szukalski played in the development of Art Déco was later entirely forgotten.

SCULPTURES: FORM

In his sculptures of the Chicago years (1913–'23), Szukalski, as he himself admitted, was a creative follower of the Impressionist style of sculpture originally developed by Auguste Rodin. The influence of Rodin became the departing point of Szukalski's quest for an original and individual style. After all, Rodin, besides Michelangelo, was the only sculptor Szukalski openly admired at that time, proudly proclaiming that "I put Rodin in one pocket, Michelangelo in the other, and I walk towards the sun."[20] In fact, in his intense search for perfect form Szukalski brought together the two sources in most of the early sculptures, creating a blend of Rodin's dry realism with the idealism of Michelangelo. These two elements conflict in his art, resulting in intense, expanding, or overflowing forms of analytical modeling.

Like Rodin, Szukalski presented people in various attitudes and stages of life (usually in some kind of conflict, either external or, most likely, internal) expressively deforming the figures by lengthening, enlarging, exaggerating, and monumentalizing certain physical elements to stress the meaning. Certain works by Rodin inspired Szukalski to make his own variations of them. The figure of Adam from the *Gates of Hell* premonitioned Szukalski's *Sleep* and *David*, and *The Mighty Hand* influenced *Struggle*; however, the artist always modified the original work and added his own interpretation to it. The influences of Michelangelo, already filtered through Rodin, are present in a series of Impressionist improvisations. *Rabindranath Tagore* (1915) is a variation on the theme of Moses. Interestingly, Szukalski used the shadowy effect of the empty eye sockets to add life to the face. The figure of *David* (1914) belongs to the same category. These thematic variations are stylistic predecessors of the method independently discovered by Francis Bacon in the 1940s.

The generative structure of Impressionism underlies almost all of the sculptures Szukalski created during his Chicago years. In the formal sense, Impressionism is based on the replacement of literary knowledge of objects by knowledge derived from the sensual experience of them. In actuality, the very name of the method is rather misleading since Impressionism is as precise and realistic as Classicism, just different in terms of perceptual perspective. The organization of Impressionist paintings or sculptures is based on the hierarchy of either visual or tactile contrast rather than on the importance of subjects. In Renoir's *The Luncheon of the Boating Party* (*Un Déjeuner à Bougival*, 1880) one hand of a woman reclining on the railing is painted with utmost precision because it touches the face, thus creating a visual contrast. Yet the other hand, similar in color to the railing, melts into the colorful fluidity of the after-image (post-visual effect). Auguste Rodin applied the same approach, but instead of visual contrast he used the touch or force of muscular tension as the organizing structure of his sculptures. In By the Sea (1906–07), the left hand and the leg of the sitting girl, bearing the full weight of her body, are sculpted with Michelangelo-like precision. The relaxed right side of the body, touched by the flowing water, dissolves into fluid surfaces of after-touch, so that only the most basic anatomical details are discernible to the viewer.

Szukalski used the Impressionist approach to translate the intrinsic message of his sculptures into the fundamental reality of the human body. In his *Labor* (1916),[21] the highly detailed left hand and feet of a tired man naturally follow the laws of gravity and human physiology in their slow descent towards the earth and relaxation. The rest of the body, even the hand that holds the tool, is less detailed, numbed by the hard work. Most notably, the head of the laborer—the locus of the human body—melts into the muscular arms.[22]

For Szukalski, Impressionism became the departing point for his further journeys into various styles and, eventually, the great unification, which occurred during the years leading up to 1923. The artist carefully explored three stylistically different areas until, in 1923, he finally made the decision to choose one of them. For the reasons explained below these areas can be called: *traditional, modern* (in Szukalski's own version), and *eclectic.*

Szukalski used the traditional style to show that he could easily practice and repeat the accomplishments of old masters whom

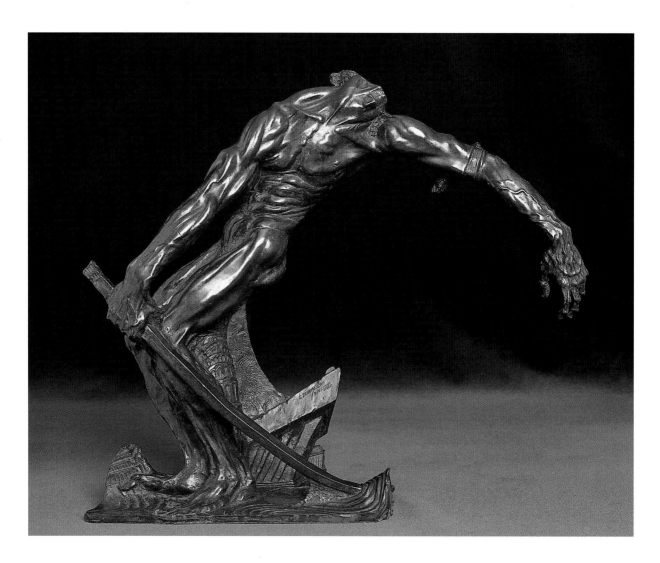

Labor (1916)

"From whose wounded arm
water flows. A project for a
fountain."

PHOTO BY JEFF VAUGHAN

he truly worshipped—especially Michelangelo. The traditional style
continued the series of formal *études* centered around different com-
positional aspects of sculpture, from parts of the human body to the
folding of its clothes. Inspired by great masters, but trained to see
for himself and to memorize forms previously seen, Szukalski nei-
ther used models nor copied other artists. In his early sculptures the
references to familiar works of art exist, yet are overshadowed by
the strong touch of Szukalski's individual style and personality.

In 1914, carrying on the tradition of the great sculptors of the
past, Szukalski created his own version of *David* in which he ideo-
logically and compositionally continued the sequence of the famous
marble David figures by Michelangelo and Bernini. Michelangelo's
Giant of Florence (1501-'04) is presented in the moment of making
his decision to fight, while Bernini's strong and expressive *David*

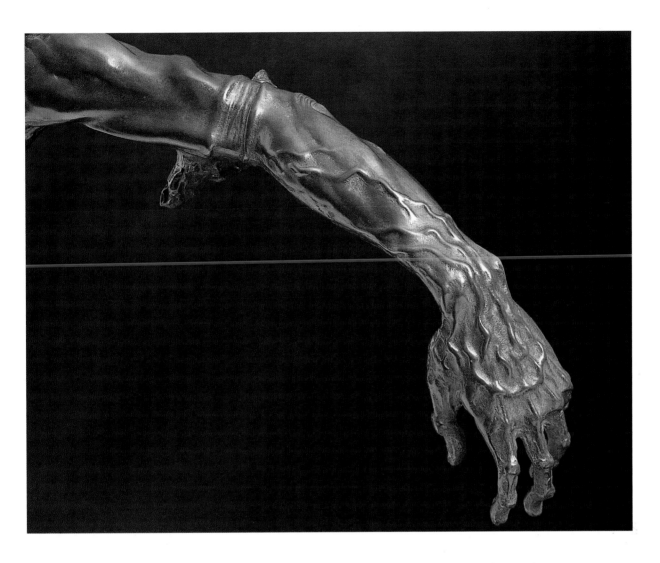

Labor (DETAIL)

PHOTO BY JEFF VAUGHAN

(1623) is shown as already acting and determined to win. The next in the series, following the expressive motion of Bernini's spiral composition, is Szukalski's astonishing *David* depicted as a man fighting with determination, but already concerned with the consequences of his action. Physically strong but emotionally fragile, he is an emotional man of the twentieth century—a man of a strong internal conflict.

This sculpture is one of the earliest and most compassionate representations of this kind in 20th century art. It alone, although in its initial form strongly inspired by Rodin, should bring attention to Szukalski and place him in the hall of fame among the greatest sculptors and the greatest prophets of history. It didn't, and it was later destroyed in World War II, as many other Szukalski works were. Today it is almost completely forgotten.

David (1914)

"Being rather indifferent to the Bible when a very young sculptor, noting mainly an edition with Doré's woodcuts, I had not retained the Bible stories in which David was a fledgling teenage boy, and made him a man of some thirty years. The work was completed in my 19th year while I was still overcoming the boyish tendency to 'finish' work as soon as possible. The hands and feet were left unfinished. The nostril is jagged. There are holes at the base of the neck. After *David*, I became obedient to my own advice and turned into a full-fledged sculptor."

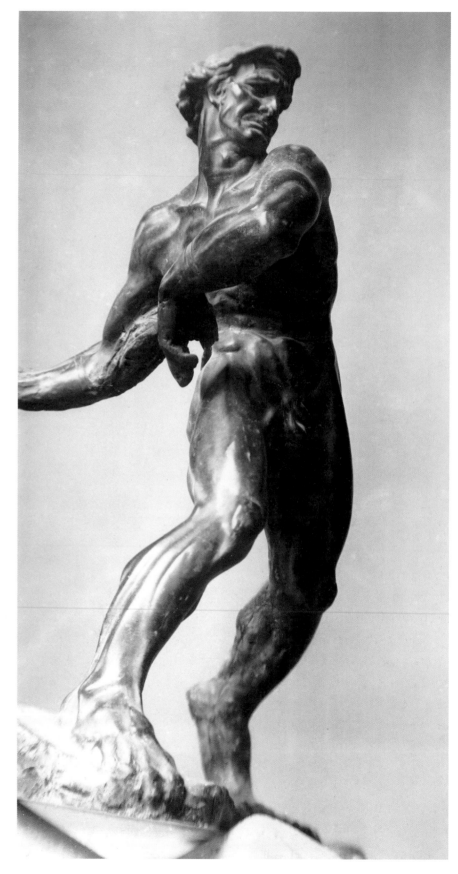

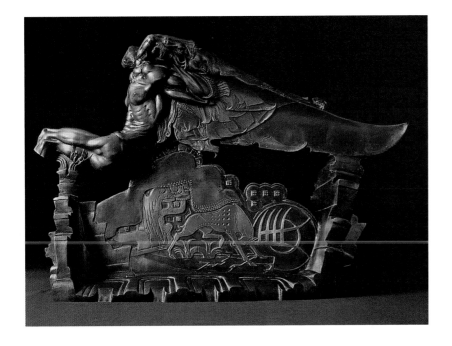

Frozen Youth (version 3, 1940s)
"A project for a monument to those who die too young in life: youth frozen in the moment of its flight."

PHOTO BY JEFF VAUGHAN

In his modernist approach Szukalski, like many of his contemporaries, committed himself to interesting formal innovations, but without any interest in the social aspects of modernism. Neither was Szukalski a follower of any particular "isms," though his works were as contemporary as the works of the most prominent artists of the early 20th century. He was an active, highly individualistic participant in the contemporary artistic discoveries. His art in this category included creative examination and, then, extension of the elements of the modern styles and tendencies, such as Post-Impressionism, Art Nouveau, Symbolism, Cubism, and Futurism. However, he always played his individual game, independently and freely departing from the limitations of the "isms" of his generation.

Two of Szukalski's sculptures, both portraits, *A Grain Merchant* (a.k.a. *Portrait of an American*, 1915) and *A Portrait of Van den Bergen* (1918-'21), show some formal innovation and therefore belong to this group of Szukalski's works. Both images are strong, extremely well defined, and sharply revealing the characters of the portrayed men. Particularly Van den Bergen portrays its subject's features as similar to elements of Gothic architecture. As he described it, his physiognomy "always seemed to resemble a Gothic steeple." [23] *Van den Bergen* proved Szukalski's highly individualized and selective interest in Cubism and the amazing skills of the artist to adopt some of its principles. Similarly, the dramatic *Flight of the*

Emmigrants (1921) includes the elements of the straightforward simplification and dynamism of the Futurists.

In his eclectic style, mostly influenced by Pre-Columbian motifs, Szukalski was already gravitating towards the ornate and rich-in-detail art he would produce between 1923 and 1939. His elegant portrait of an Indian, *Hopi Indian* (1917), shows the elements of static austerity so prominent in Toltec art. Similarly, the dramatic face of *Frozen Youth* (second version, 1922) resembles Mayan sculpture. *The Prophet* (1919), *The Heavenly Nurse* (1922), and *Nature and Wisdom* (before 1923) all incorporate the element of the Meso-American symbol, the Snake of Wisdom, together with the concentration of ornamental details characteristic of the art from that region.

The perfectionist, technically near-magical method of sculpting developed by Szukalski during these years can be described as the ability to understand and control any new material without preliminary testing of its qualities. Indeed, Szukalski, who throughout his life usually did not have enough money to purchase stone or to cast his pieces in bronze, didn't have any problems using different materials whenever he could afford such luxuries. He never lost the perfection he was able to develop during his formative years. Despite their actual (rather small) sizes and materials, all his sculptures are so detailed that they remain monumental in their proportions.

The formalism of the years 1910-'23 was the most creative and the least controversial stage in Szukalski's life. Most of his art was still free from the heavy mythologizing of his later works, and can be understood without the necessity of reading the artist's own complicated comments. Similarly, he limited the outbursts of his temper to personal incidents which he did not yet attempt to interpret in the terms of his later, self-centered mythology.

2. DECORATIVE ECLECTICISM

Life

A COSMOPOLITAN POLE

During this stage of Szukalski's life, his actions and decisions paralleled his internal artistic path. In 1923 he completed the development of his new decorative and eclectic style. Armed with his own style and with his own political views already formulated, he was ready to initiate the artistic invasion of Poland and even Europe. However, the continent to which he returned in the early 1920s, was quite different from the one he had left in 1913.

Poland's cultural life was dominated by highly educated artists well versed in the latest of the European art scene. Władysław Strzemiński, an architect by education, a superb painter and a devoted Marxist, had worked with Russian Constructivist artists before managing to leave the Soviet Union—he later died of tuberculosis during the days of Communist Poland. Leon Chwistek was an accomplished mathematician, painter, a nd art critic. Stanisław Ignacy Witkiewicz (Witkacy), a friend of Chwistek's, was a painter and a playwright. During his colorful life Witkacy accompanied another friend, Bronisław Malinowski, on his anthropological expeditions. He also served in czarist guard units, and later became a regimental commissar. These firsthand experiences with social engineering made him completely disillusioned with Communism. Witkacy committed suicide in September 1939 after learning that the Soviet troops had invaded Poland. Moreover, most of these artists—unlike Szukalski who had spent World War I in the safety of Chicago—had either fought in the field or firsthand witnessed the terrible crimes committed by the Bolsheviks. Therefore, the patriotism as expressed by Szukalski did not win much respect. Even worse for Szukalski, post-war Europe was undergoing a massive cultural re-evaluation; Paris was Surreal and Dadaist, Berlin was Expressionist, Rome Futurist. There were movements like Bauhaus or De Stijl that eventually shaped the intellectual and artistic scene of the years to come. Talent was in high supply, so nobody was waiting for a new prophet. Eventually Szukalski, as much as he insisted on his patriotism, spent only a little more than five years in his supposedly beloved Poland.[24]

JOAN LEE DONOVAN SZUKALSKI

In this situation, following in the footsteps of many radical artists before him, Szukalski was ready to accept the services of a domineering Prince. Marshal Piłsudski, "the savior of Poland," was a natural selection for Szukalski. Alas, Marshal Piłsudski was so busy orchestrating the conversion of Poland from a democracy to a benevolent dictatorship that he did not pay much attention to just another artist who wanted to glorify him.

Fortunately, at the same time, Szukalski's financial problems were resolved by his marriage to Helen Walker, a rich young lady with artistic interests. Later, in 1932, he divorced her and married Joan Lee Donovan, his daughter's kindergarten teacher from Chicago. Joan remained his devoted wife until her death in 1980. Szukalski's daughter with Helen Walker eventually broke off all relations with her father.

After his return to Europe in 1923 Szukalski participated in the exhibition in Warsaw's Zachęta.[25] His talent was immediately recognized by several influential Polish critics who also noticed the artist's fascination with Egyptian, Asian and Pre-Columbian art.[26] Despite this recognition, Szukalski left Poland soon after and spent the next five years traveling in Europe and visiting the United States. In 1925 he participated in the *Exposition Internationale des Arts Décoratifs et Industriels Modernes* in Paris, where he won numerous awards.[27] His success, although important, didn't bring him any fame in Europe, and did not give him an entry into the main

European art scene. In addition, his victory was criticized by the Polish press because Szukalski, representing Poland in the exhibition, did not even live there, which hurt the nationalistic feelings of some influential Polish critics and journalists. In the same year, after sending his entry from Paris, Szukalski won a competition for the monument of *Adam Mickiewicz*, a great Polish poet of the Romantic era, in Vilnius (in today's Lithuania).

The monument depicts the poet as a naked man sitting on the top of a pyramid and feeding an eagle with his blood. Such a radical composition, breaking with the standard style of nationalistic statues, caused fervor among the same nationalistic circles that had criticized Szukalski so severely for his success at the Paris exhibition. As a result, the plans to build the monument were quickly abandoned.[28]

Szukalski was not one to forget the series of insults he suffered from his compatriots in 1925. After his European travels, he arrived in Kraków in the fall of 1928 planning to retaliate and with a detailed design for an artistic and political coup, conceived on a—typical for him—grandiose scale. The mainstay of his ideas was the replacement of traditional Polish culture by one he himself invented. After several unsuccessful attempts to exhibit his work, the presentation was finalized in 1929 at the Guild of Fine Artists, Unicorn, in 1929.[29]

During the opening of the exhibition, Szukalski made a speech in which he launched a vicious attack on prominent members of Kraków's artistic circles. Such an unheard-of approach to self-promotion brought him the immediate attention of the public and his exhibition was visited by crowds of people "who never went to art exhibitions."[30] After the exhibition, an unrepentant Szukalski launched a frontal attack on all Polish artists and the entire art establishment.[31] The style of the attack and the following barrage of publications, flyers, and verbal exchanges firmly established Szukalski as the most controversial artist in Poland.[32] He organized a group of his enthusiastic artistic followers into the Horned Heart Tribe under the formal leadership of his devoted admirer, Marian Konarski. In his unpublished text, *Szukalski in Kraków*, Marian Konarski describes the excitement and hope that Szukalski ignited among several art students in Kraków—unfortunately some of them were expelled from the Academy of Fine Arts, which resulted in the organization of the Horned Heart Tribe.[33] Szukalski's artistic

Striking Sculptures by a Polish Artist

Symbolic Work of Stanislaw Szukalski, Who Asserts That Modern Artists Are Held in Slavery by the Rules and Teachings of the Old Masters

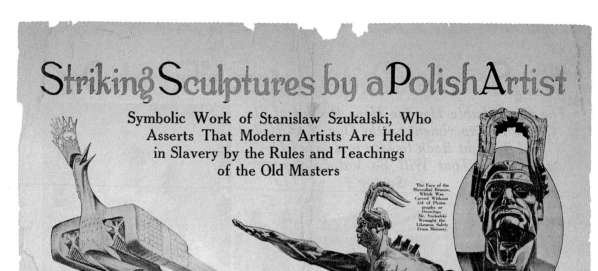

The Face of the Mussolini Bronze, Which Was Carved Without Aid of Photographs or Drawings. Mr. Szukalski Wrought the Likeness Solely From Memory.

One of the Latest of Mr. Szukalski's Masterpieces—A Huge Sculpture in Bronze, Black Metal and Chromium, Picturing the "Krax," Mythical Hero-god and Legendary Founder of the Artist's Native City, Cracow, Poland.

A LITTLE less than ten years ago the son of a Polish blacksmith left his native city of Cracow bound for the United States with the ambition of starting an art revolution. He was convinced that America had won its full independence in the wars with England. As far as art was concerned, this country was groping in darkness and following blindly the old-fogy conventions and rules laid down by the ancient European masters. It was this youth's purpose to start a revolution, which would win artistic independence for a new and virile country which knew and appreciated only the anemic doctrines taught in the fossilized academies of Paris and Rome.

The immigrant was Stanislaw Szukalski, who had won fame as a child prodigy in sculpture in Cracow, and then the derision of his countryfolk because of his radical departures from the tenets of accepted art. He was neither a cubist nor a futurist; he belonged neither to the school of specialists nor to that of the impressionists. He had no respect for any other form of art than his own, and he was determined to make this individual technique the new, strong art of America, just as Tin Pan Alley composers had made of the jazz tempos the new music typical of the pulse of the United States.

Young Szukalski arrived in America and fell in love with and married the daughter of a Chicago millionaire. He set the country to chuckling when the father of his sweetheart vigorously opposed the marriage. His answer to the parent was that he would wed the girl and start a pig farm. This shocked the objecting father, who finally welcomed the young man to the family.

As interludes in the news between the episodes of the young romance the critics had begun to call him, supplied many news paragraphs by attacking American art appreciation, by parading the streets of Chicago in the velvet habiliments of the Paris Art Quarter, by indirectly setting the various art cults at each others' throats and by ridiculing American taste and, finally, startling everybody by his curious conceptions in the form of statuary. Additional notoriety was given him when someone discovered that the young artist's radical ideas had begun the day after he had performed a surgical autopsy on the body of his father in Cracow—"in the interests of anatomical study."

Szukalski goes about advising American students to shun the art schools of Europe and warning them that if they do not learn their own art at home they will remain enslaved by the conventions of doddering old men with medieval ideas and never develop for America its own "strong art."

The accompanying photographs show the remarkable technique of Mr. Szukalski, which runs to symbolism, though it retains a great deal of realism. Back of each of his achievements can be found a perfectly clear motivation. One of his newer masterpieces is a remarkable bronze of Mussolini, with Romulus and Remus, mythical founders of Rome, occupying the original Seven Hills. The wolf-children are quite conventional in the Szukalski conception, but Il Duce is presented in a position that is not customarily done. Mussolini is shown on all fours, and the possessor of a ponderous tail, which he is wearing a fearful frown. The likeness, however, is there and it is a trib-

The "Krax" Motif Recurs in This Massive Sculpture, Designed to Commemorate Poland's Repulsion of Bolshevik Invasions. As in Many of the Szukalski Works, There Is Also an Equine Domination, Due, Perhaps, to the Artist's Early Impressions as a Blacksmith's Son. The Map of Poland Can Be Traced on the Horse's Hide.

ute to the skill of the artist, who carved and moulded the face of the Italian dictator, without any reference to photographs or drawings. He did it from memory, he says.

But of this sample of "strong art" is grotesque, then the interesting statue which he made in Cracow, Poland, as a memorial to the repulsion of the Bolshevik invasions, is weird. It reveals a predatory-appearing bird, anatomically part of one of the sculptor's beloved horses, armed with sword and flame. The bird is a representation of "Krax" who, as every Polish child reads in the school books, is a hero-god, reputed to be the founder of the beautiful city of Cracow, just as Romulus and Remus are fabled to have started Rome in incipience on a thriving capital. But one of the "new art" touches which has been added to this giant statue is the map of Poland which rambles all over the body of the horse. That is symbolical, of course, and averts any misunderstanding of the artist's message. The horse is a symbol of Poland, and the good Krax is the embodiment of the armed forces of the people, determined to repel anybody, Bolsheviks included, who has any mischievous notions of trying to oppress the Polish people.

The same hero-god, Krax, wearing no symbolism at all, can be recognized in the sculpture shown at the upper left, and the strange bird assumes in a vague way, the general appearance of an airplane.

Nationalism is one of the stronger motifs of the Szukalski sculptures. In all his works there is a trace of history or legend. Tom Paine, the American firebrand, is one of his heroes. And why not! Was he not credited with kindling the American Revolution? He did, in a political sense, what Szukalski came to America to do in an artistic sense. Szukalski's tribute to Tom

Occasionally the Polish Artist's Unconventionalities Incline Toward Aboriginal Design. The Ornamentations Which Characterized Aztec and Egyptian Art Can Be Seen in This Bronze Likeness of Boleslaw the Righteous.

Paine is in the form of a massive carving. It shows Paine igniting a human heart, from which the flame of independence and self-reliance is bursting.

A Revolutionist of the Art World, Szukalski Cherishes a High Regard for Tom Paine, the Philosopher, Who Is Credited as the Father of the American Revolution. Hence This Weird Memorial Showing Paine Kindling Human Hearts. The Statue, Only Part of Which Is Shown, Is Called "The Divine Incendiary."

The artist has labeled it "The Divine Incendiary."

The works of Mr. Szukalski are so massive that it is almost impossible to show their remarkable detail in photographs which take in the entire sculpture. Some idea of the great care which he takes with countenances, for instance, may be had by studying the face of Mussolini, or that of Boleslaw, the Righteous. In the latter, critics have noticed a reversion to the primitive art of the American Indians, or perhaps the ornamentation which the ancient Egyptians went in for. It is another instance of Szukalski's linking the ancient with the modern.

This Figure of Mussolini, With the Body of a Lion, in Company With Romulus and Remus, Mythical Founders of Rome, All Occupying the Original Seven Hills, Is the Work That Has Brought the Artist More Fame and Controversy Than His Remarkable Romance With the Daughter of an American Millionaire.

It was his father's craftsmanship, though crude, which decided young Szukalski to take up sculpture, and to prefer metals. When he advises students to shun European art schools he speaks as a man who has had experience with them. He studied at the Academy of Fine Arts at Cracow, but he tells his friends and followers that he is rather exceptional, because he did not cherish the conventional things, once he had acquired a technique. He has made many carvings, a few of which follow conventional lines, and few of which extend far enough beyond the conventional pale to be called extreme.

He never misrepresents, yet he endows his figures with stark, contorted gestures, ligamentous twistings, and where feminine characters are attempted, he supplies odd undulations. But always the studious spectator will find behind these anatomical hysteries the suggestion of the myths, poems and tracts. These are the blood of his work, the artist says, blood that is young and virile, the blood of a new thought, inspired by the spirit of a young nation.

Stanislaw's individualism has been commended by Mrs. Harry Payne Whitney, Robert Henri, John Sloan, Peter Larsen and other distinguished figures of the art world, and patrons of art. Many of these patrons bought the sculptures of Stanislaw, but he would immediately invest the majority of his profits in some new achievement, and ponderous statues like those which he makes are not cheap, even in the modelling stage.

If, during impoverished intervals, he had been able to sell his copious collection of sculptures it would have required a small warehouse to hold them, and had they all been collected into a single scene they would have presented the appearance of a population of a deformed race, suddenly stricken rigid. In fact, many of these odd busts and figurines had been ordered by patrons, or subjects, and had been refused once a completed statue was shown them. This, say friends of Stanislaw, is what convinced him that art was largely unappreciated in America.

But even in his home town, where, at sixteen, he was a prodigy in the Cracow Academy, his art has not been received enthusiastically, except in instances when he has turned out something so emphatically patriotic that it could not be criticized gracefully. They call Stanislaw in Poland "the Rebel." And he rather likes the title, because he believes he has been successful to some degree in fomenting an artistic revolution without enlisting the cohorts of crazy futurists or cubists, or impressionists. These people are the anemic faction of the art world, he believes. They have done nothing that might look as if blood coursed through it. Their silly creations and nightmares have no souls.

The soul, in the sculptor says, must be one of the prime considerations of ambitious art students. Real artists, he teaches, can put spirit into their creations, and make them really live, in the artistic sense. Hence, because of this preachment, Mr. Szukalski became known to the students whom he met and cultivated in America as "The Sculptor of Souls."

Back in Poland, Stanislaw is still news. They remember him there as the young artist who was so proficient in the Academy, and as the lad who wanted to dissect his father's body, after the elder Szukalski had been killed in a motor accident. When asked why he applied for a permit to take the body from the morgue he said simply to the police that he was a student of anatomy. "I am too poor to buy cadavers," he explained, "and my father would wish that I get a lesson this way." He was allowed to perform the autopsy.

It was a strange occurrence, but from that day, on the Polish records show, Szukalski began to depart from conventional art—the sort, which he says, most American students go abroad to study and waste their time upon.

© 1934, by American Weekly, Inc. Great Britain Rights Reserved

program (which then regularly appeared in *Krak*, an ephemeral periodical he published as almost the sole voice of the Horned Heart Tribe) was first introduced in *The Attack of Krak* and included the founding of a teaching institution (Twórcownia) dedicated to the artistic education of young boys devoted to their masters.[34] The Horned Heart Tribe organized several exhibitions, then effectively dissolved when the war began. Several members died fighting Poland's German and Russian invaders; the survivors went on with their own lives and careers.

In his artistic program, Szukalski may have been inspired by the principles of Bauhaus (1919–'33). The members of the early Bauhaus were as spiritual and viciously anti-academic as Szukalski. They also cherished the mediæval ideal of a master-and-apprentice relationship. Therefore, the Bauhaus professors were officially called "masters," their students "apprentices" and the courses "journeys." In the curriculum, the main emphasis was placed on the students' creativity and intimate knowledge of materials, not on traditional academic training.

The cosmopolitan lifestyle still did not lose its appeal for Szukalski. He left Poland again, and in the years 1930–'35 he was thought to have permanently settled in California "devoting his inexhaustible energy not only to painting, sculpture and architectural designs but also to international problems. He wrote a book *Neuropa* based on his own philosophical thoughts—fantastic but unique in conception and interesting."[35] In Szukalski's own version of events, he went back to the United States only to raise money for the Tribe.[36] Still, Szukalski attempted to remotely direct the activities of his Horned Heart Tribe in Poland. Artistically very active, he demanded more and more exhibitions, for which he sent many of his newest, increasingly visionary and fantastic works, mostly designs for monumental architectural and sculptural projects such as *Sunflower* (a figure of a nude man with a stylized sunflower in the background), and a monument dedicated to the mediæval Polish historian Jan Długosz.

In the 1930s, Szukalski also created his first fully developed conceptual environmental projects, elaborately expanding on his earlier architectural visionary fantasies. The first one in the series is a monument to the Pan-American Union, meant to be built on the border between the U.S. and Mexico.[37]

The artistic and political program advocated by Szukalski

during this stay in the United States included the reunification of Europe—with the exception of such "inferior" nations as Great Britain, France, Italy and Germany—into a new federation called Neuropa. The symbol of Neuropa would have the form of a double gammadion. Kraków, of course, would be the cultural center of such a federation.[38]

In January 1936, helped by the Minister of the Treasury, Ignacy Matuszewski, Szukalski once again arrived in Poland where, in the Silesian capital, Katowice, he was finally blessed with the patron for whom he had been longing for so many years. His "Prince" materialized in the person of Michał Grażyński, Governor of Silesia and a hero of the Silesian Uprisings. Grażyński's intention was to counter Nazi propaganda with art that would be monumental, Polish and of high quality. This was an ideal role for Szukalski, who decided to definitely settle in Poland where he was granted a studio and many commissions pleasing his artistic vision. Ben Hecht mentions in *A Child of the Century* that Szukalski received great recognition from his compatriots, including being put in charge of a museum devoted to his art.[39] This statement is simply not true. As explained above, Szukalski had never been accepted by the Polish art establishment. In fact, the Polish artistic world had become even more unyielding towards Szukalski's extravagances. When, three months after his return, Szukalski resumed his old habit of insults, he was simply sued and sentenced to a fine and a three-month prison term (the sentence was suspended).[40]

This experience appears to have had a sobering effect on Szukalski who, instead of politicizing, now concentrated on his art. In Katowice he completed several sculptures (most notably the monument of *Bolesław Chrobry*), designs in bas relief decorating the new building of the Silesian Museum and one of the local government buildings. Later, most of Szukaski's works from Katowice were destroyed by Nazi "cultural correctness" squads, as was the entire new Museum of Silesia—the most modern museum building in Europe at the time.

This creative period in Szukalski's life ended abruptly after Germany and the Soviet Union joined each other in starting World War II. Threatened with the nightmare of being caught either by the Nazis or the Russians, Szukalski temporarily suspended his anti-Anglo-Saxon theories and attached himself to the entourage of the American Embassy that was fleeing a collapsing Poland. His

arrival in the United States was noted by the press and his state-
ments were full of praise for the "most free" country on Earth.[41]

A FAREWELL TO ARTS: THE END OF AN EPOCH

Szukalski's radical nationalistic beliefs earned him the accusation
from Communist circles of being a fascist. Such accusations were
as biased and unbalanced as the 1930s themselves. During that time
there was no Center in the bifurcated political life. While the intel-
lectuals flirted either with Left or Right, the hopeless masses were
grimly bracing themselves for the inevitable total war.

Many artists, mostly those influenced by ideology, used a simi-
lar approach. Diego Rivera, an avowed Communist, also intro-
duced the elements of Pre-Columbian art (combined with the prin-
ciples of Soviet soc-realism) into his paintings and murals. Since the
continuity of Meso-American art was lost in Mexico during the
Spanish rule, his approach was as artificial as that of Szukalski—
with the only claim to continuity being that of geographical proxim-
ity. Similarly, on the other end of the political spectrum, some fascist
artists such as Arno Breker, Robert Steiler, Gustinus Ambrosis,
and, in architecture, Albert Speer attempted to introduce artificial
reconstructions of "pure" Germanic or Italian (Roman) art .

Szukalski's approach to tradition—real or imaginary—was
entirely different. In his works and views, he showed the utmost
disregard for any evidence of cultural tradition, even for geographi-
cal proximity. In a visual sense his art was truly cosmopolitan, so
it cannot be construed that it was either fascist or Communist.
Paradoxically, driven by his megalomania and against all evidence,
Szukalski himself considered his art as being innately Polish in its
nature and, therefore, predestined to be the very soul of Polishness.
This stubborn attitude, combined with his singleminded personal-
ity, earned him his bad reputation. Only after 1939, during the last
stage in the development of his art, he developed his "science,"
Zermatism, which explained this and other apparent contradictions
in his own—scientifically questionable—way.

It is true that Szukalski can be accused of being a racist, but his
racism did not follow the standard divisions of racial hatred.[42] For
example, crossing all racial lines, he abhorred Anglo-Saxon politi-
cians, fascist Germans and Communist Russians alike, believing
they (among others) were the descendants of ancient interrelations
between humans and apes.

39

It must have been clear to Szukalski that by September 1939 the adventure of European avant-garde was over. The great movement, initiated in the middle of the nineteenth century and continued for several generations, had burnt itself out. The ideas of unifying European civilizations, generating an unparalleled efficiency, self-confidence and security, were betrayed and used first as hypocritical explanations for the enthusiastic and meaningless slaughter of World War I and then as the justification of exterminations that inevitably resulted from attempts—as numerous as they were infantile—to socially re-engineer Europe and the world. The echo of loud manifestos proclaiming the endless march of artists towards more and more innovative forms of expression finally died. The new era of loss, coldness, desolation, mass media, and manipulation had dawned on Europe and the world.

Art

THE TIME OF SELF-CONFIDENCE

Sometime around 1923, the style of Szukalski's art had undergone a major transition. In the process that took several years, the formalism of the preceding decade was replaced by a mythological and decorative eclecticism that freely absorbed Meso-American (Pre-Columbian), Ægean, Classical and other influences. Later, on a few occasions, Szukalski would return to the formal mastery of his earlier art as in a beautiful, in its Art Déco simplicity, stone sculpture *An Animal Licking Out a Splinter* (1927),[43] but the balance of his art had changed in favor of an eclectic and monumental universalism.

Szukalski first expanded on the Impressionist core of his earlier works, then to a great degree destroyed it. This was necessary to absorb the grandeur of his new style that pure Impressionism simply couldn't hold. The combination of the *horror vacui* of the empty after-touch surfaces and his authoritarian personality made it hard for Szukalski to leave any parts of his sculptures to free interpretation. As was shown by his later actions, he wanted absolute control over his artistic and political message and was not interested in leaving anything open to the audience—especially the critics.

Around 1923, still following the artistic principles of Impressionism, Szukalski began to utilize the after-touch surfaces of his

sculptures to introduce the complicated symbolism (as in his earlier drawings) of his personal mythology. Thus, Szukalski resolved the formal conflict that plagued his earlier art—the incompatibility between drawing and sculpture.

However, this strictly formal synthesis introduced a new contradiction (never to be reconciled) between the visual and literary messages of his later art. The visual element was based on the deconstructive separations and transpositions of meanings, while the literary part was an ego-centered and convoluted mythology of Polish patriotism according to Szukalski. There was no relation between the traditional, cultural significance of the symbols that Szukalski appropriated and their new meanings as intended by the artist. These visual elements of his art were cosmopolitan and thus opposed to the newly assigned literary messages which were nationalistic.

Years later, independently of Szukalski, the French philosopher Michel Foucault defined this general problem in simple terms: "how a sign can be linked to what is signified" and, subsequently, he defined the separation imposed by the Classical age, from "a culture in which the signification of signs did not exist, because it was reabsorbed into the sovereignty of the Like; but in which their enigmatic, monotonous, stubborn and primitive being shone in an endless dispersion."[44]

The inevitable—and never successful—effort to reconcile this contradiction led Szukalski into the conceptualization of the ideal audiences and disciples eager to follow his ever developing ideas. Thanks to his overwhelming talent and ever-present desire for change, he partially succeeded in his plans by organizing the aforementioned group of devoted artistic followers, the Horned Heart Tribe, and attracting the attention of influential politicians like the Silesian governor Michał Grażyński and Ignacy Matuszewski, the Minister of the Treasury. Szukalski never escaped the triple entrapment of literary mythology, visual deconstruction and escapist conceptualization of the ideal audience. Ironically, because of this entrapment, he did not only anticipate art of the future, but also exposed the painful essence of being an artist. As Robert Hughes explained, "[an artist] is a predecessor, the truly significant work of art is the one that prepares the future. The transitional focus of culture, on the other hand, tends to treat the present (the living artist) as the culmination of the past."[45]

Later in this text, the generative structure of Szukalski's works will be discussed in detail. For now, the simple meaning of the alabaster sculpture, *Cecora* (1927)[46] is a good and intuitively obvious introduction to the eclectic style Szukalski developed during these years.

AN EXAMPLE: CECORA

Cecora commemorates the death of the Polish hetman (commander-in-chief) Stanisław Żółkiewski at the hands of the Turks. The sculpture contains all the elements of the deconstructive and mythological approach. The cut-off head of the hetman shows a disdainful grimace as he drinks the blood from the wound on his forehead. The helmet of the old soldier is covered with ornament showing the oblong of wagons from inside of which the surrounded Polish army fought the Turks. To make things more complicated, the formal organization of the sculpture shows great influence of Meso-American art, especially visible in the sides of the helmet and the high collar.

The contradiction between visual and literary meaning, intrinsic to *Cecora*, is also prevalent in most of the later art of Szukalski. Because of the replacement of the Polish iconographic tradition with that of Meso-America, the visual message of *Cecora* borders on a satire of Polish patriotism. (According to Lechosław Lameński, the leading—if not the only—Polish scholar devoted to the art of Szukalski, *Cecora* even shows Assyrian influences.)[47] However, Szukalski—himself an unconvincing patriot as well as a natural born runaway[48]—was so deadly serious about the true patriotism of the literary message that he attempted to enforce it on the audience with a page-long literary interpretation attached to his own sculpture.[49]

LITERARY MYTHOLOGY

Mythology is at the core of the monumental understanding of history. The term, originally introduced by Friedrich Nietzsche, was resurrected by Michel Foucault who, being obsessively fascinated with Nietzsche, followed Nietzsche's thought in bringing into light the meanings of history: monumental (assignment of significance to historical data), antiquarian (organization of historical data) and critical (re-evaluation of historical data).[50]

According to Foucault, Nietzsche, faced with the fluidity of

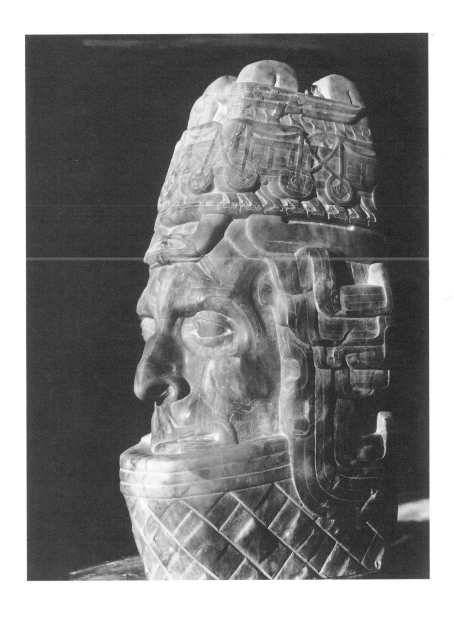

Cecora (1927)

IN ALABASTER

history, believed that historians offered the "confused and anony-mous European, who no longer knows himself (...) the possibil-ity of alternative identities."[51] In the actual text Nietzsche refers to modern man who, like his ancient Roman counterpart, "suffers from a weakened personality" and resembles the ancient Roman who "ceased to be a Roman through the contemplation of a world that lay at his feet; he lost himself in the crowd of foreigners who streamed into Rome and degenerated amid the cosmopolitan carni-val of arts, worships and moralities."[52]

In his art of the eclectic years, Szukalski (free of any known influence by Nietzsche) followed the path of the monumental inter-pretation of history: designed to provide his Polish compatriots

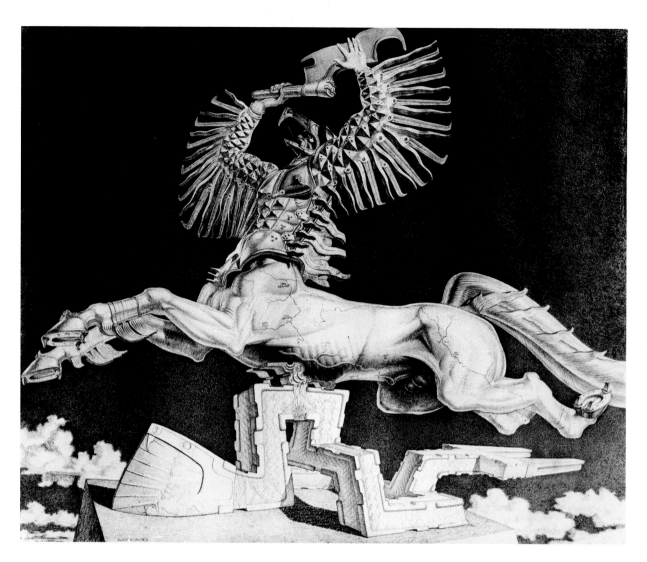

Politvarus (1929)

"The mythic figure Politvarus
combines the names of three soil-
tilling (non-predator) nations:
Poland, Lithuania, and Ruś (the
present Ukraine). Beneath the
galloping Politvarus streaks the
lightning of swift *resolve*."
This drawing (more than likely
destroyed in the bombing of
Warsaw in WWII) is a sketch
for a sculpture that was never
completed.

with the possibility of alternative European and universal identi-
ties. Furthermore, convinced that the traditional Polish or European
history did not bear sufficient significant meaning, he attempted to
provide such.[53] Again, he accomplished it through mythologizing,
deconstruction and conceptualization.

Szukalski's individualistic mythologizing can be explained in
structuralist terms as the usage of existing symbols to create an
essentially parasitic significance of the myth. Roland Barthes analyz-
es this process as a "second-order semiological system" based on
the usage of an existing sign (already including the richness of "the
tri-dimensional pattern" of the signifier, significance and the sign)
as the starting point to initiate the symbolic process once again.[54] It
does not take much imagination to realize that the myth, as defined

by Barthes, has been the name of the game in the propaganda of any political correctness that has occurred in the tumultuous history of the politicized 20th century.

The series of designs for a never-realized monument, *Politvarus* (1921-'23), is one of the first examples of the mythology inherent in Szukalski's decorative ecleticism. The very title of the project is an abbreviation of the names of three countries that once constituted the ancient Commonwealth of Poland and Lithuania: Poland, Lithuania and Ruś (today's Ukraine).[55] The ladder of the myth begins with the ancient symbol of the centaur—a creature that combines a horse's trunk with a human torso. At the first level of the myth, Szukalski overlays this symbolic base with another mythical symbol, the emblem of Lithuania—Pogoń (Pursuit—a warrior riding a white horse and brandishing a sword). At the second level of the myth, Szukalski transmogrifies the torso of the original centaur into the Polish national emblem—the White Eagle. Finally, at the third level of the myth, Szukalski inserts the head of marshal Piłsudski (the savior of Poland and the victor of the Battle of Warsaw, who in 1920 saved Europe from the bliss of an early Bolshevik invasion) into the beak of the White Polish Eagle. The stylized moustache of the old marshal hangs over the lower part of the eagle's beak. As if these three levels of structural myth were not enough, Szukalski covered the trunk of the original centaur with a map of imperial Poland/Lithuania, stretching from the river Vistula to the river Don, which actually is the only reference to Ukraine—as arrogant as it can be, since Szukalski did not bother himself to use the Trizub (Trident), the national symbol of Ukrainian independence. Instead, Szukalski faithfully introduced an element of Meso-American art in the image of a snake (Quetzalcoatl?) over which the mythical Politvarus gracefully jumps. The in-essence Toltec snake vomits the relief silhouettes of Polish soldiers charging with fixed bayonets. Interestingly enough, in the initial version of *Politvarus* (1921), there is no head of marshal Piłsudski protruding from the Polish Eagle's beak and the snake does not regurgitate. Still, the final design is very elegant, especially if the viewer is not familiar with—or bothered by—the underlying ad-hoc mythology.

VISUAL DECONSTRUCTION

The underlying question of Szukalski's art was interwoven with the cognitive dissonance he naturally experienced because of his

prolonged isolation from Polish and European tradition and lack of formal education. The rejection of historical Polish iconography was only a natural consequence. Never sure of the results of the pundit interpretation of what he wanted to express, Szukalski visually challenged the supposedly eternal meaning of signs.

This state of "confusion" fortunately did not affect the quality of Szukalski's creations. Structurally, his art resembled the art of his beloved High Middle Ages—based, among other things, on the transposition of meanings—when, according to Erin Panofsky, "classical motifs were not used for the representation of classical themes while, conversely, classical themes were not expressed by classical motifs."[56]

The deconstructive manner in which Szukalski defined his visual symbolism is the second element of his eclectic style. Szukalski freely re-interpreted the imagery of different cultures, most notably the Meso-American, and attempted to present them as intrinsically Polish. This process of deconstruction was clumsily formalized by Jacques Derrida. As radical and as puzzling as Szukalski, Derrida once wrote: "I am European (...) but I am not, nor do I feel, European in every part."[57] Therefore, Derrida's theories, as arrogant and incoherent as they may be, provide the ideal tool for analyzing the deconstruction attempted by Szukalski.[58]

According to Derrida, the process of deconstruction is necessary because we lack the knowledge of the historicity, modality and originality of the cultural statements we make. As a result, the opinions we utter are necessarily confused by the inherent fictionality of all methods.[59] This approach is a remote and confused echo of the famous theorem of Kurt Gödel, which has troubled all sciences since the 1930s by stating that any kind of universal, general statements leads to inevitable contradiction. It happens simply because any global statement, in order to be universal, has to include references to itself and therefore evoke the "liar's paradox."[60]

According to Eva Tavor Bennet, an interpreter of Derrida's approach, Derrida bases the deconstructive process on four operations: division of meanings traditionally considered to be related, pivotal transposition of established hierarchies, articulation of symbolic series inevitably selected on the basis of either symbolic or visual proximity, and displacement resulting from the presumed fictitiousness of all analytical methods.[61]

There are two types of division described by Derrida: vivisection of a single symbol and separation of two entities considered to be inexorably linked to each other.

The former is exemplified by the symbol of "Toporzeł"—the traditional White Eagle of Poland in the shape of Szukalski's battle-ax.[62] Szukalski did numerous studies of the national Polish emblem before finally, having become frustrated with its shape of "a stuffed white rooster in the neo-realistic style [which] cannot be the emblem of the Nation," designing his own version.[63] It goes without saying that all Poles were expected by Szukalski to immediately discard the White Eagle and adopt the "Toporzeł." In the late 1930s Szukalski, attempting to follow the current surge of religious feelings, changed the name of the stylized bird to "Topokrzyż," a combination of "Toporzeł" and the Christian cross.[64]

The latter type of division is visible in Szukalski's re-interpretation of the symbolic meaning of the snake. According to the Judeo-Christian tradition, the snake is seen as the representation of evil and treachery. However, the Meso-American snake is a symbol of wisdom and humanity (Quetzalcoatl). Szukalski separated the biblical significance from the serpent and replaced it with the Meso-American meanings. He played with this idea in the ethereal *The Prophet* (bronze, 1919), which incorporates two large snakes of wisdom symbolizing the insignificance of the small, snake-like human standing in front of them.[65] The Meso-American snake is also present in *The Heavenly Nurse* (1922)[66] and in the designs for *Politvarus* (1920-'23). In another design, *A Monument to Commemorate the Union of Pol-Litvania* (1927), two snakes twist together in a spasmodic embrace serving as the pedestal for two small human figures, presumably Poland and Lithuania.[67] The fact that people in both Poland and Lithuania have been for many centuries fiercely catholic and, therefore, interpreted the snake according to their beliefs, never bothered Szukalski.

TRANSPOSITION OF HIERARCHIES

The pivotal reversal of established hierarchies dominates the deconstructive monument of *Remussolini* (1932, plaster). Szukalski initially was an admirer of Il Duce, raving: "Behold Piłsudski, Mussolini, Kemal Pasha, the Titans who bring about successful changes."[68] In contradiction to his official faithfulness to the literal sense

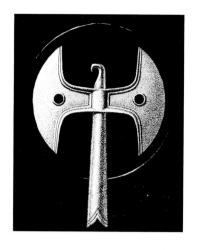

SZUKALSKI'S EAGLE-AX

[47

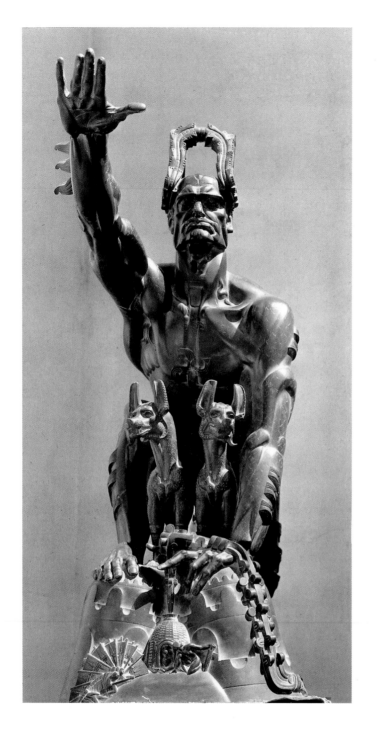

Remussolini (1932)

of the rules imposed by Mussolini on the Italians, Szukalski followed an entirely different visual path of aggressive deconstruction that, without the knowledge of Szukalski's views, could have been construed as a ridicule of Mussolini.

Clearly, the departure point for Szukalski is the famous *She-Wolf* of the Museo Capitolino in Rome. The ancient Etruscan She-Wolf was already altered during the Renaissance by the addition of two contemporary sculptures of Romulus and Remus suckling her nipples, such alteration being intended to support the myth of Rome's origin. Szukalski continued this already deconstructive process. He transformed the She-Wolf into a naked man—Il Duce, Benito Mussolini; then he changed the twin founders of Rome into two little wolves. Thus, he first deconstructed Mussolini by transforming the politically correct standard of depicting Mussolini—at the time still a respectable European politician—into a naked, half-animal-half-man, though extending his hand in the fascist greeting, then by questioning his Italian virility by turning him into the formal semblance of the female wolf.[69]

This approach was not only a reversal of the official art of Mussolini's regime, but even of the meaning of numerous statements Szukalski had made about Il Duce. In an earlier design, the leader of fascist Italy is portrayed naked and outfitted with a muscular tail, kneeling on two mounds that vaguely resemble a female body. The lower parts of the mounds are covered with other naked bodies, snakes, and more mounds.[70] In the final version Mussolini, still naked, kneels on several ornamental rocks.

A massive tail sticks out from between the buttocks of Mussolini. Under the Duce's stomach are two wolflings, not even Romulus and Remus, alert and following the destination of Mussolini's hand, also extended in the fascist greeting. There is no possibility of protection or nourishment as in the Capitolian She-Wolf. Still, both the title and the design of Szukalski's sculpture made an obvious connection to the ancient Etruscan piece. In this process of transposition of meanings, Szukalski visually deconstructed Mussolini from a masculine hero of Italian fascism into a visually obvious feminine ideal of a nurturing mother.

This complicated gender-maneuvering is also present in the works of Derrida: "'Woman'—an epoch-making word—does not believe either in the simple obverse of castration, anticastration. Much too clever for that she knows (and we—who we?—should learn from her, or at least from her operation) that such a reversal would deprive her of any possible recourse to simulacra [resemblances]."[71]

ARTICULATION OF SYMBOLIC SERIES

Articulation of connotations and visual similarities of symbols overwhelms another of the important sculptures by Szukalski, *Boleslav the Brave* (1927, bronze).[72] As Derrida wrote, "Each time that a rhetoric defines metaphor, not only is a philosophy implied, but also a conceptual network in which philosophy itself has been constituted."[73]

The sculpture is a full demonstration of the new omnipresent style adopted by Szukalski. The Polish king resembles more a Maya warrior than a mediæval European king. His oversized crown is ready to fall down—a symbolic representation of his troubled life. Even his sword is turned into an elongated, capricious Meso-American club, totally useless as a weapon. Eventually morphing into the likeness of a snake, the sword becomes, according to Szukalski, "the Deed that sucks the king's blood;"[74] therefore, the exposed veins on the king's muscular arm are empty. The club-like sword bounces against the backs of the procession of figures that follow the king, and the dynamics of the process are expressed by a series of four tactile and explosive protuberances of flames that decorate the blade of the sword.

The cloak of the king, no longer left to the Impressionist method of the after-touch, has become a procession of symbolic figures

embracing the eight hundred years of Polish history that followed the king's reign. According to Szukalski's own commentary: "All the little figures offer their best to the flames and snakes. There are a priestess with milk and cheese, a knight with a helmet full of his blood, an eighteenth-century Pole with a falcon clutching a moth, a fisherman with a fish, a Siberian [a Polish prisoner in Siberia, EDK], a youth with nothing in his hands to give, (…) the servant, the priestess with honey, the poet with his manuscript, the mountaineer, the legionnaire [a soldier of Polish legions organized by marshal Piłsudski in 1914, EDK], the shepherd, the modern non-entity."[75] All the figures—that would have been artistically redundant according to Impressionist principles—that hide behind the lonely statue of the king, are intended to bring the association with Polish history and its related meanings, and enforce this background on the viewer. The sculpture is extremely precise in the likeness of its parts, so according to a few lucky ones allowed by the museum in Bytom to see the piece "…some details can be seen only through a magnifying lens."[76]

DISPLACEMENT THROUGH FICTITIOUSNESS

Finally, like Jacques Derrida, Szukalski did not allow any analytical methods to be applied to his art. He never acknowledged the rights of critics to express their independent opinions because, according to him, critics were only unrealized artists, incapable of giving birth to real art and therefore existing "…just like old and chronic virgins, giving the world their opinion about giving birth to children."[77] The process of deconstruction rejects all methods of interpretation—except itself—as suspect, because they are based on real or presumed biases. This creates a contradiction resulting from a simple question: Why is deconstruction more reliable than what it attempts to deconstruct? However, every student of basic logic understands that allowing the equivalents of A and not-A in anyone's system of beliefs, guarantees the god-like ability to prove anything one wants to prove. This is the reason that Szukalski stated that "An artist who searches for 'new art,' 'a new way,' and through them a new himself, does it from very petty-minded impulses…" In the same publication, Szukalski continues his sermon adding that "Creative innovating in concepts is the essence of wisdom."[78] Similarly, Jacques Derrida, whose philosophical extravagances Szukalski parallels in his artistic message, includes numerous contra-

dictions in his texts: "What deconstruction is not? Everything, of course! What is deconstruction? Nothing, of course!"[79]

CONCEPTUALISM

The literary meaning of Szukalski's art during this Decorative Eclecticism phase was mythological and a search for solid, individualistic consistency in the redefinition of Polish patriotism. At the same time the visual message of his art was deconstructive and, thus, self-questioning, ironic, characterized by the fluidity of symbols and an almost perfect lack of any relation to the traditional iconography of Polish culture. Officially, Szukalski never acknowledged this problem.[80] However, after leaving Poland for good, he attempted to resolve it by inventing Zermatism, so he was able to claim that all languages, art and culture were centered around Poland, so, obviously, the free use of different cultural motifs was irrelevant to his Polishness.

Still, in the 1920s and 1930s, when Szukalski still had access to public opinion in Poland, he made another attempt to level the dichotomy between the literary (intended) and visual (perceived) meanings of his works. His skill in architectural design and literary attitude towards art became the tools used in numerous projects intended to breach the wall between the exotic iconography of his art and traditionalist Polish audiences. In this effort he attempted to create a new tradition that would fit his intellectual and artistic whims.

In the literary area Szukalski committed himself to the reinvention of the myth of Krak—a legendary king of Kraków, originally a cobbler, credited with having killed a dragon living in the Dragon's Den next to the royal castle on Vavel Hill. As Szukalski noticed himself, there were very few literary or visual references to Krak in Poland's literary tradition, therefore Krak became the ideal medium for his reinterpretation of Polish tradition.[81] True to his commitment, Szukalski made a sculpture of *Krak*[82] and wrote an impenetrable theatrical play, *Krak, the Son of Ludoli* (*Krak syn Ludoli*). Szukalski's first artistic manifesto was titled *The Attack of Krak* (*Atak Kraka*), and an ephemeral periodical he published was also called *Krak*.

In the visual area, Szukalski made numerous and elegant drawings of buildings and different architectural designs.[83] His major conceptual project of the time was that of *Duchtynia* (*The Temple*

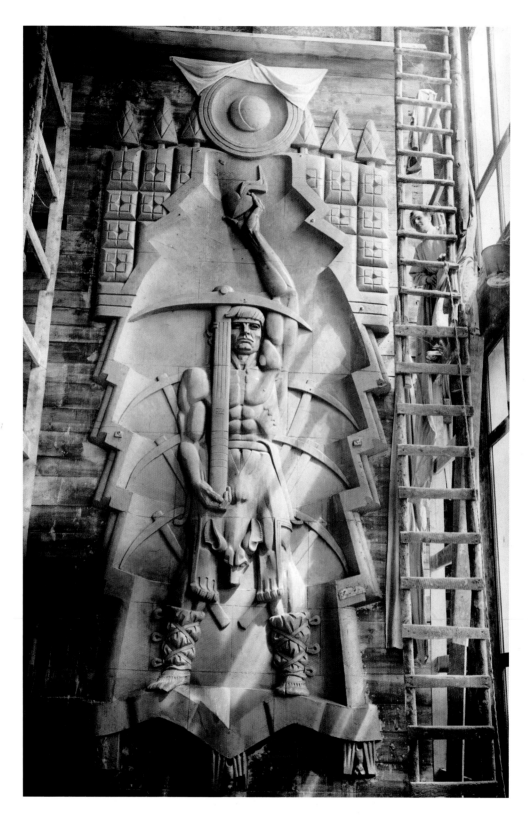

Monument to a Miner (1939)

SZUKALSKI'S ONLY REALIZED FULL-SCALE PROJECT, COMPLETED IN WARSAW SHORTLY
BEFORE THE NAZIS BOMBED THE SCULPTURE. SZUKALSKI IS SEEN ON LADDER, TOP RIGHT.

of Spirit), dedicated to the Polish tradition and to be located in the Dragon's Den next to Vavel—therefore also called The Vavelian Project.[84] With a precision comparable to that of conceptual artists of the 1970s, Szukalski describes the initial partial demolition and acid cleaning of the Dragon's Den (one of the landmarks of Polish tradition)—it must be admitted that he was going to allow the archæologists to perform their official research before the total rebuilding. After the actual rebuilding, the interior of Szukalski's Dragon's Den would include the tomb of marshal Piłsudski, a statue of Światowid (one of the the major deities of the pagan pantheon of ancient Poles) combined with the sub-statues of the four pre-eminent historical figures riding a giant horse and looking out towards the four cardinal sides of the world. The figures included: marshal Piłsudski, Casimirus the Great (a mediæval king of Poland), Copernicus and Mickiewicz (the great Romantic poet), each of them assigned special meanings. The pedestal supporting the sculpture was to be partially empty inside to allow for the sculpture of Toporzeł. The numerous openings in the pedestal would allow the visitors to put their hands inside to touch the Toporzeł and thus participate in the communion of Polish national identity.

Postmodernism (1939–1987)

Postmodernism was anticipated in literature and by visual artists such as Francis Bacon in the late 1940s and early 1950s, but the progressive avant-garde attitude would still prevail in visual arts for about 30 years. Szukalski, who never followed the mainstream of modernism in his lonely and parallel adventure with the art of the 20th century, was able to naturally discover postmodernism much earlier than the rest of the art world. He used postmodern elements in his art before World War II, but fully developed his own postmodern approach by the mid-1940s. The outrageous anthropological and linguistic theories he formulated at that time strongly supported his previous, but even more so his new art.

Szukalski's approach to postmodernism was simplified and more direct than the standard one. The postmodern translation of existing cultural symbols and meanings is a three-step process involving, first, the selection of the symbol by the mass media, fol-

HERALD CHICAGO **AMERICAN** 2 FRO ND PAG

SECOND SECTION THURSDAY, NOVEMBER 30, 1939 13

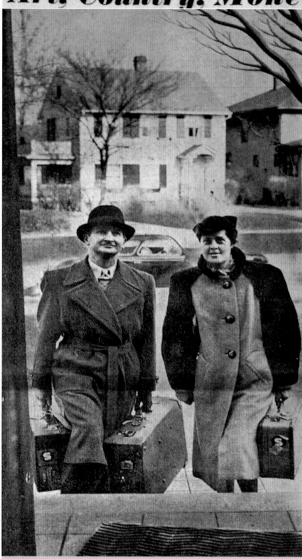

His Masterpieces Smashed in Polish Ruins

Sculptor Back Sans
Art, Country, Mone

Stanislaw Szukalski, the noted Polish sculptor, arriving with his wife at their Riverside home after fleeing from Pola (Herald-American photo.)

Lived in U. S. Embassy Basement
During Seige of Warsaw

Stanislaw Szukalski, noted Polish sculptor, returned from his war-torn homeland today—a man without his art and without a country. He is also financially ruined.

Creator of innumerable pieces of art, Szukalski, former husband of Helen Walker, Chicago heiress, said his masterpieces—hundreds of them—are in ruins amid the shambles of Warsaw, Krakow and Katowice, in Poland, destroyed during the ruthless Nazi German invasion.

He returned from Poland with his second wife, Joan Lee Donovan of Riverside, where they both live. During the one month siege of Warsaw, Szukalski and his wife, with seventy other Americans, lived in the basement of the United States embassy.

LIFE WORK GONE.

Heartbroken, Sculptor Szukalski

gone. The German bombs destroyed my masterpieces. I feel today as the great singer who has lost his voice . . . "

As he has not obtained citizenship papers in the United States, Szukalski is also a man without a country. He continued:

"But I'll get them as soon as possible; America is the greatest country in the world."

Szukalski won world recognition by his works which were characterized by a strangeness of conception, for example, his "Conscience," which is depicted as a monster of writhing tenacles and myriad eyes. Conscience to Stanislaw (Stanley, to us) looks at once like an octopus, a gnarled, branded tree, a nightmare and a worm.

One of the pieces of art lost in Poland was his conception of "Grief," which was depicted by a

of a nude man lying between huge bird's feet.

Szukalski was engaged in ing on his huge monumen honor of the eleventh ce Polish hero, Chrobry, when first German bombing started dropping their death ing missiles upon Warsaw.

The monument to the hero also was known as the King of the Slavs," was hal ished when a bomb dropped the building in which Szul was working.

GOD OF HEREDITY.

Among the many art work stroyed by German raiders huge statue of Duce Muss which Szukalski named mussolini," a proposed wor honor of Copernicus and a monument depicting the "G Heredity."

Szukalski blamed the fall o land upon the Polish govern which, he said, was steeped

NEWSPAPER ARTICLE, 1939

lowed by its trivialization and lowering to the lowest common denominator, at which stage such a processed symbol can become the spiritual food for a postmodern artist. While typical postmodernists can in fact not exist without their natural habitat of the world ruled by big corporations and mass media, Szukalski's postmodernism was possible because of himself. He did not need the æsthetic authority of the mass media, because he trivialized the symbols himself; he did not need the audience because he was his own audience.

After returning to the United States in 1939, Szukalski found himself without money, so he soon decided to move to Southern California where he had lived before, and try his luck there. Unfortunately, luck and the ability to attract the attention of artistic circles had irrevocably left Szukalski, so he and his wife lived on a very modest income in small apartments, mostly in the suburbs of Los Angeles, even in an upgraded chicken shack in Tarzana.

He visited his beloved Poland only one more time, in 1957, during the short period of relative liberalization that followed one of numerous uprisings punctuating the history of Communist Poland.[85] At that time it was obvious that the Communists were not interested in allowing anybody to mesmerize artistic circles with a barrage of spectacular provocations. The only mania allowed in the workers' paradise was that of Marxism-Leninism. Under these circumstances, Szukalski made several statements, met with his friends and family and promptly returned to California—his "cultural Siberia."

There his life and art became even more removed from the reality of the surrounding world than before the war. Nothing came of his efforts to retrieve his own sculptures and his exquisite collection of prints by renowned European artists that were stolen by the Communists.[86] However, driven by the powerful concept that "*spiritus fiat ubi vult*," and despite the miseries of his mundane daily life, Szukalski never lost his vigor, imagination, and ability to construct grandiose schemes "explaining" human civilization.

He conceived a new theory—a global extension of his previous beliefs. It was as scientifically unsound as there are deviations of the human brain. (Today, for example, we have the idiosyncracies of Afro-Centrism, Creationism—now taught in the Kansas school system—or the still pervasive ideology of Aryan supremacy as adopted by the Nazis.) Szukalski's theory involved the concept

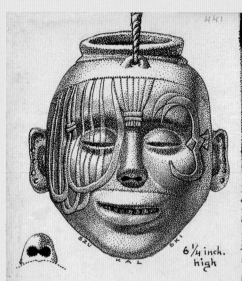

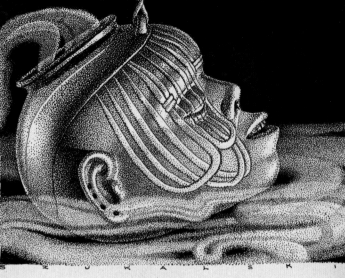

Flayed-head skin "last" for drieing it from inside by he slow heat of he glowing embers. Eearles skin of he Gon was stretched over it to preserve his "likenes". Note he partition-less nose hole. He Crab (Grave-maker) takes possesion of he oher of he "Oce" (Otseh). Arkansas.

Head-shaped incense-jar commemorative of a Gon whose face, (on a string) "swims" upon he settling smoke hat simulates sea.　He came from one of he "Oce" (eyes)-ans, which here is symbolicly "over-covered" by he "Sea" pictograph.　Prehistoric Arkansas. U.S.A.

(gold)

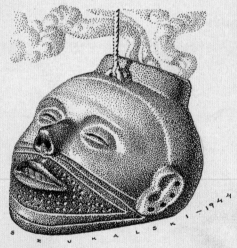

"Sacred Isle" ear-pendants found in he graves of prehis-toric Poles, in Poland. Compare wih porforated ears of Americas.

Head-jar wih Flood-scum marks gahered on he face of Gone, while swimming. Could he ear-perforations indicate he number of Floods? Arkansas.

ZERMATISM #441 (1944): DEVELOPMENT OF THE "FLOOD-SCUM" MARKS IN REFERENCE TO THE "GREAT DELUGE." DRAWING FROM THE ARTIST'S SCIENTIFIC WORK TITLED "ZERMATISM"

of *Protong*, the primordial language of humankind, naturally—in his world—based on the Polish language and Polish neologisms invented by Szukalski to better express his ideas. According to Szukalski, the "real" Germans and Russians—as opposed to their Nazi and Bolshevik counterparts—were actually Poles, who had once been conquered by Hunanized Germans and Russians. The world, destroyed by the Great Deluge, had been rebuilt by the culture emanating from Easter Island. Therefore, the different marks and body ornaments found in tribes all over the globe invariably were commerorative symbols of the mud residuals remembered on the faces of the ancestors who had escaped the Deluge by swimming. Also, humankind was troubled by the internal abomination of Yetinsyny (Sons of the Yeti in Polish), the terrible offspring of humans who had mixed with Yetis. According to Szukalski, that diverse group included, besides Nazis and Bolsheviks, such persons as Machiavelli, Robespierre, the Egyptian King Faruk, Winston Churchill, and—of course—Krushchev.[87]

To find foundation for his theories, the artist spent numerous hours in libraries, making thousands of meticulous drawings of people and places. Many of these were later edited by Glenn Bray and Lena Zwalve and published in the double volume *Troughful of Pearls / Behold!!! The Protong*.[88]

It is a sign of Szukalski's unusual creativity that in the midst of his studies he also found the time to pursue his unrestrained artistic visions. Most of his work from that time are portraits of friends, technically exquisite drawings, designs for medallions, and various monuments—all of these spiced up by only a few large sculptures. The most interesting (if difficult to interpret) example of the artist's sculptural work of the period is the elaborate and complicated bust of Polish general Bor Komorowski (1955), leader of the Warsaw Uprising in 1944.

Szukalski's financial situation simply did not allow him to do what he always did best—sculpting. Instead, he continued to work on grandiose conceptual projects which incorporated sculpture as well as architecture. Realized only in drawings and (sometimes) plaster models, they were mostly memorials to people, events or ideas. "He was always thinking only of the monuments; how to build them—to whom to propose them—from where to obtain the funds—which king, which head of state, which government."[89]

The designs of these monuments follow the tradition of the

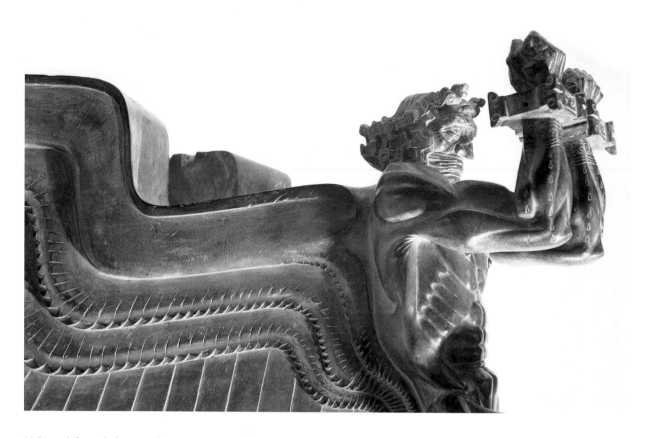

Yaltantal (1945) (DETAIL)
A statue commemorating the
Yalta conference of 1945 with
disastrous consequences for
Poland. "This is the Caucasian
Prometheus called Tantalus, who
is a lover of Mankind."

artist's earlier projects, and fit well into the decorative ornamental eclecticism he had developed before ww II. The only new element was the heavy dose of Szukalski's detailed and complicated, but at the same time elementary symbolism, at that point already removed from any sensible or justifiable context. As vague is it seemed, it did anticipate the typical postmodern attitude that whatever the artist does makes sense because he thinks so.

Two of the most interesting examples of such works are *Prometheus* (1943), later redone as *Yaltantal* (1945), and a visionary project for the city of Paris, *The Rooster of Gaul* (1960). In a way typical of Szukalski's visionary environmental projects, they consist of both architectural and sculptural elements.

In Prometeus and *Yaltantal* Szukalski used his earlier ideas for a monument to the Polish Romantic poet *Julius Słowacki* (1929).[90] Inspired by his longtime unconditional supporter and admirer, Aleksander Janta-Połczyński, Szukalski designated the monument as a gift from the Americans to the United Nations. It was meant to

Rooster of Gaul:
SKETCH, SETTING, SHOWING
INTENDED SIZE
(SEE ALSO PP. 159–167)

be erected in front of the U.N. Building in New York, surrounded by a complex of galleries (the "Prometheum") depicting the most important achievements of humankind.[91]

The iconography of the monument is, as always in Szukalski's later work, overly detailed and therefore not immediately clear in its meaning. After a closer look, however, it becomes an extremely dramatic evocation of Szukalski's early sculpture of *David*. Now another hero of humankind, this time "the winged half-god,"[92] or rather a titan, *Prometheus* is depicted as unable to act, trapped and immobilized by his own weapon—a strung bow ready to launch an arrow.

Szukalski's David did act and did win, but was psychologically paralyzed by the consequences of his action. Szukalski's *Prometheus* cannot do anything; he is disabled and frozen in a gesture of protest as the smoke from crematory chimneys tangles his wings. He wants to speak, maybe even scream, but he is gagged.

Ironically, seen from the perspective of the early 21st century,

Rooster of Gaul: PRELIMINARY
LEFT AND RIGHT: SKETCHES OF "MARIANNE"

the dramatic *Prometheus-Yaltantal* conveys besides its original meaning a bitter commentary on the effectiveness of the U.N.'s contemporary international efforts.

Another elaborate vision, *The Rooster of Gaul* (*Le Coq Gaulois*), was designed as a memorial to the glory of the French maquis (guerilla fighters in the resistance movement during WW II). The intended location was appropriately prominent—on the Île de la Cité in downtown Paris, on the parvis of the Notre Dame cathedral.

The monument was planned to be situated on a small piece of land in the middle of a deep rectangular pool surrounded by steps, gradually opening towards its top. It was the negative image of a typical step-pyramid, which Szukalski often used in his projects. The artist planned to fill the pool with water connected to the natural flow of the Seine river.

The scaled-down monument itself consists of a pedestal with a gigantic upside-down rooster on top. The pedestal, constructed of a dolmen-like wall, was to contain an intricate system of corridors and staircases leading to a sanctuary holding an unusual group,

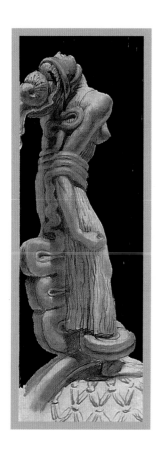

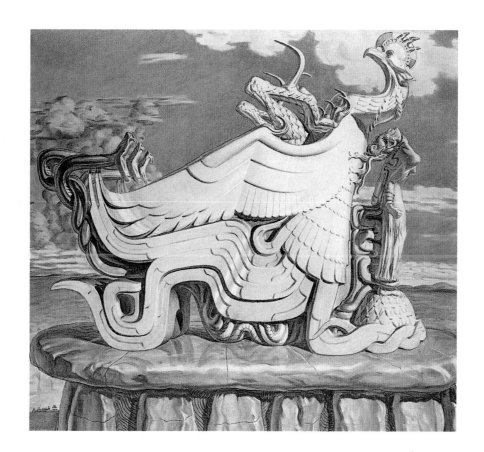

Rooster of Gaul
DRAWING (1959)

including the Holy Mother with her Son—a variation on the traditional image of the Pietà. In Szukalski's version, the Mother desperately tries to save her dying Son by pulling him out of purgatory.

The dramatic main scene on top of the pedestal depicts a rooster—the old symbol of Gaul, laying on its back and simultaneously fighting three snakes to protect Marianne, the symbol of the French Republic, who is struggling to stay alive behind him. The composition is filled with meticulous details, such as an elaborate model of the Notre Dame cathedral placed between the claws of the rooster.

After *Prometheus* and the *Rooster of Gaul* Szukalski created a few more of such visionary and fantastic projects, such as *Katyn* (1979), the monument commemorating the death of 20,000 Polish intellectuals, first interned, then killed by the Soviets, officially Poland's allies in ww II;[93] and the monument intended for the city of Venice, featuring the Polish Pope, John Paul II, as a strong, muscular man covered with feathers, twisting the head of a giant Hydra (1982).[94]

In his glorious pride, Szukalski refused to exhibit anywhere but

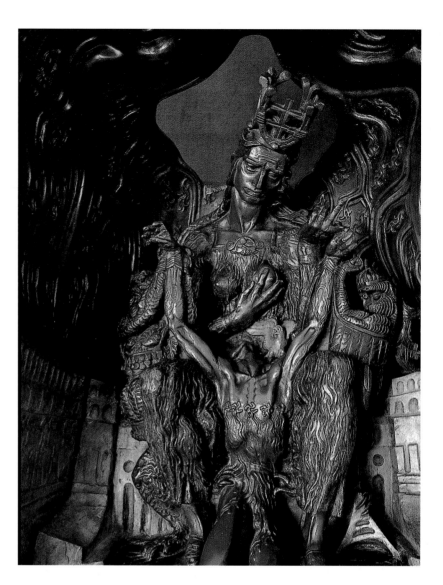

Rooster of Gaul: Pietà ("Mother France") (c. 1960)

Designed to fit inside a niche in the Central Pillar in the monument to France, this Pietà portrays Mother France resurrecting her Nazi-machine-gunned son who rises from the grave. "With one finger she raises him, while readying her virginal breast for him to participate again in the sacrament of Life. On her head she has a crown made of the four lost horseshoes of the Apocalypse. Jesus' wrists, however, are tied to the wrists of a Traitor and a Cosmoparakeet. They pull down Jesus and dig their foot-claws into His sides, to return him to his grave and death.

The Traitor on his right is a Yetinsyn (son of the Yeti) covered with animal fur and the medals from the enemies of France, while the Cosmoparakeet screeches his Sorbonne-learned 'isms,' theories and existentialist catchwords in service of cosmopolitan subversion.

photo by Jeff Vaughan

in reputable museums. However, whenever he was given the rare opportunity to speak to curators, he routinely started the conversations with outspoken criticism of their collections, alienating them before they even had a chance to get interested in his projects. The only notable exception to that rule seem to be Glenn Bray and Lena Zwalve, founders of Archives Szukalski in Sylmar and the owners of the artist's works, who also published several books about Szukalski and organized two important exhibitions of his art.

Until his death in 1987, Szukalski retained his typical energy and determination to work. The same can be said about his ability to insult people and devote himself to new grandiose schemes. Though his ideas were, to put it mildly, rather eccentric, his ability to reason and memorize was outstanding. He was very clear about what he wanted to say and how he said it.

The ideas of postmodernism suited Szukalski's own experiences well. World War II had proven to him that savage brutality formed the core of highly developed technological civilizations. The war ended the long era of modernity based on continuous progress in technology as well as in art and society. The key issue of postmodernism, the relationship with the past, is also at the center of Szukalski's post-war art. The avant-garde rejects the past, replacing the tradition by radical "isms" preached by disciplined artistic groups. Postmodernism, by contrast, accepts the past but without trust, so the past and its symbols have to be re-interpreted. After 1939, Szukalski made a heroic effort to reinterpret both the past and the present, simply because he inhabited an unliveable, cold and unreal afterworld.

2 Understanding Szukalski

THE ENIGMA of Szukalski involves his personality as well as his art. Fortunately, the principle of the visibility of human souls unifies both. As much as Szukalski never attempted to hide his megalomania, he created symbolically transparent art and frequently provided his personal instructions on the interpretation of his work. Therefore, the best way to understand Szukalski is to look at his art.

As mentioned above, the years before 1923 were the formative years of Szukalski's life and art—so deeply intertwined. Today it is easy to see that the artist never escaped the consequences of the artistic choices he made during the essential year 1923.

During the time leading up to 1923 Szukalski made two sculptures which visually and metaphorically already are the fullest manifestos containing the artist's plans, hopes, beliefs and fears. The dramatic *Struggle* (original Polish title: *Struggle Between People and a Human, Quality and Quantity*, 1917) is the key to Szukalski's personality. The ravishing *Echo* (1919) is the key to Szukalski's art. Both sculptures combine the modernist and the eclectic elements of Szukalski's style.

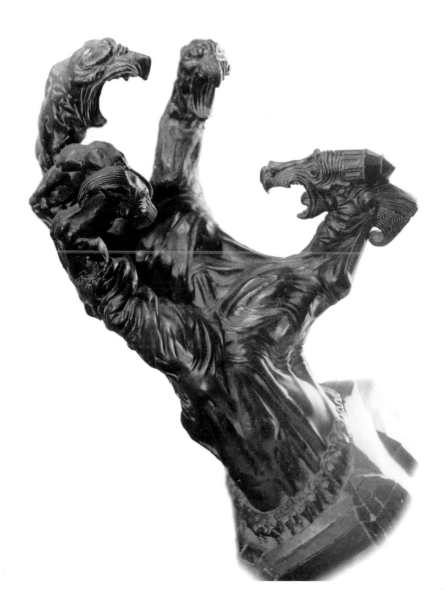

Struggle (1917)

IN PLASTER

Personality

STRUGGLE

Szukalski's life exemplified the conflict between the individual and the masses, and the very similar conflict between quality and quantity. His 1917 sculpture, *Struggle*, may be considered the most important manifesto of his life—a key to his personality combining visionary imagination with an individualistic philosophy. More than his other art marked by an obsession with exaggerated, "talking" hands of different kinds (*The Lost Tune*, *Labor*, *The Birth of Thought*, *Man and His Brother*, or *Flight of the Emigrants*), he created this work as

a proclamation. "The thumb," the artist explained, "is Quality, and the fingers are Quantity." The thumb is also an Individual, the artist himself, fighting against Society. "Without thumbs we couldn't make tools, and without tools we couldn't make civilizations," Szukalski further explained. "Out of a dozen people, one person will be creative, the one who provokes and proposes ideas. This individual is sent by Nature. He is the means by which people can survive historically against adversity."[95]

As much as he desired to organize a group of devoted and elitist followers, or even lead masses towards the future designed by himself, Szukalski was also an eccentric and unrestrained individualist. Such a conflict made it impossible for him to win the popular recognition that he undoubtedly deserves and for which he was longing so passionately.

Furthermore, Szukalski was a workaholic, indiscriminately dedicating his genius and talent to grandiose ideas of the Szukalskicized society of the future, as well as devoting his time to thousands of drawings he used to "prove" the Szukalskicized theories of existence. He drifted from the uniqueness and perfection of the relatively few sculptures he made in his early years to mass production of thousands of illustrations in his pseudo-scientific research books. Eventually, the desire to produce a large body of technically superior but, arguably, artistically redundant graphic material overcame his ability to produce just a few, but very likely artistically much more significant pieces. In a sense, he was deluged by his own creativity, and maybe this is why the Deluge plays such an important role in his late theories. It explains why a lonely island surrounded by water is such a recurring motif in his late art. Another recurring motif defining the artist, is the drama of the lonely individual in his hopeless struggle—the struggle that disables and paralyzes him.

In 1923, at the peak of his intellectual and artistic powers, Szukalski had already come to fully understand that intrinsic conflict of his life. *Struggle* had shown that he knew that he might be driven and eventually destroyed by the entropy born from the desire to devote himself to the realization of obviously contradictory concepts. He made the decision not to take sides in this struggle, and he was fractured and, finally, immobilized by the powerful forces that, once released, were beyond his control. Then it did not matter at all because he disappeared from the event horizon of artistic affairs to live in Southern California, entirely in his own lonely world filled

only with echoes and laboriously illustrated transformations of the imponderabilia that meanwhile were shaping the world in which we live.

Art

ECHO

Szukalski understood the gist of the century in a perfect yet capriciously paradoxical way. The perfection displayed by Szukalski was incongruous because he offered an alternative and highly individualistic interpretation of his time. Like many other artists, he chose the noble path of provocation intended to shock the audience, question the validity of their views by sharing the underlying principles and then developing them in a different direction.

Echo, a sculpture he made in 1919, is the key to Szukalski's art. The muscular female figure of Echo is headless since she doesn't

originate sound, but re-echoes it only, similarly to what Szukalski later expressed in his art. Gracefully and timidly at once, she hides her shoulders with beautiful long-fingered hands—evoking Rodin's Cathedral—and deceives her trustful listeners by distorting their original sounds.

Szukalski wanted to discover a new Earth, he wanted to be another Columbus and find his own enchantment with the "Isla Hermosa." He embarked on a dangerous journey to discover an

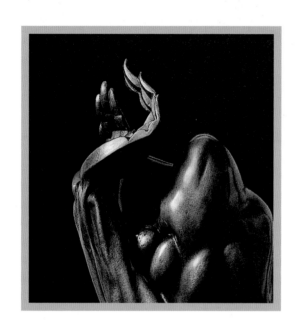

Earth different from the one that physically exists. As a result, he became an echo of the world we know, less and less intelligible to the audience. Becoming less and less real, Szukalski slowly disappeared from the cultural discourse of his time to become one of the first-class geniuses of our century, as defined by Lem.[96]

The modal conflict between the necessary and the possible contained in Szukalski's art, by far exceeds the one the artist faced in his personal life. Therefore, if we want to understand Szukalski, we have to relegate our everyday reality from the status of necessity to that of possibility. Inevitably, Szukalski is impossible from the point of view of our necessity. He can be accepted only if we acknowledge that we ourselves are possible rather than necessary, if we question what we believe in or admit that our views without the support of our spiritual peers may be as erratic and misunderstood as his.

Szukalski's art can be irritating to us because we can see ourselves in it depraved of the supporting voices of those who usually share our follies, spiritually naked, facing our own mythologies and delusions. The message is unsettling: Szukalski was a talented megalomaniac and was possibly wrong in many of his beliefs, but how do we know that we are different? After all, the list of idiocies that we ourselves have accepted, just because of skilful marketing, as valid points of view, is as long as the list of Szukalski's follies: racism, affirmative action, creationism, Africano-Centrism, angels, psychic phenomena, tv evangelists, UFOs, Communism, fascism, contract with America, family values etc. Logically, they are as inconsistent and disregarding of any kind of scientific evidence as were the views of Szukalski. The difference lies in the fact that

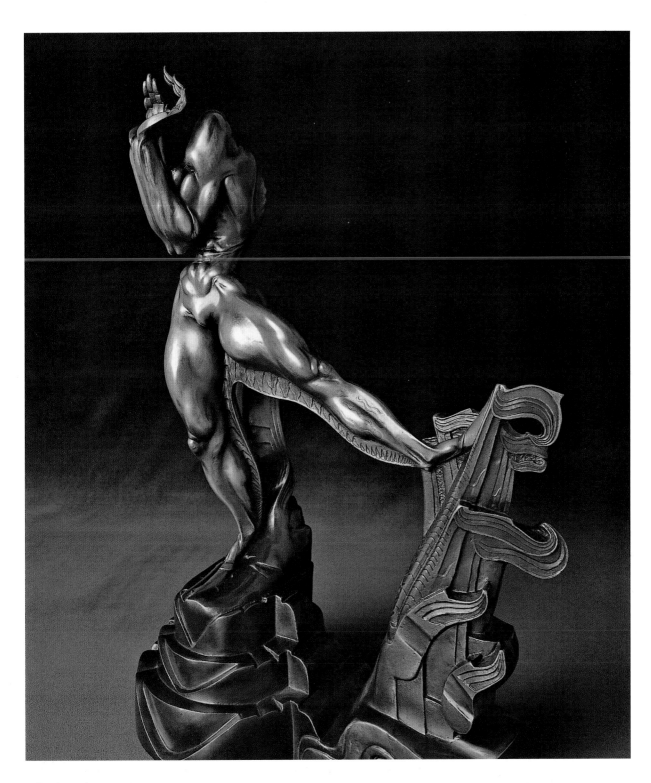

Echo (1919)

"The figure of *Echo* is headless, as she does not originate the sound of the echo. To hide the absence of her head, she places her hands together and deceives her listeners by distorting the sounds they make, re-echoing it to them. She is resting her inflamed foot on a tree, tired of running from hill to hill."

(*Troughful of Pearls, The Lost Tune*)

PHOTO BY JEFF VAUGHAN

his originality and prophetic appeal were no match for professional marketing campaigns.

The past cannot be changed. What is left of Szukalski is in the soil of the sculptors' quarry, Rano Raraku, on Rapa Nui (Easter Island), where, according to Szukalski's theories, the new Civilization of Earth had originated after the Deluge. It was here that Szukalski's friends, Rick Griffin, Camille Houston, Robert and Suzanne Williams, Lena Zwalve, and Glenn Bray scattered the artist's ashes on July 30, 1988.

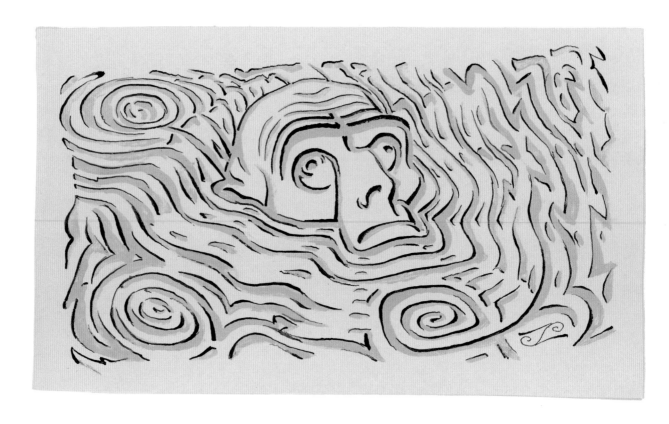

Deluge (c. 1954)

Drawing from the massive *Zermatism* books

1 Stanisław Lem, "Odysseus of Itaca by Kuno Mlatje," in: *A Perfect Vacuum: Perfect Reviews of Nonexistent Books*. New York and London: Harcourt Brace Jovanowich, 1978, pp. 102 and 111

2 Ben Hecht, *A Child of the Century*. New York: Simon & Schuster, 1954, p. 242

3 In addition to Glenn Bray and Lena Zwalve, this group includes Robert and Suzanne Williams, the late Rick Griffin, Ray Zone, George and Leonardo DiCaprio, and Jim Woodring.

4 The Municipal Museum in Bytom is currently in the possession of twelve works by Szukalski:

Pomnik Bolesława Smialego (*The Monument to Boleslav the Brave*), bronze (1926–'28);
Geniusz (*Genius*), bronze (1918);
Orator, bronze (1919);
Æsop (1919);
Zycie Ludzkie (*Human Existence*), patinated gypsum plaster (1923);
Glowa meska (*A Head of a Man*), pencil drawing (1918);
Czarownica (*A Witch*), tempera (1933);
Studium portretowe Dr Michala Grażyńskiego (*A Portrait Study of Dr. Michal Grazynski*), pencil and lithographic crayon drawing (date unknown);

Alegoria Smierci (*The Allegory of Death*), woodblock print (date unknown);
Glowa meska (*Male Head*), dry point etching (1916);
Zastygła Młodość (*Frozen Youth*), 2nd version, bronze (1922); and
Studium glowy (*The Study of a Head*), etching (1917).

5 Szukalski writes about his "stolen" collection stored at the Municipal Museum of Bytom, Upper Silesia: "Eventually I took my entire collection from America to Poland, with all my works. All of it the official 'culture vultures' of Poland have stolen. Presently, in Upper Silesia, there is a Museum of Engravings, supposedly formerly owned by General Zając ('hare'), which actually is my property consisting of over three thousand items of the finest masterpieces of Dürer, Altdorfer, Aldegraver, Burgmayer, Vit Stwosz, Hammerskerker, Solis and many other masters (...). The American State Department would not assist...." Stanislav Szukalski, *Behold!!! The Protong*. Sylmar, Ca.: Archives Szukalski, 1989, p. 94.

6 One such piece was *Struggle*, mentioned later in this text. It was purchased in 1998 by Glenn Bray, the legal owner of Stanislav Szukalski's estate.

 The authors of this text conducted an independent (and by nature limited) research in this field. Anecdotal evidence collected from Polish sources preferring to be anonymous leads to the belief that a large

number of Szukalski's pieces is still kept by the people who stole them during the Communist years and will eventually become available for sale.

On the day following Szukalski's death, Glenn Bray received a call from a Polish Consulate official inquiring about the ownership of the artist's estate.

7 *The Work of Szukalski.* Chicago, Ill.: Covici-McGee, 1923 (unpaginated)

8 The word "Zermatism" closely resembles "Sarmatism," the cultural paradigm of the the 17th and 18th century Republic of Poland-Lithuania. Like Zermatism, Sarmatism was based on the belief that the Poles and Lithuanians were the ancient descendants of both Romans and Iranian Sarmatians. There is no scientific evidence for Zermatist ideas. Szukalski himself claimed that the name "Zermatism" was derived from the Swiss town of Zermatt, in: "To Koło Na Orlim Ogonie" ("This Circle on the Eagle's Tail"), an open letter, Kraków, Poland: *Przekròj,* July 5, 1987, p. 17.

9 To attest to the harshness of almost three centuries of Russian occupation and domination of Poland—sometimes conducted together with Germany and Austria—it is sufficient to mention that out of about 20 major uprisings that occurred during that time, twelve were exclusively aimed against Russia or the Soviet Union.

10 The rewards included two silver medals and monetary awards. The most significant exhibition he participated in was the Continuous Exhibition organized by the Friends of Fine Arts Society, together with recognized Polish artists of the time: Olga Boznańska, Xawery Dunikowski, Władysław Ślewiński, and Jacek Malczewski.

11 There are only five sculptures known from that period, all of them now owned by the artist's nephew,

Roman Romanowicz, who lives in Warsaw:
> *Postać Młodzieńca* (*The Youth*) (1911);
> *Glowa kobiety* (*A Head of a Woman*) (1912);
> *Portret Tadeusza Kaczmarzynskiego* (*Portrait of Tadeusz Kaczmarzynski*) (1912);
> *Iskariot-Fantazja* (a.k.a. *Judas*) (1912); and
> *Mezczyzna w długim Płaszczu* (*Man in a Long Robe*) (1913).

Lechosław Lameński, "Pro Memoria," in: *Rzeźba Polska,* Centrum Rzeźby Polskiej w Orońsku- Rocznik, 1987, p. 329.

12 As noted by one of Szukalski's friends, Marian Rużamski, the artist decided to go back to Chicago in 1913, saying, "I am going… to make a portrait of my father, who won't live much longer." Marian Rużamski, *Kto to jest Szukalski?* (*Who is Szukalski?*), Warsaw, 1934, p. 8

13 Ben Hecht, *A Child of the Century,* pp. 239–241

14 In her 1994 dissertation, *The Prophets of Modernism: Art in Chicago, 1900–1924,* Constance Katherine Campbell Poore mentions several events from Szukalski's life, mostly based on Ben Hecht's memoirs, *A Child of the Century.* Another contemporary source mentions Szukalski's talents in a review of the exhibition of American Art at the Art Institute. Maude I.G. Oliver, "Chicago in Art," in: *International Studio,* Chicago, December, 1916, vol. LX, #238.

15 Ben Hecht, *A Child of the Century,* pp. 240–241

16 Donald Kuspit, *Hysterical Painting: The New Subjectivism. Art in the 1980s.* New York: Da Capo Press, 1993, pp. 183–184

17 Kuspit, *Hysterical Painting,* p. 184

18 Ibid.

19 The term "Art Déco" was coined by British art historian Bevis Hillier in the 1960s and is derived from the name of the 1925 Paris exhibition.

20 Ben Hecht, *A Child of the Century*, p. 242

21 The sculpture is dated 1918 in Lameński, "Pro Memoria," and 1920 in Stanislav Szukalski, *The Lost Tune: Early Works* (1913–1930). Since then this sculpture was found in a private collection, and its actual date, 1916, was established.

22 After his return to Chicago and the death of his father, both in 1913, Szukalski was forced to work in a butcher's shop.

23 Stanislav Szukalski, *The Lost Tune, Early Works* (1913–1930). Sylmar, Ca.: Archives Szukalski and Chicago, Ill.: Polish Museum of America, 1990.

24 The whereabouts of Szukalski can be traced through his file at the Department of Labor, which states clearly his departures from the United States (1923, 1925, 1936, 1938) as well as his returns from Poland (1924, 1930, 1937, 1939). From this source, and the knowledge of his travels through Europe, it can easily be deduced that between 1923 and 1939 he spent at most five years in Poland.

25 Marian Wallis, "Sztuki Plastyczne—Wystawy w Zachęcie" ("Plastic Arts—Exhibitions in Zachęta"), in: *Robotnik* (*Worker*) 11/12, 1923, vol. 332, p. 2, as quoted by Lechosław Lameński, "Stanisław Szukalski—Życie i Twórczość" ("Stanislav Szukalski—Life and Art"), Warsaw, Poland: *Biuletyn Historii Sztuki* (*Bulletin of Art History*), 4/1976, p. 311

26 Jerzy Żyznowski, "Wystawy bieżące w Towarzystwie Zachęty Sztuk Pięknych" ("Ongoing Exhibitions in Zachęta"), in: *Tygodnik Ilustrowany* (*The Illustrated Weekly*), 1923, #51, pp. 814–815, quoted by Lechosław Lameński, op. cit., pp. 311–312

27 Szukalski won the Grand Prix for his bronze sculptures, a Gold Medal for his works in stone and a Diplôme d'Honneur for his architectural designs. Interestingly enough, Szukalski was originally commissioned to design the pavillion housing Polish works, but because of internal intrigue the commission was taken from him as "not displaying Polish character." M. Rużamski, *Kto Jest Szukalski?* (*Who Is Szukalski?*), as quoted by Lechosław Lameński, op. cit., p. 313.

28 Lechosław Lameński, "Stanisław Szukalski–Życie i Twòrczość" ("Stanislav Szukalski—Life and Art"), pp. 313–316

29 He initially intended to have the exhibition at the Friends of Fine Arts Association, but engaged in a serious conflict with the executive Council, which dissolved the plans. At the Unicorn (*Jednoróg*) Guild the monument of *Bolesław the Brave* and the award-winning design of the monument of *Adam Mickiewicz* were shown among other sculptures, drawings, and visionary architectural designs. Ibidem.

30 *Kronika Artystyczna* (*The Art Chronicle*), Sztuki Piękne, Kraków, Poland, V, 1929, p. 229. Quoted by Lechosław Lameński, "Stanisław Szukalski–Życie i Twòrczość" ("Stanislav Szukalski—Life and Art"), p. 320

31 For example: *Biała Zaraza w Krakowie* (*White Plague in Kraków*), Kraków, undated (assumed 1929)

32 Stanisław Szukalski, *Atak Kraka* (*The Attack of Krak*). Kraków: Gebethner i Wolf, 1929

33 Marian Konarski, *Szukalski w Krakowie* (*Szukalski in Krakòw*), 1996. Unpublished.

34 Stanisław Szukalski, *Atak Kraka (The Attack of Krak)*

35 Blanche Gambon, "Stanisław Szukalski: Painter, Sculptor, Architect, Philosopher," in: *The New American. A Monthly Digest of Polish-American Life and Culture*, Cicago, September, 1935, Vol. II, No. 10

36 Stanisław Szukalski, *Szukalski and The Horned Heart*, Poland: self-publication, 1936 (unpaginated)

37 Lameński, "Pro Memoria", p. 334

38 Stanisław Szukalski, two unpublished letters to Marian Konarski, 8/1930 and 6/1931, as quoted by Lechosław Lameński in "Stanisław Szukalski—Życie i Twòrczość" ("Stanislav Szukalski—Life and Art"), p. 325; Blanche Gambon, "Stanisław Szukalski: Painter, Sculptor, Architect, Philosopher," in: *The New American. A Monthly Digest of Polish-American Life and Culture.*

39 Ben Hecht, *A Child of the Century*, pp. 240–241

40 Szukalski was sued by artist Wojciech Jarzębowski, whom he had accused of corruption and called a dwarf. Andrzej Gass, "Sąd broni karła" ("The Court Defends a Dwarf"), in: *Kulisy (Behind the Scenes)*, 6/1999, #117, p. 11

41 *Chicago Herald-American*, November 30, 1939

42 Szukalski, *The Self-Born Image Maker* (unpubl.), Vol. 2, pp. 163, 167, 193.

43 Stanislav Szukalski, *The Lost Tune, Early Works (1913–1930)*, p. 101

44 Michel Foucault, *The Order of Things*. New York: Pantheon Books, 1970, p. 43

45 Robert Hughes, *The Shock of the New*, New York: Alfred A. Knopf, 1980, p. 366

46 In 1999 *Cecora* was added to the art collection of George DiCaprio.

47 Lechosław Lameński, "Stanisław Szukalski: Życie i Twòrczość" ("Stanislav Szukalski: Life and Art"), p. 318

48 Szukalski conveniently escaped two world wars, in 1913 and in 1939, never applying himself to actually fight for his beloved Poland.

49 The sculptor's own interpretation of *Cecora*, in: *The Lost Tune, Early Works (1913–1930)*, p. 110

50 In this deconstructive age, it is very hard to make any constructive statement about the widely recognized philosophers: the very title of Nietzsche's work has undergone a veritable deconstruction process in English translations. Within 35 years, it has been published as *The Use and Abuse of History* (1957), *On the Advantage and Disadvantage of History for Life* (1980), *On the Uses and Disadvantages of History for Life in Untimely Meditations* (1983)—all listed below. One and the same quote reads, respectively:
"History is necessary to the living man in three ways: in relation to his action and struggle, his conservatism and reverence, his suffering and his desire for deliverance. These three relations answer to the three kinds of history:—so far as they can be distinguished—the monumental, the antiquarian, and the critical." (Friedrich Nietzsche, *The Use and Abuse of History*, translated by Adrian Collins. Indianapolis / New York: Bobbs-Merril, Inc., 1957, p. 12)
"History belongs to the living man in three respects: it belongs to him as long as he is active and striving, so far as he preserves and admires, and so far as he suffers and is in need of liberation. To this triplicity of relations correspond three kinds of history: so far as they can be distinguished, a *monumental*, an *antiquarian*, and a *critical* kind of history."

(Friedrich Nietzsche, *On the Advantage and Disadvantage of History for Life*, translated by R.J. Hollingdale. Cambridge, Mass.: Cambridge University Press, 1980, p. 67)

"History pertains to the living man in three respects: it pertains to him as a being who acts and strives, as a being who preserves and reveres, as a being who suffers and seeks deliverance. This threefold relationship corresponds to three species of history—insofar as it is permissible to distinguish between a monumental, an antiquarian and a critical species of history." (Friedrich Nietzsche, *On the Uses and Disadvantages of History for Life in Untimely Meditations*, translated by Peter Preuss. Indianapolis / Cambridge: Hackett, 1983, p. 14)

51 Michel Foucault, "Nietzsche Genealogy, History in Æsthetics, Method and Epistemology," in: James D. Faubion (Ed.), *Essential Works of Foucault, 1954–1984*, Vol. 2. New York: New Press, 1998, p. 390

52 Friedrich Nietzsche, *The Use and Abuse of History*, p. 28

53 Szukalski's manifestos kept at Archives Szukalski, Sylmar, Ca.

54 Roland Barthes, "Myth Today." In: *Mythologies*, London: Jonathan Cape, 1972, pp. 114–115

55 A series of drawings from 1923–'29, in *Szukalski: Projects in Design*, Chicago, Il: The University of Chicago Press, 1929 (unpaginated)

56 Erwin Panofsky, *Introductory Studies in Iconology*. New York etc.: Harper & Row, 1972, p. 18

57 Jacques Derrida, *The Other Heading: Reflections on Today's Europe*, Bloomington: Indiana University Press, 1992, pp. 82–83

58 In 1992 a group of philosophers, outraged by Cambridge University's decision to award an honorary Doctorate to Derrida, protested in an open letter published in the London Times on May 9, 1992. The letter seriously questions the honesty and significance of Derrida's works stating for example: "M. Derrida's voluminous writings in our view stretch the normal forms of academic scholarship beyond recognition. Above all—as any reader can very easily establish for himself (and for this purpose any page will do)—his works employ a written style that defies comprehension." The letter is included in a collection of interviews with Derrida, Points, Stanford: Stanford University Press, 1995, p. 419.

59 For more information on Derrida and his theories, see also: Eve Tavor Bannet, *Structuralism and the Logic of Dissent*. Urbana and Chicago: University of Illinois Press, 1989. Because of their inherent ambiguities and contradictions, Derrida's texts are quite clumsy. Therefore, the application of Derrida's theories to the puzzling work of Szukalski is based on Bannet's book.

60 The meaning of Gödel's Theorem is very easy to understand in an intuitive way as in the case of the ancient statement accusing all Creteans to be liars: if a Cretean says that he is telling the truth he can be called a liar; similarly, if the same Cretean claims that he is lying he is telling the truth.

For an explanation of Gödel's Theorem, see Ernest Nagel and James R. Newman, *Gödel's Proof*, New York: New York University Press, 1960.

61 Eve Tavor Bannet, *Structuralism and the Logic of Dissent*, pp. 204–223

62 "Toporzeł" is a combination of two Polish words: *topór* (ax) and *orzeł* (eagle)

63 Andrzej Gass, "Sąd broni karła" ("The Court Defends a Dwarf"), in: *Kulisy* (*Behind the Scenes*), 6/1999, #117, p. 11

64 Stanisław Szukalski in *Krak*, December 1937, p. 80

65 Stanislav Szukalski, *The Lost Tune, Early Works* (1913–1930), p. 109

66 Ibid., p. 63

67 A drawing in: *Szukalski: Projects in Design* (unpaginated)

68 *Szukalski: Projects in Design*, Introduction, p. 15

69 Lechosław Lameński, "Stanisław Szukalski—Życie i Twòrczość" ("Stanislav Szukalski—Life and Art"), p. 322

70 *Szukalski: Projects in Design* (unpaginated)

71 Jacqes Derrida, "From Spurs: Nietzsche's Styles," in: Peggy Kamuf (Ed.), *A Derrida Reader*. New York: Columbia University Press, 1991, p. 362

72 *Boleslav the Brave* is still kept in storage at the regional museum in Bytom, Poland. It has never been exhibited, since it was treated as a spoil of war and the museum does not have any document stating that the sculpture is its property (the same applies to several other pieces of Szukalski kept in the same basement). According to Szukalski, the sculpture was cast in bronze (*The Lost Tune, Early Works* (1913–1930), pp. 102–103). For some strange reason, several dark and unclear close-ups of *Boleslav the Brave* were included in a short documentary film, *In the Circle of Stanislav Szukalski*, made in 1986. The very experience of Glenn Bray and Lena Zwalve, who visited the place in 1998, resembles the dark images of the Stalinist era.

73 Jacques Derrida, "White Mythology: Methaphor in the Text of Philosophy," in: *Margins of Philosophy*. Chicago: University of Chicago Press, 1982, p. 230

74 The translation of his description

75 The artist's own comments in: *Szukalski: Projects in Design* (unpaginated)

76 Lechosław Lameński, "Pro Memoria," in: *Rzeźba Polska*, p. 331

77 Stanisław Szukalski, *Szukalski and the Horned Heart* (Poland, self-published, 1936)

78 Stanisław Szukalski, *Atak Kraka* (*The Attack of Krak*), pp. 13 and 18

79 Jacqes Derrida, "Letter to a Japanese Friend" in: *A Derrida Reader*, p. 275

80 In 1985 a Polish journalist, Olgierd Budrewicz, inteviewed Szukalski and recorded the artist's fierce rejection of any relationship between his and either Pre-Columbian or Egyptian art. Olgierd Budrewicz, "Rzeźbiarz i heretyk" ("A Sculptor and a Heretic"), *Perspektywy* (*Perspectives*), January 1, 1985.

81 Staniław Szukalski, "Dlaczego Krak" ("Why Krak"), in: *Krak*, December 1937, pp. 8–10

82 *Szukalski: Projects in Design* (unpaginated)

83 Ibid.

84 The conceptual description of the project is included as "Duchtynia" in *Szukalski and The Horned Heart*, pp. 31–33. Elements of the visual design are included as "The Vavelian Project" in *Szukalski: Projects in Design* (unpaginated). The name *Duchtynia* is a combination of the Polish words *Duch* (Spirit) and *Świątynia* (Temple) and therefore can be loosely translated as "The Temple of Spirit."

85 Lechosław Lameński, "Pro Memoria," in: *Rzeźba Polska*, pp. 335–336

86 Lechosław Lameński, "Pro Memoria," in: *Rzeźba Polska*, p. 335. Also in: Stanislav Szukalski, *Behold!!! The Protong*, p. 94

87 Behold!!! The Protong, p. 94

88 Stanislav Szukalski, Behold!!! The Protong/ *Troughful of Pearls*, Sylmar: Glenn Bray Pub., 1980

89 Suzanne Williams, "Stanislav Szukalski," in: *Stanislav Szukalski: Song of the Mute Singer*, edited by Jacæber Kastor and Carlo McCormick, New York: New York: Psy-Sol Word Press, 1989 (unpaginated)

90 Lechosław Lameński, "Stanisław Szukalski—Życie i Twòrczość" ("Stanislav Szukalski—Life and Art"), p. 321. The sculpture also continues the idea of the earlier works such as *Frozen Youth* (*Flight*), 1920 (stone) and 1922 (bronze).

91 Aleksander Janta-Polczyński, "Sprawa Szukalskiego" ("The Case of Szukalski"), in: *The Culture.* Paris, 1965, pp. 301–304

92 Aleksander Janta, "Myś lowinieta rzeźbą, Uwagi o dziele i sprawie Szukalskiego" ("A Thought Wrapped Up in Sculpture; Comments on the Art and the Case of Szukalski"), in: *Wiadomości* (*The News*), London 1955, nr. 15/16, p. 2. Also in: Aleksander Janta, *Lustra i reflektory* (*The Mirrors and Reflectors*). Warsaw: 1982, pp. 241–258

93 *Behold!!! The Protong*, pp. 84–89

94 Lechosław Lameński, "Wielki Przegrany, Rzecs o Stanisławie Szukalskim" ("The Great Doomed One. The Ballad of Stanislav Szukalski"), in: *Między Polską a Światem: Kultura emigracyjna po 1939 roku* (*Between Poland and the World: The Polish Immigrant Culture after 1939*). Warsaw: Wydawnictwo Krąg, 1992, p. 74

95 Stanislav Szukalski, *Troughful of Pearls* (unpaginated)

96 Stanisław Lem, "Odysseus of Itaca by Kuno Mlatje," in: *A Perfect Vacuum: Perfect Reviews of Nonexistent Books*. New York and London: Harcourt Brace Jovanowich, 1978, pp. 102 and 111

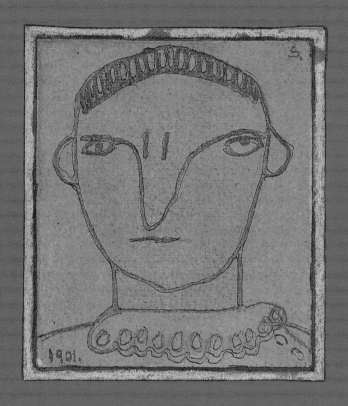

Self Portrait

1901

I

DRAWINGS

■ ■ ■

TEXT BY SZUKALSKI

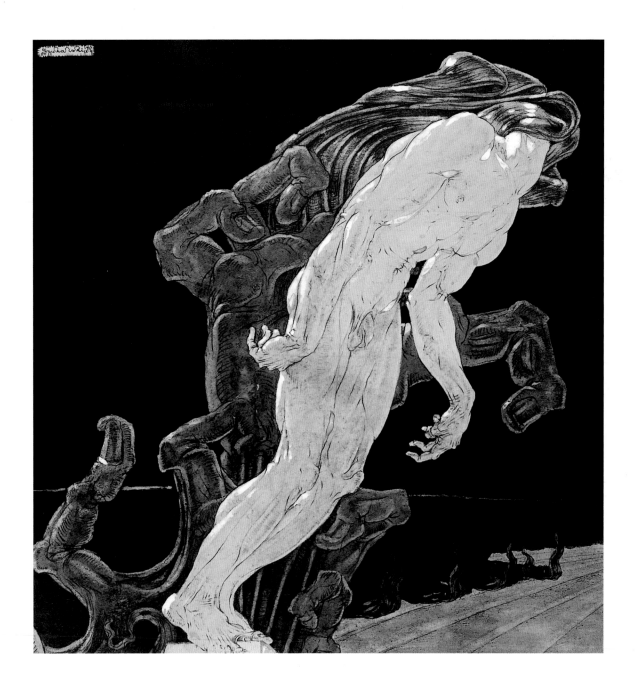

The Climbing Deluge of War

1917

Blood in the form of an enveloping hand climbs
the pedestal upon which man has raised himself
and, wrapping his head, it drags him down.

ORIGINAL PHOTOGRAPH ENHANCED BY THE ARTIST

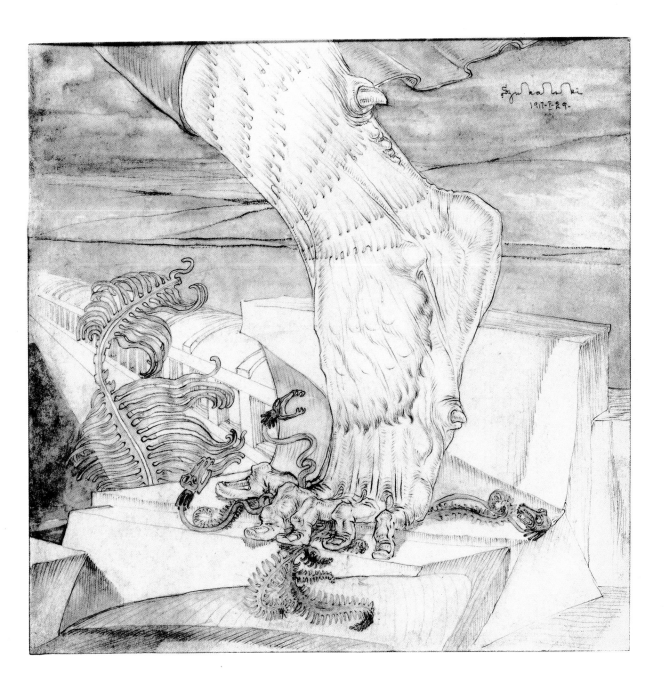

Invasion

1917

Flowers turn into snakes in order to protect themselves.

(This recently discovered photograph of the 1917 drawing shows much more detail than the reproduction seen in *The Work of Szukalski* (1923), the artist's first book. The original drawing was more than likely destroyed in the bombing of Warsaw in WWII.)

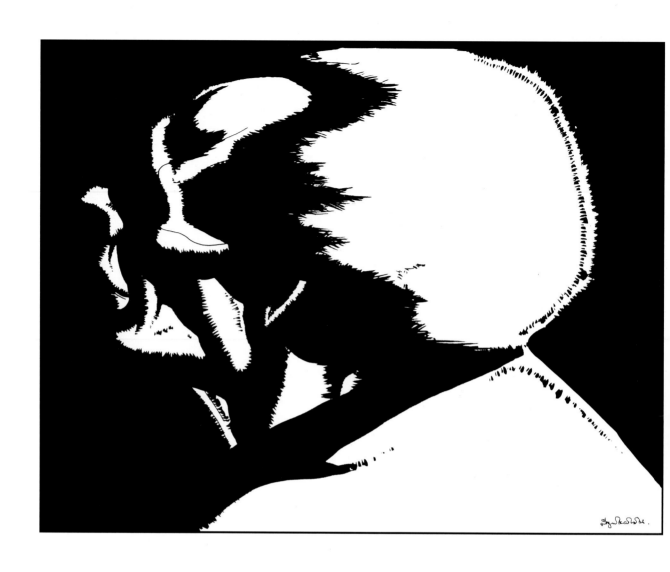

Man Looking Away

1919

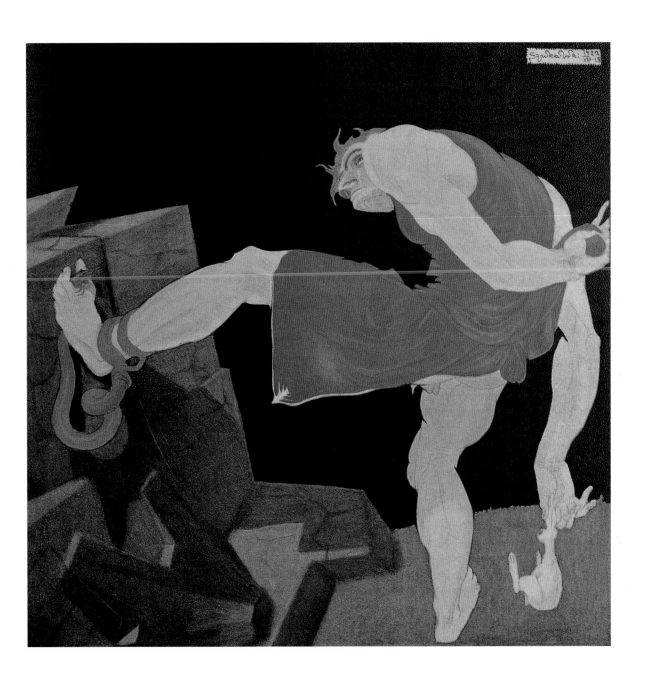

If God Created the Rabbit, WhoThen Made the Viper?

1922

(From: *The Work of Szukalski*, 1923)

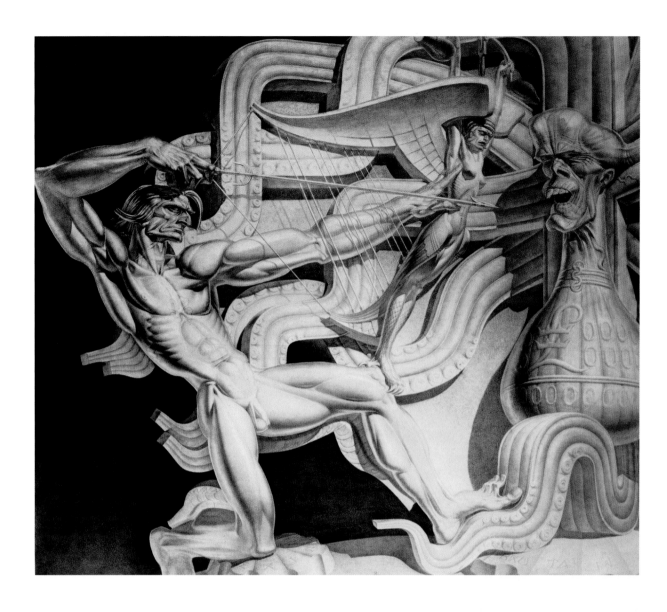

Ireland (Predators Make Empires)

1932

Project for a sculpture. Drawn in 1932 before De Valera became the president of Ireland. e is about to release his arrow, aiming at the head of the invading English octopus, whose belly is filled with pounds of Sterling. (Reproduced from the only existing photograph. The drawing was more than likely destroyed in the bombing of Warsaw in WWII)

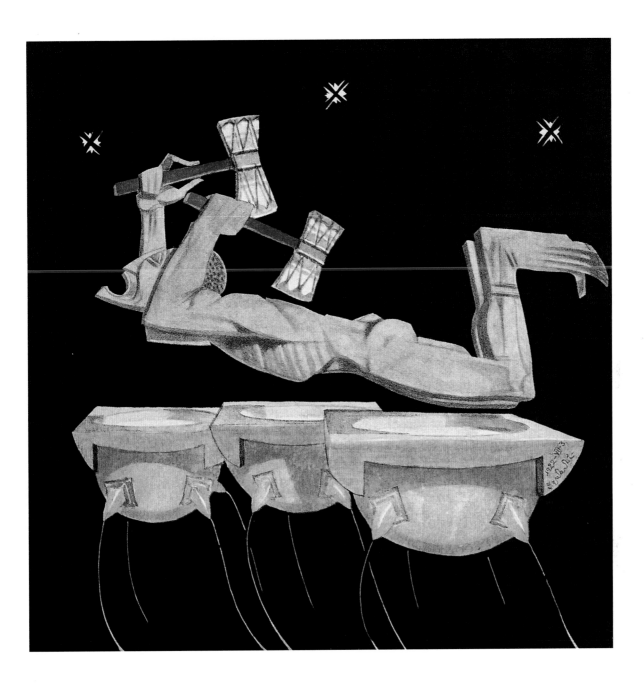

Storm

1922

The shouting God of storm inflicts his tom-tom
hammers into the brass drums. These drums are
four-nippled udders out of which he releases
nourishing milk-rain.

(From: *The Work of Szukalski*, 1923)

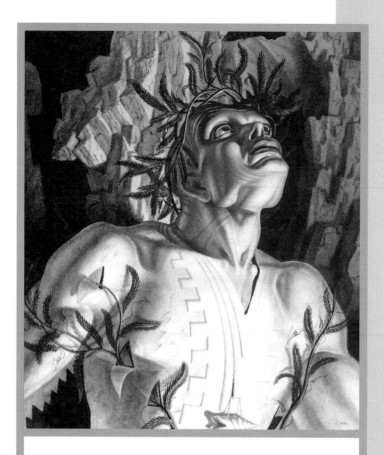

Bybyots

1939

He is the Legend-teller, green-complexioned and
immortal, but only as long as there are new and
newer stories founded on new heroic deeds. He
is an old man but very youthful. He has no eye-
brows with which to scowl or get angry, yet he
never laughs.

(From the tragedy Rege! Rege!)

Fallen Angel

C. 1940

From the original delicate pencil
drawing (about 3" tall), showing
an architectural design with a
fallen angel watched over by
Dawn-greeting figures.

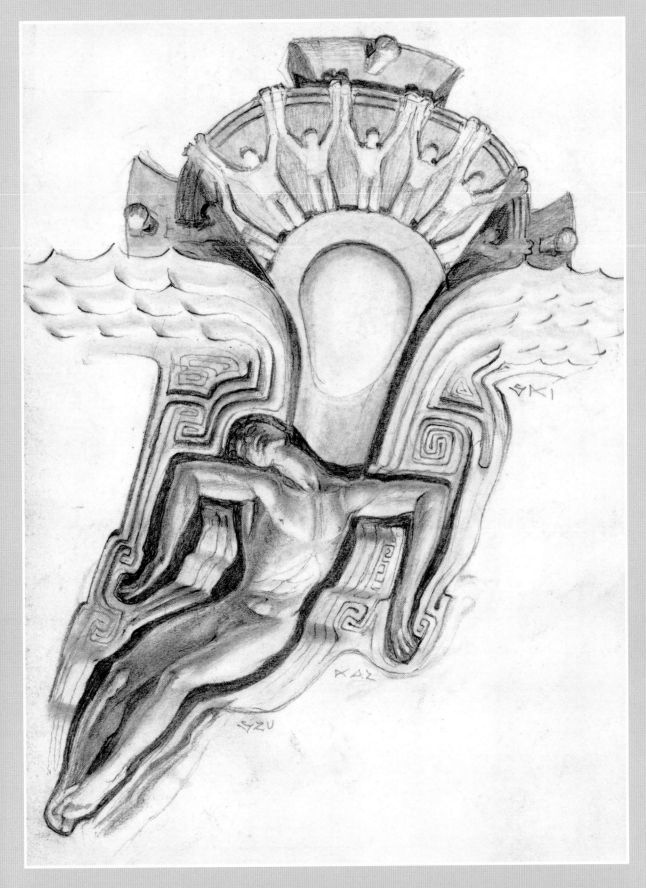

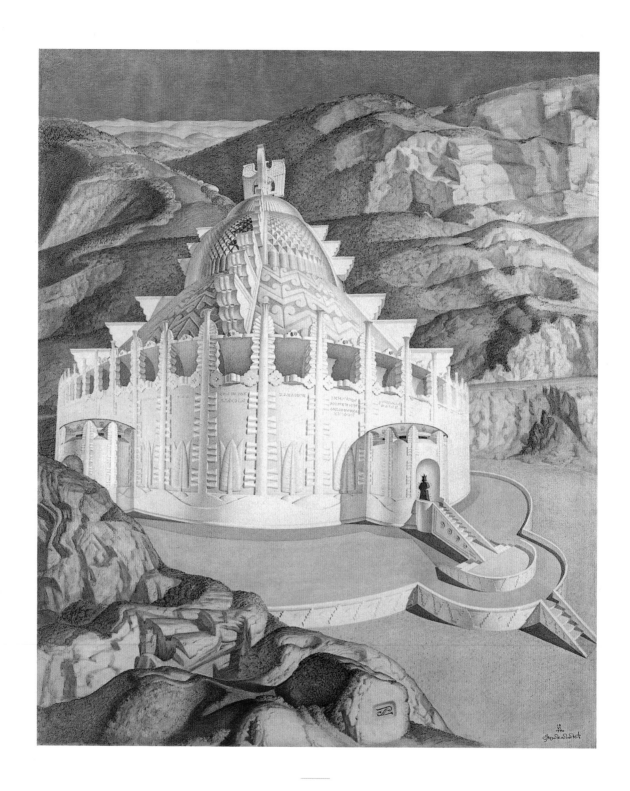

Gammadeum Lecture Hall

1940

An offer for a lecture hall, emblazoned with the names of the world's great deliberators: Thomas Paine, Lincoln, Buddha, Confucius, Kopernik, Taos.

Design for a Pottery Relief

c. 1945

Showing twin-headed Serpent, Frog, and the eyes of Oce-On.

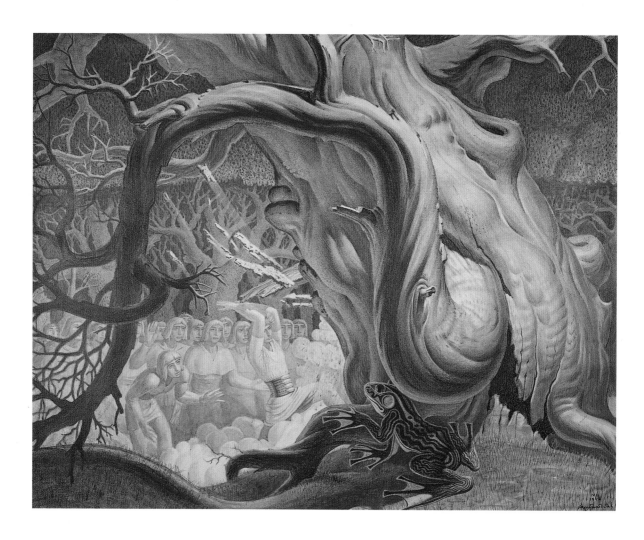

Krak at the Confessional Oak

1946

In the deep jungle stands a dead oak tree, occupied by the never seen Confessor. To the oak come all sorts of people, the innocent and the politicians who run the nation. After knocking on the tree they plead loudly before the Confessor what they should do. To some of the queries, he knocks from within and people depart, doing what they were instructed to do by the wise Confessor.

However, when presented the question as to the existence of the Dragon and the neces-sity of being sacrificed as victims of the great reptilian, the answers came contradictory. So Krak rushes to the side of the oak, tearing off the loose and worm-eaten slats of its side, sending the frog Rege, Rege, who is the Nurse of the race, to fetch out the Confessor.

After much noise and commotion within, amid the flying dust, Rege brings out the wise man who ordains the History and Fate of the nation, but who is a mere… woodpecker.

(From the tragedy *Rege! Rege!*)

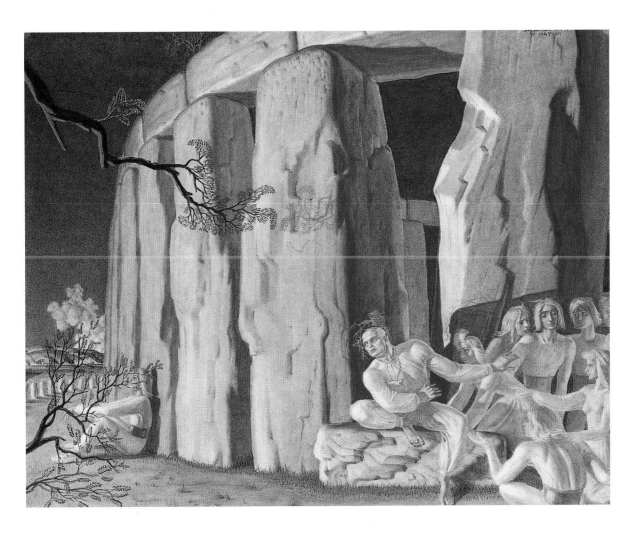

Krak Meets Bybyots

1947

This first scene from my tragedy *Rege! Rege!* occurs within Stonehenge, the cyclopean monument of prehistoric Britain.

The light of the late afternoon falls upon the great monoliths while Krak sits alone on the ground, leaning against one of the stones. He is lost in melancholy thoughts.

Nearby, a group of boys and girls sits surrounding a green-complexioned supernatural being, the storyteller Bybyots. His round face is like that of a newly born infant, having no eyebrows or hair on his head. Upon his bald pate reposes a loosely formed crown of flimsy strands of devil grass, the transparency giving the impression of cobwebs rather than of a solid wreath.

Recognizing Krak, Bybyots turns back and signals his companions to sit down, so that he might relate the legend.

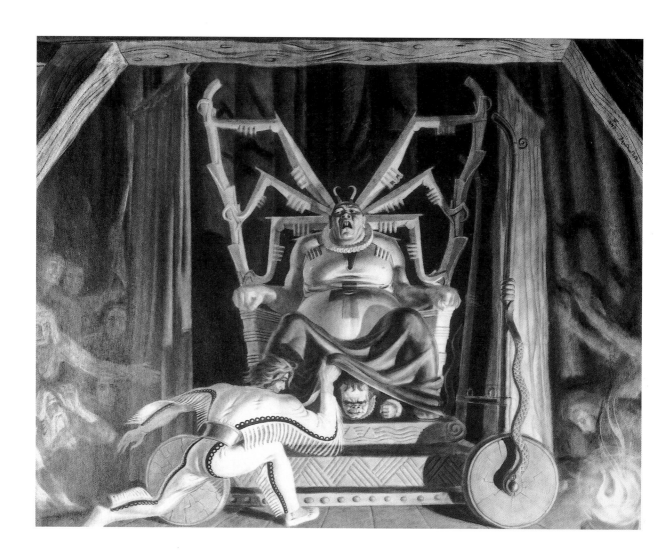

Amassiah

1947

In the last scene, Krak reveals the hiding place
of the dwarf Zradar ("Gift-of-Betrayal") beneath
the throne of the All-Powerful *Amassiah*. The
ruler *Amassiah* actually has no arms at all, but
when sitting on his throne, fits in a sculptured
wooden contrivance making him appear to have
huge spider-arms.

(From the tragedy *Rege! Rege!*)

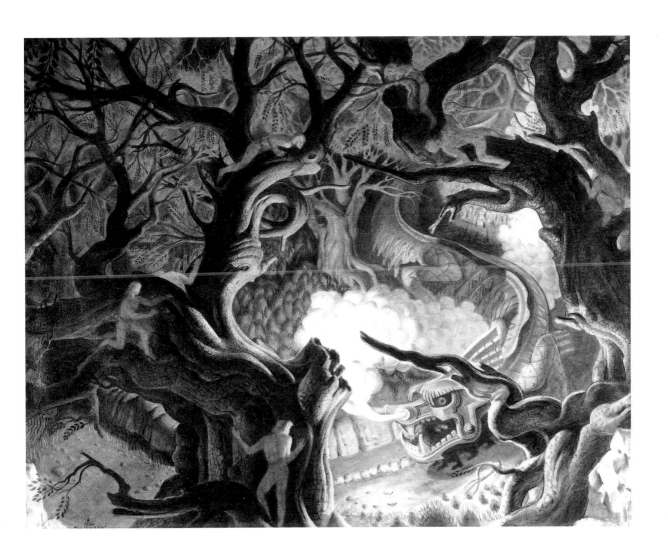

The Scarecrow Dragon

1949

The young boy Krak is seen hiding in the trees, noting that the feared Dragon is actually a scarecrow made by the priests (note feet). Previously, each year, the most adventurous boy and the most beautiful girl had been sacrificed to the Dragon.

(From the tragedy *Rege! Rege!*)

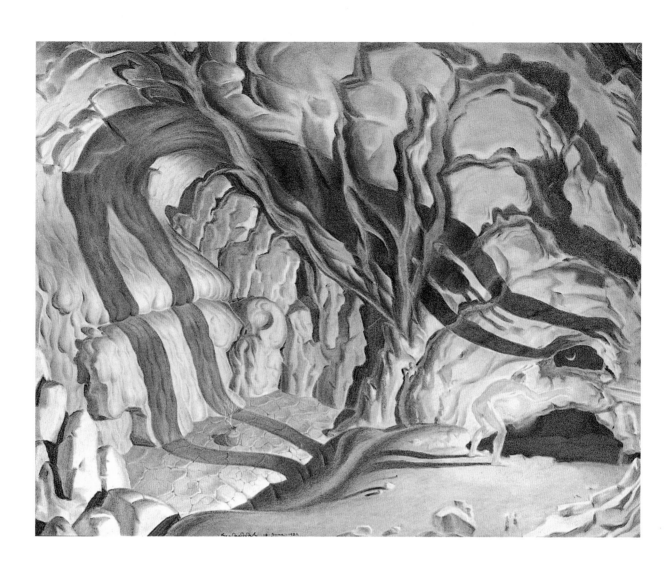

Invitation to Ancestors

1952

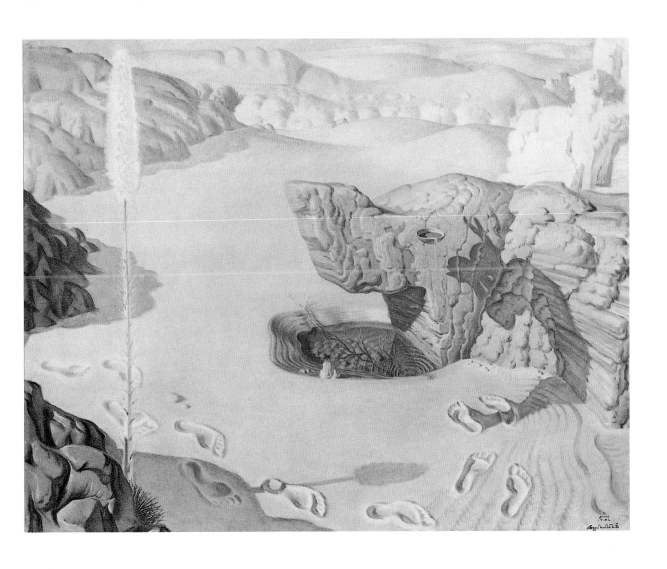

Thirsty Ancestor

1952

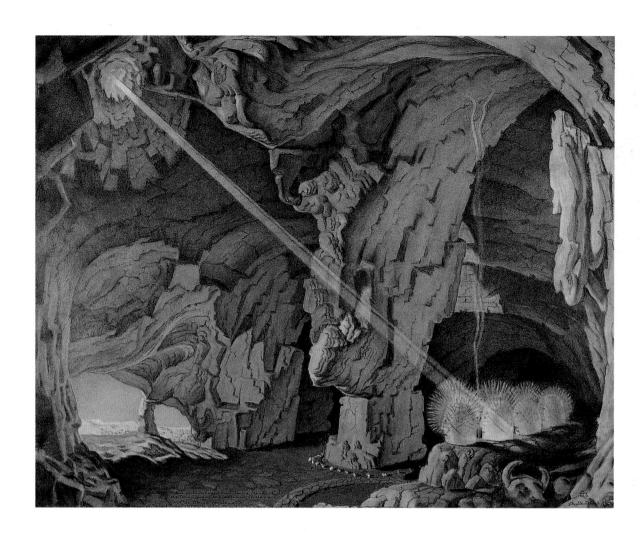

In the Cave of the Four-Faced Dawn God

1952

Images of the white clay pot faces were seen in a Smithsonian report. They had many holes at the top of the heads that possibly held pine needles, symbolizing emanating rays of the sun. The setting of the cave is entirely invented.

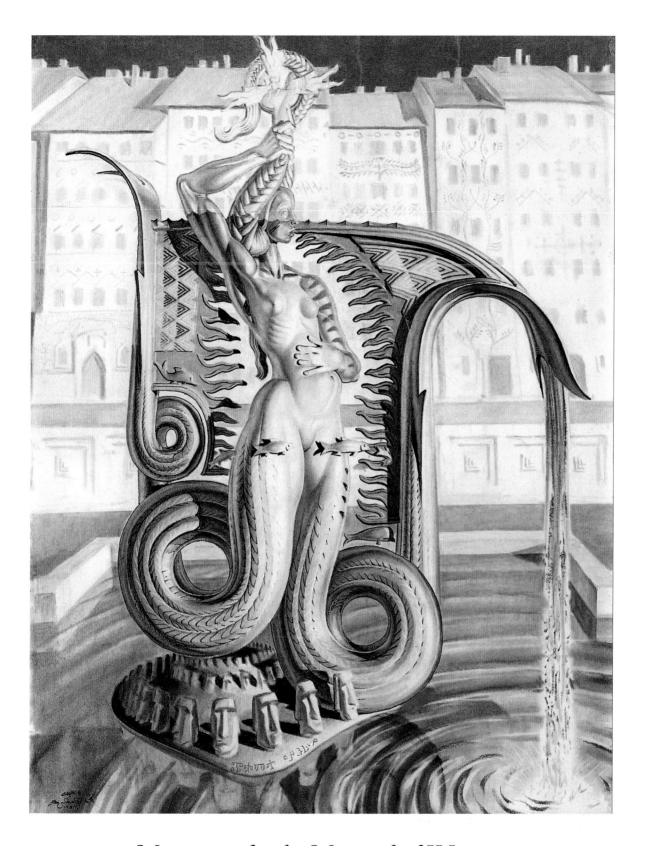

Monument for the Mermaid of Warsaw

1954

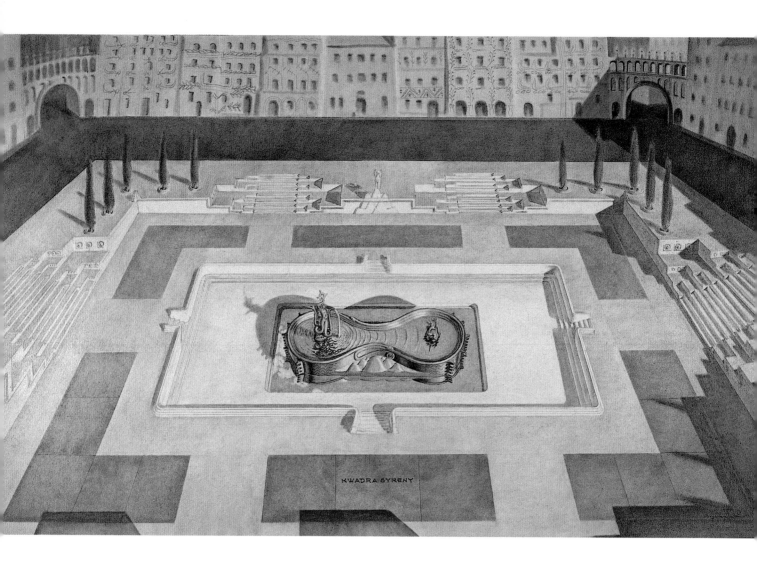

KWADRA SYRENY

Monument for the Mermaid of Warsaw

1954

The very first Poles were known as the Sarmati, who, after the great Deluge, trekked from the newly reemerged Alps and the vicinity of Zermatt to found Warsaw. They worshipped the Mermaid, the personification of their submerged original Motherland, which later would be named Easter Island.

All communities, wherever they began around their first fires, established some religious ceremony and the object of their dedication is hinted at in what became their eventual name. Since primitive man could only handle the shortest of words, a primal language developed which I discovered and named Protong. The diluvial refugees, in memory of their vanished Motherland, described their community

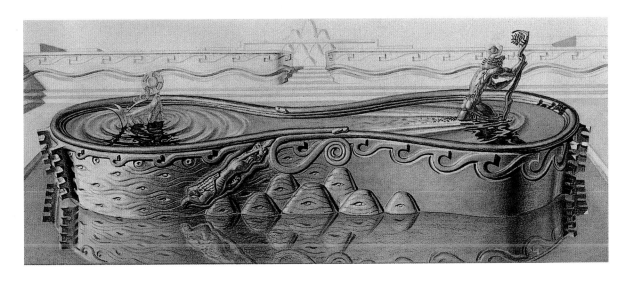

as *War Z Za Wo* (eventually changing it to *Warsawa*, making it feminine), a Protong phrase meaning "Worship from Beyond Water," i.e. "from the Pacific Ocean." Since no one in the world has ever known the significance of pictographs but I—after spending years on the matter—the Mermaid in the coat-of-arms of Warsaw was taken to be a meaningless fancy and, probably under the rule of some German king, thoughtlessly changed so that she is now holding a military shield instead of a mirror.

I made this project for a dual fountain of connected basins. Beneath the water there was to be a metal balance, so articulated that the bronze statues of the Mermaid on one side and St. Christopher on the other would alternately rise and submerge. The Mermaid is pregnant with the new Dawn. She feels her abdomen for the life of the Dawn infant, Jesus, due to which she is all radiant. Her tail squirms, creating three *Bi* symbols (meaning "killed" in Chinese) for the three lavaic land-masses that comprised Easter Island. Her tail rests on the island where still stand the colossal heads carved in local lava.

The entire statue is polished black but for the half of her head and the right arm holding the Dawn-greeting mirror, which are gilt. She is black because she is still submerged in the distant Pacific, though she is vomiting the flooding seas she has swallowed. As she begins to sink again, first the arm of the infant "Day-Giver" (*Dzi Da* in Protong, later Jesus) rises out of the other basin, then the shoulder of St. Christopher holding his joyous burden, their reflection shining in the sunlit mirror.

Actually, I have known for years—prior to the Vatican's announcement to that effect—that St. Christopher is something more than a saint. He is God-the-Father personified, while his name, *Kri Z Top Wer* ("Hidden from [[the]] drowned Worshipped"), reveals that he represents the Atlantic twin to Pacific Easter Island.

99

The Bound Legs of Swiat-Owid (World Enlightener)

1954

In the project for this Slavic Dawn God, which combines the traits of the four most distinguished Poles of genius, I picked Chrobry as the one in the lead, sitting over the neck of the White Horse (associated with Morning, Spring, the Awakening of History). To the right we see the leg of astronomer Copernicus (associated with Evening, Autumn, Cultural Harvest, and Decline of History). The bundled feet of the Siberian prisoner are those of Mickiewicz (associated with Night, Winter, and the Foreign Bondage deserved by the brainlessness of the society that produced him).

When a nation trusts in God for the fortunate continuance of its history, it invites conquests by predators. To save face it now accuses its neighbors of cruel aggression, or lays the blame on God, saying that it was the "will" of their God not to deserve a happier existence. But God should not be blamed, nor the fact that the Polish nation was never introduced to the Tibetan Praying Wheel.

Desert Scene

1955

OIL ON BOARD

Invented Landscape

1955

OIL ON BOARD

Invented Landscape

1955

OIL ON BOARD

The Lowing Ox for Wolin

1958

The German chroniclers Dietmar, Von Bremen and Von Besau report that the seaport city of Wolin, once located on the Baltic shore, was "the greatest Metropolis of Europe." Much earlier, Ptolemy, the Roman historian, geographer and traveller, reported that where now Poland stretches from the Black Sea to the Baltic, there was a *Mare Longum* ("Long Sea") over which the Greek ships sailed for the city of Calisia (now Kalisz). But excavations in Biskupin reveal an even earlier existence of the Polish state. Legends and folk songs report the sinking under the Baltic Sea of the metropolis Wolin, whose name means "of the Ox," according to ancient rebus used to convey thoughts before writing.

To hint at Wolin having been built by the Flood Refugees and being submerged again, I gave the Ox horizontal stripes, a symbol for "waters." In between these I modeled whales and other sea creatures. The Ox is lowing. Its breath rises in the wintry air, folding over its head and back, depicting the seas over which the ancient Scandinavians made their voyages.

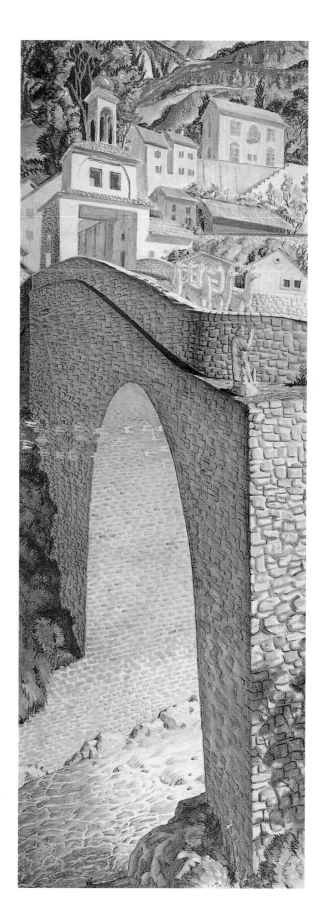

Bridge in Izcuchaca, Peru
(over Mantaro River)

1964

O XII - 1959

Broken-Off Heynal

When the Nearsolar Epoch started, and the Gobi Desert began to shine with sands because of progressive dehydration, the Mongo-Tartars and the Arabs began to leave the former verdure-covered living space of their ancient homelands. These nomads, the ancestors of the Moscovites, began to press upon still-moist Europe, in attempts to conquer it and make it their permanent pastureland, where grass for their cattle would be plentiful.

While the continent continued to develop its civilization uninterrupted and in comparative peace, Poland, stretching between the Black and Baltic Seas, stood in the way of Mongol ambitions to conquer Hyperborea (Europe's oldest, Greek name) and save their herds from starvation and their predatory species from extinction.

The constant military pressures on Poland were beyond her numeric strength, which was even more tragic because, as an agricultural nation, she never had a standing army. When attacked, she resorted to the system of *potrzeba* ("need"), in which every able-bodied man went to war, leaving his plow and fields unattended.

From the first Asiatic stirring on, when Dzingis and his sons Batu and Kublai drained their manpower to press against Poland, the nation survived these avalanches of predatory multi-multitudes, unconquered. Yet they leveled the great civilizations of ancient India and China.

Taking the entire history of Poland, including the later German-Austrian-Russian attack and the partitioning under the English plan to destroy Poland, and spreading all wars equally, it has averaged one war every three years. This historical background of countless calamities should make it easier for the non-historic Americans to understand the character of the Poles. Their sense of loyalty, wherever they find themselves, is most passionate; their tenacity is legendary—as attested by the Russian saying, "When a Pole sits down, you cannot cut him out… not even with an axe." (Historic nations are those that suffered calamities, for they have "learned" their lessons in survival.)

Every spring, when the snows melted and ensuing floods drained off into the Baltic Sea, there was an invasion by the Tartars or their branch, the Moscovites, which succeeded in settling in the north.

There used to be a small wooden church of Mary in Kraków's square, on the tower of which a trumpeter would hourly play a "Heynal" to let the town know that all was well. One day, in the middle of the Heynal, the trumpeter suddenly stopped playing. The townspeople instantly knew something must have happened to him. They rushed to the little church and found him, a Tartar arrow shot through his windpipe, voiceless, pointing to a peephole, whence they saw the Tartars swarming. The Tartars were repulsed.

Centuries later, each hour, day and night, the Heynal is still played. But the melody stops abruptly, as it did in the throat of that heroic Heynalist of Kraków.

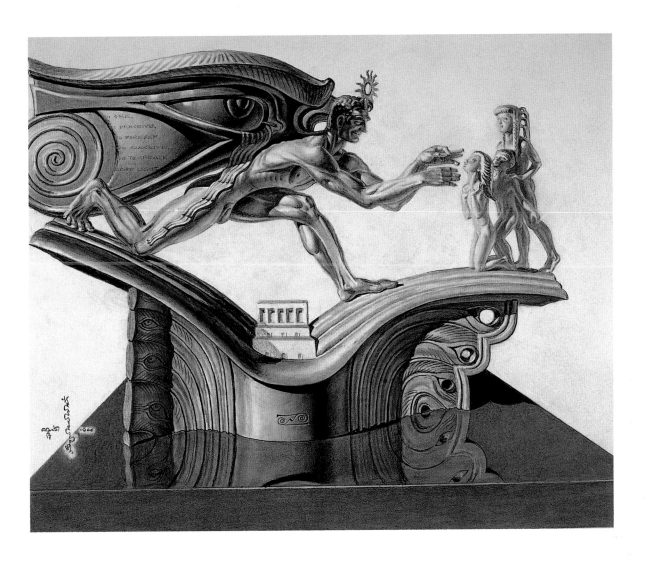

Monument to Jules Stein Eye Institute

1966

Ever since the eye hospital was built in West-wood, California, I have wished to make a monument to its donor, Jules Stein. Not knowing his face, I placed the portrait of a stranger in its place in my drawing of the project.

He is eagerly stepping forward from his prayerful kneeling position to magically touch the blind child's eyes so that it may *see*. To *see* his wonderful world will be the most glorious of its life's experiences, for, like any child, it is but a foreigner...

Please note the peacock feathers that make up the pedestal to this monument. It has two kinds of eyes; the ones that see and the ones that have no eyeballs. Instead of Wings of Inspiration, I gave the donor of this superb hospital the Eyes of Inspiration.

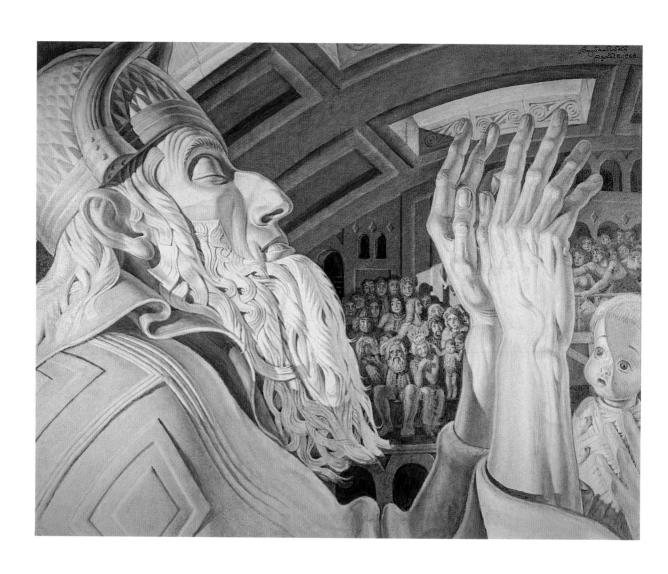

Blessing the New Citizen

1968

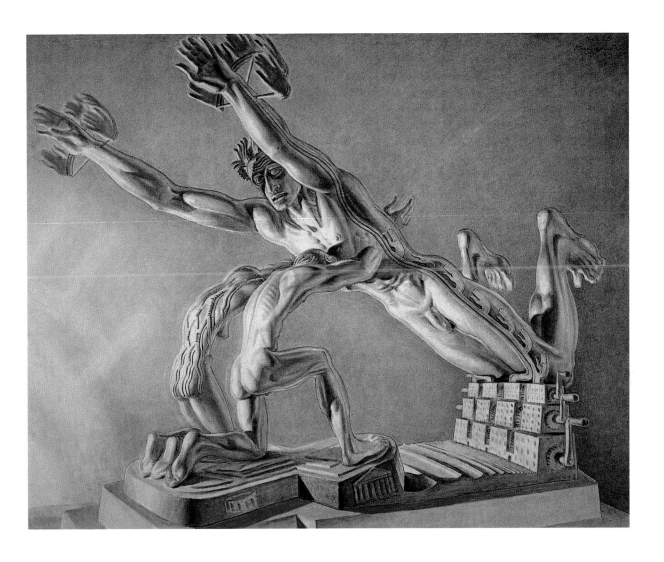

Longing
a.k.a. *Far and Long Ago*

1969

In this drawing for a never-done sculpture, I show my and other buried-alive creators' thinking of our Europe, where we were born and where we left our young parents. The figure stretches across the Atlantic, longing for interhuman Love, while kneeling on a device that simultaneously serves as a meat grinder and cash register. His arms are outstretched, away from prosaic reality where two mottoes are imprinted on every man's forehead:

"Opportunity knocks only once in a lifetime!" —therefore, grasp at any means that will make you rich, therefore, have no moral scruples; while the other motto is "Business before Pleasure, before Love, before Country, before Right or Wrong!"—therefore, sell your mother, your firstborn, push them into the meat grinder and get your "dough."

PHOTO BY JOE HERNANDEZ

Of Maggots and Men
1980

To get the imprint from this piece of pinewood (that I have carried with me from Gidle since I was twelve) I pressed very thin tissue paper against it, making a pencil "rubbing" so to only mark the protruding details of the beautiful pattern. Later, when I inked the pattern in pen, I noticed another, coincidental pattern, as if drawn there intentionally for me. So with brush and ink I blocked out the superfluous parts and retained the image of a pregnant yet breastless woman, just like many of the prehistoric images of the Mother of the Dawn God.

A closer look will reveal that her body is vertically streaked with wide, uniformly broad channels where moth mothers once, after perforating the young pine bark, seeded their eggs in inch-long clusters. On hatching, their little larvae began to feed on the bark, forming the tunnels, while each time when two of them parted, each would proceed to eat away its own microscopic tunnellet in the opposite direction from the other, till all individual tunnellets together resembled one centipede whose feet had got a little muddy.

Seeing this system of the widening paths of dispersal, I was reminded of the great migration of the Ice Age Saki from all over Europe towards the Asian vastness. Initially, the teenage Saki, driven out by their barely surviving parents, made their slow way southeastward on thin, worn-out grass paths. But since human families have children the year round, there was a progressively greater population on the move towards the warmer climate. Their paths grew

into broad ways, advancing in stages, some remaining here, remaining there, having babies, some forming bands that attacked small communities, looted homesteads. Thus, each annual crop of expelled youngsters, spreading the ribbon of their migration, added more confusion to the preceding one.

It is not true, though, that the Sciti (from the *scyty* or pinnacles of the Pyrenees), the Sarmati (the youths from Zermatt) and the Saki were intrinsically nomadic. Entering the Unknown, they could not possibly all, year after year, settle in one place, so they had to keep on travelling, perhaps for several years, till they found a locality open to their settling. While travelling, they could not grow crops and prepare provisions, so they were forced to be marauders, and loot even from their own Saki who had arrived in their territory just a year ago. By these tragic circumstances they were kept constantly on the move and in perpetual uncertainty. Untried and unorganized, they were often defeated and discouraged, but through millennia, they learned their lessons and began to be the power of which we heard as Sciti. Thus, the reluctant prodigals became the prodigious Civilizers of various races. They obsessedly modernized the aboriginals they came in contact with, producing the distinct Cultures of India and China, everywhere carrying with them their Protong language, so that today I can still translate the original meaning of the names they gave to villages and rivers wherever their influence stretched. They hatched in caverns and carried with them their æsthetic Culture, to re-establish it among the Hindi the Chinese and the Egyptians.

Thus, I thought, looking at this piece: How similar were the patterns of migration of the species of insects and the puny humans…

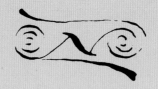

2
SCULPTURES

PHOTOGRAPHED BY JEFF VAUGHAN

■ ■ ■

TEXT BY SZUKALSKI

Head of a Woman

1912

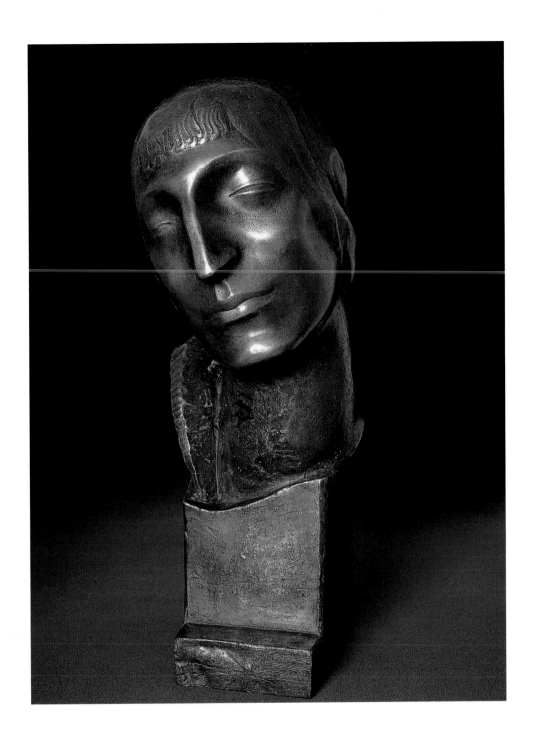

Judas

1912

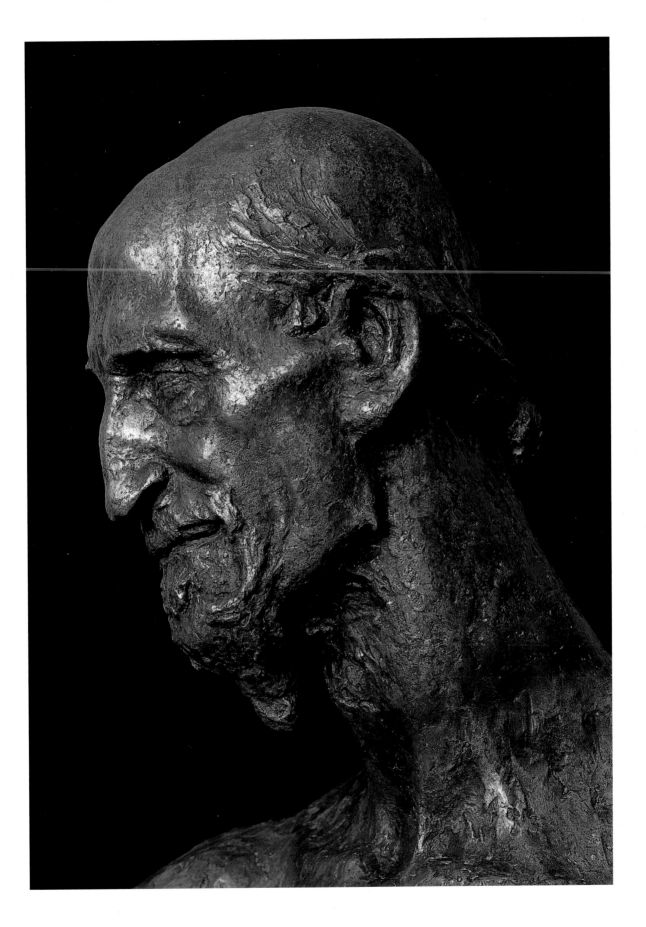

My Blacksmith Father

C. 1913

DIONYSY SZUKALSKI

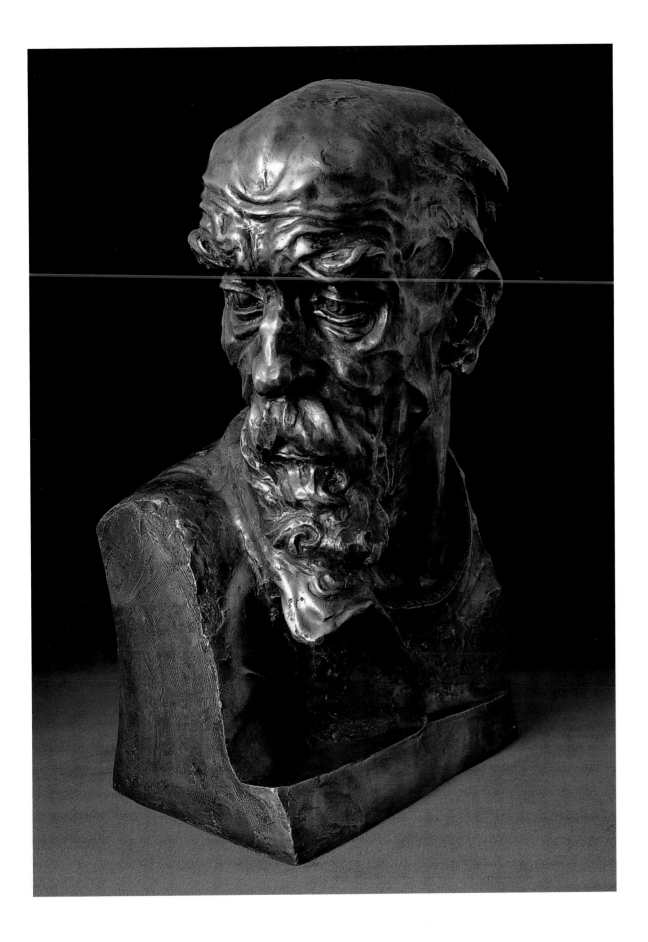

Self Portrait

1913

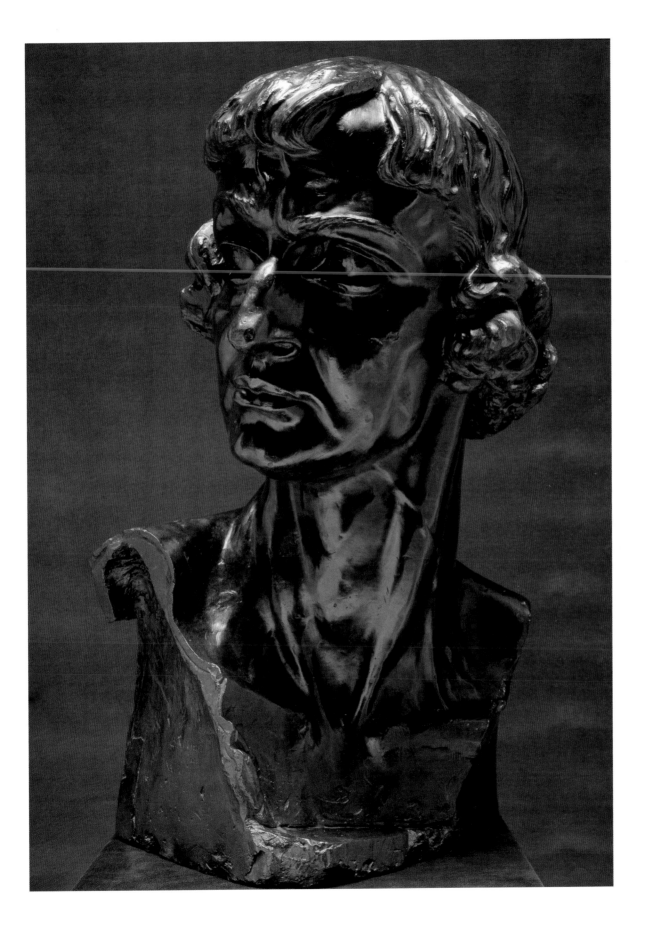

Man in a Long Robe

1913

This was done in order to teach myself to sculpt folds, from memory.

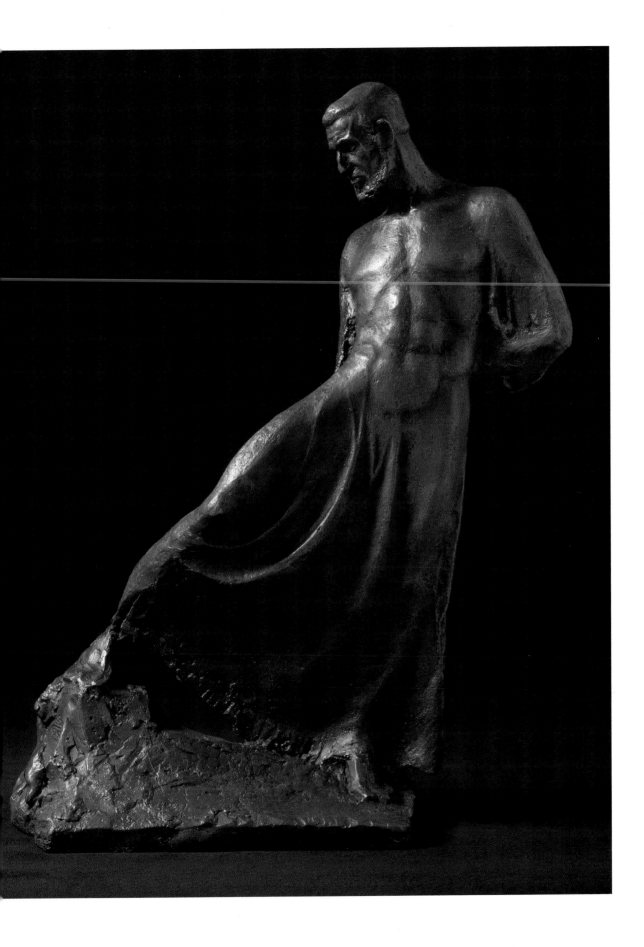

An Irishman

1914

Right after finishing my *One-Armed Man in the Wind* at the Chicago Art Institute in March 1914, I started this portrait of a man who had never spoken to me. He was rather shy and seemed as if in a perpetual daze, but he often visited Professor Mulligan's class just to see how I progressed with my sculpture.

He was short, with even shorter legs than was proper for his body. His arms hung stiffly downward, never swinging, somewhat zombie-like, and there was no light shining from within. Paradoxically, his complexion was ruddy and his hair red which, despite the paleness of his total withdrawal, gave the semblance of health. I attempted to draw him out of his shell in discussion, but he usually responded in monosyllables. He posed for me on two afternoons and, because he brought such a heavy mood into the room whenever he visited,
I finished the oversized sculpture without his presence. When he saw it finished, he looked at it as if not seeing it at all, as there was not a ripple of response.

It would be an interesting experiment to so arrange a portrait of a person who would never have spoken to me, not even have let me hear his voice, not knowing a thing about his national background, his social level, his education, or even his name. Then to finish the portrait, using as many sittings as needed to make absolutely, in my opinion, the best portait I'd ever done.

Then, on showing him the finished masterpiece, to be introduced to him, hear his voice, learn of his past, his profession, his national origin and philosophic attitude towards life. After this total acquaintanceship and unguarded friendship, to do another portrait of him and have him again pose as long as need be to finish as perfectly as the first version. I am positive that the portraits would be as unlike to each other as if made of two totally antonymic beings.

We must remember that exactly copied from nature, a portrait is never a good "likeness." I have seen photographs of people that I would swear were made of two different people. The "likeness" is in the intangible relationship of lines and shades which we interpret in association with the disposition of a particular man. If he is unknown to us, as portraits of

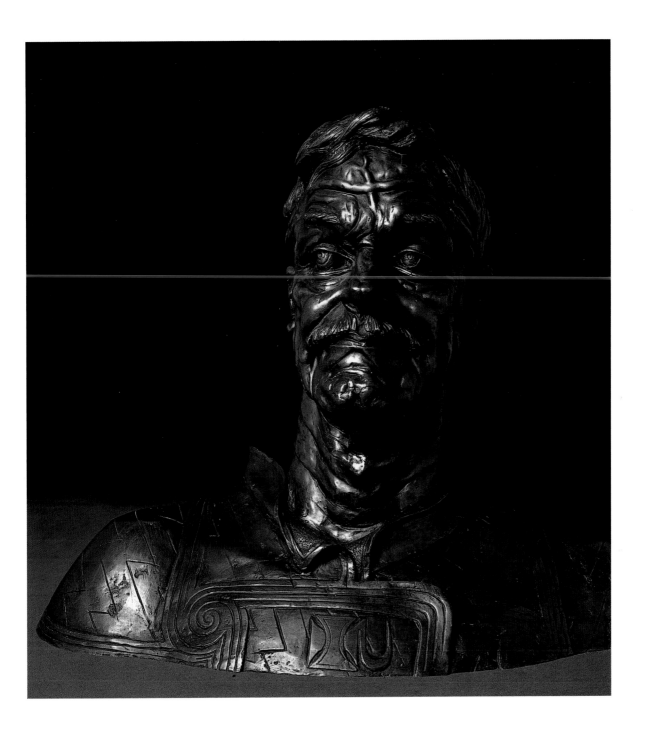

long-dead people are, we are rather at a loss and mereley jump to conclusions in interpreting our unfounded impressions.

Similarly, while I made the portrait of this Irishman without sounding his disposition, temperament, prevalent mood and attitude towards life, I was only guessing at him, very likely misrepresenting him. This may not be a portrait of this man at all.

Imploration
(a.k.a. *A Plea*)
1914

Progressively, I became known in Chicago as a Wonder Youth who, while still in his teens, produced sculptures superior to those of the mature Rodin, then the greatest sculptor in the world. I was popularly regarded as a genius and because of my looks a fashion started whereby many youths with artistic ambitions also began to wear long hair. Thus began the fashion for long-haired "geniuses" in Chicago. On occasions I would hint at my disapproval by saying that just being a genius was not enough: being the best pickpocket or the longest holder-of-a-finger in the fire would qualify one to wear long hair, but one should be a genius in something.

Aside from having gained many friends and their admiration for my sculptures, I was desperately poor and could not make as many sculptures as I would have liked, because of the cost of casting, sometimes having to wait for months before I could take my latest work to the caster. People raved about my precocious talent and the museal quality of my work, and my skills in discussion provoked complimentary acclaim. But the fame was purely platonic and, while nursing my creative aspirations, I felt like a bird with leaded wings and feet nailed to this prosaic land.

No wonder that this sculpture expressed my prevalent mood of helpless despair to which I had to resign myself as long as I remained in America. I had yet to fathom the motivation for the mutely nursed hidden resentment towards me as a foreigner, and did not realize that all the words of these gushing Anglosaxons, however effusive, would not weigh more than a single crumb of bread, merely enough for a picking sparrow to assuage its hunger. In fact, to them I was an exotic creature with an accent, a bird in a wire cage that, though fed with empty words, smiled back as if stuffed with loads of unmeant promises.

So I made this powerful youth who found himself mute and all but inarticulate, begging for a little sparrow at his fingertip to speak in his stead. On his side, a Serpent of Adversity glides upwards, imperceptibly slinking towards his raised arm, nearing the eloquent bird… to swallow it in a single gulp.

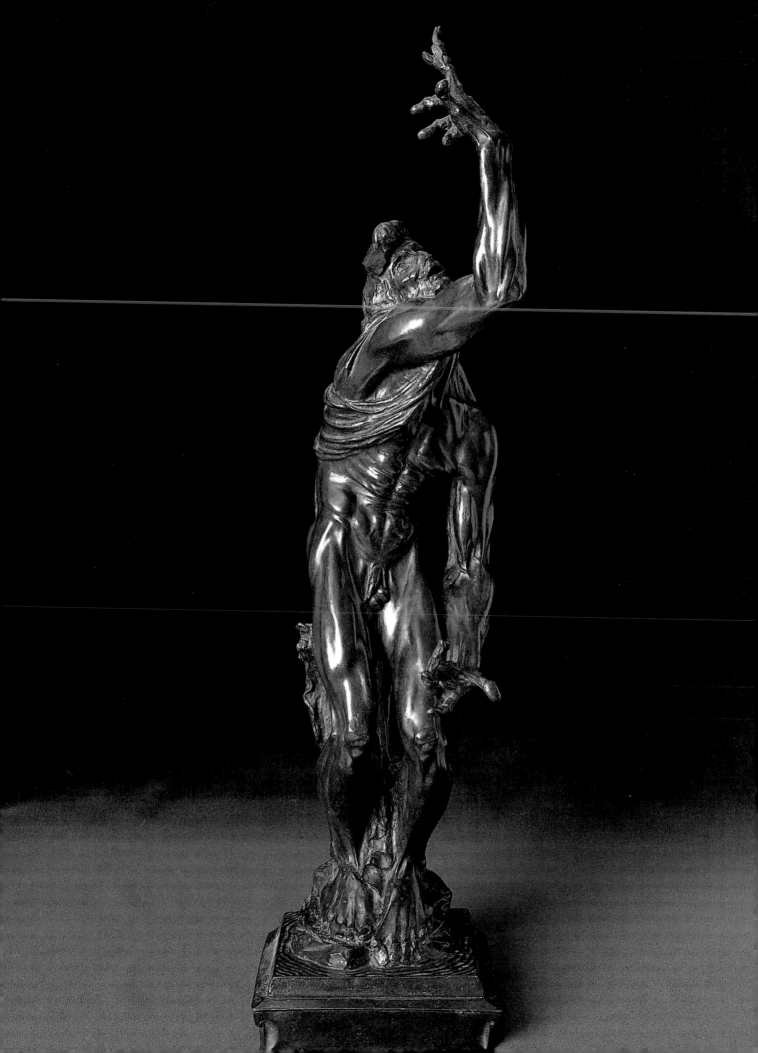

Birth of Thought

1916

(VINTAGE PRINT – MISSING WORK)

The hands, in bondage, deliver Thought out
of the cranium.

 Man is the only species extant that populates
this universe with Man-like Gods he creates
in his own image.

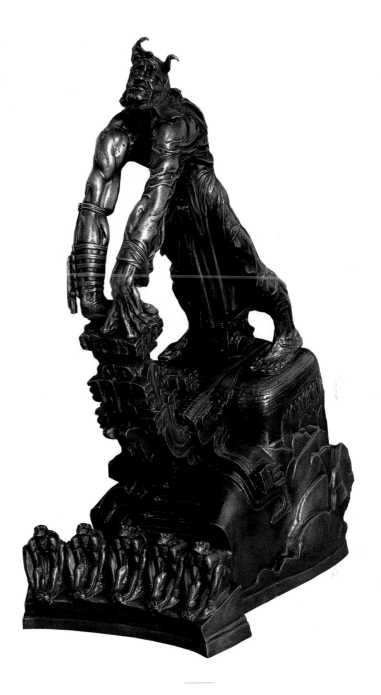

Law

1916

PHOTO FROM ORIGINAL GLASS NEGATIVE
(MISSING WORK)

Defense
(a.k.a. *The Defender*)

1916

One of a two-part work, *Law* and *Defense*.
The defender pleads his case of which five
crouched jurors are seemingly oblivious—
but only seemingly, for they intently watch
the opposing *Law*'s reaction.

⟦ 133

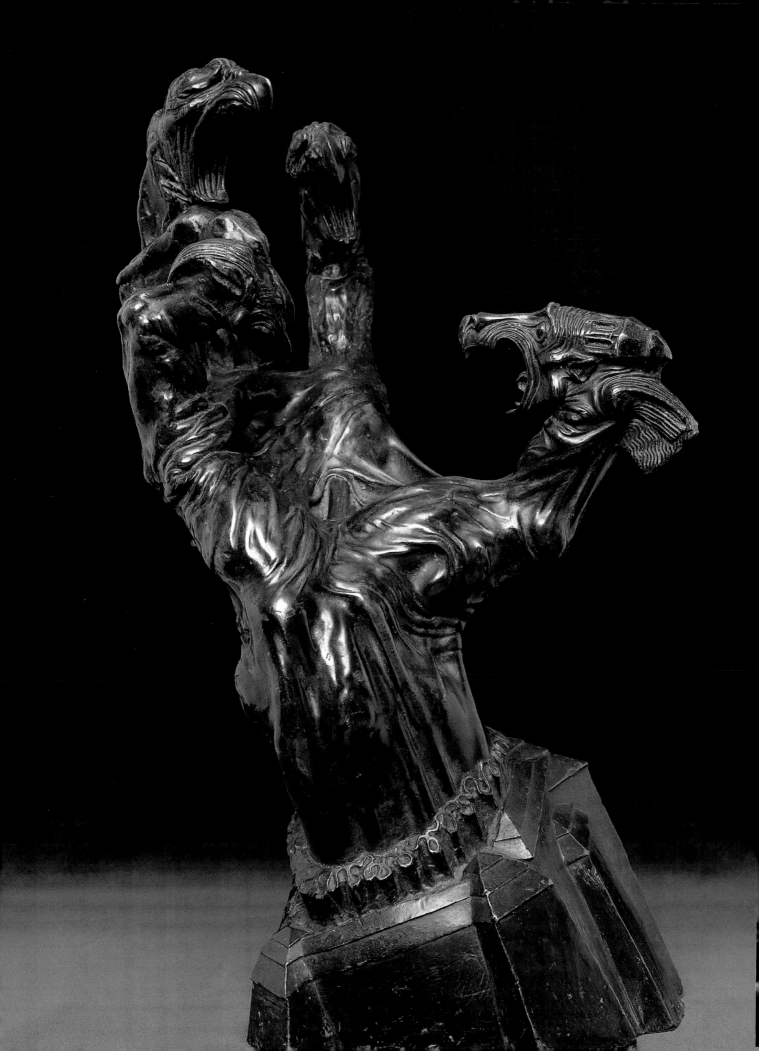

Struggle

1917

This sculpture, a few times larger than life-size, expresses the struggle between Quantity, the fingers, and Quality, the thumb. It is not the fingers nor the Gods which make man survive, but his opposing thumbs. They are the makers of things, the builders, the creators of Cultures and Civilizations. The thumbs are like creative individuals who make the mammal herd into the human society.

Here the four fingers of the hand attack the opposing thumb in mortal struggle. The thumb carries a temple tower as a part of its head. The fingers dig a hole in the center of the hand, so as to cut themselves off from their Inspirer, not realizing that when they tear the hand apart, their concerted attack is in reality suicidal to their social organization, and they will perish or become slaves.

Atlantea
(a.k.a. *Man and Thought*)

1919 / 1949

She is sitting on the horizon with her head in the
clouds, gigantic yet beautiful. She grieves over
her deluged Metropolis, which perished beneath
the seas, and over the vanished attainments of
her Culture and Civilization which are lost to
human history. Man, riding on the back of a snail,
looks up to *Atlantea* and can only offer her…
a snake.

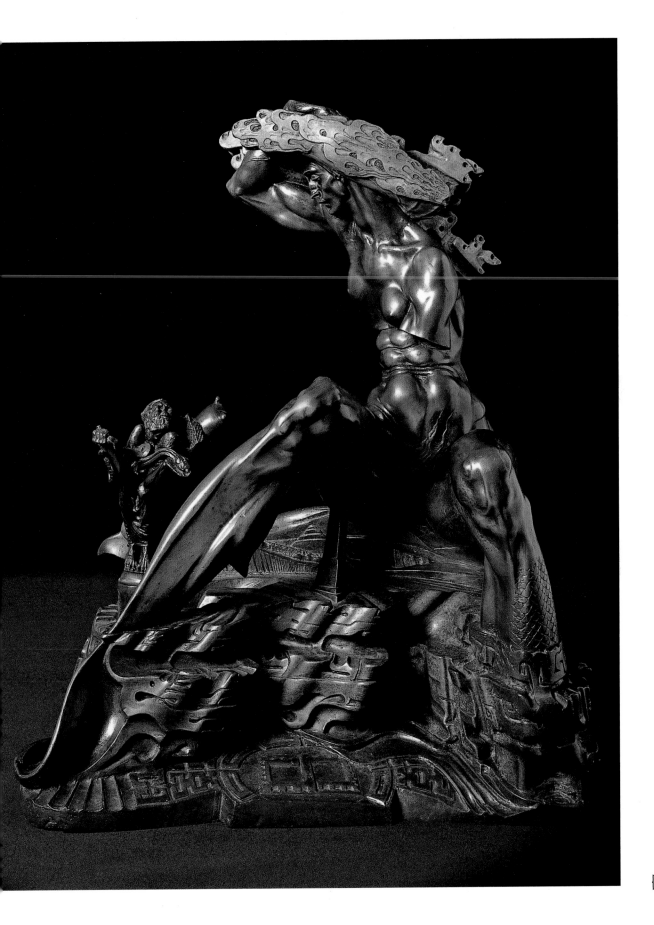

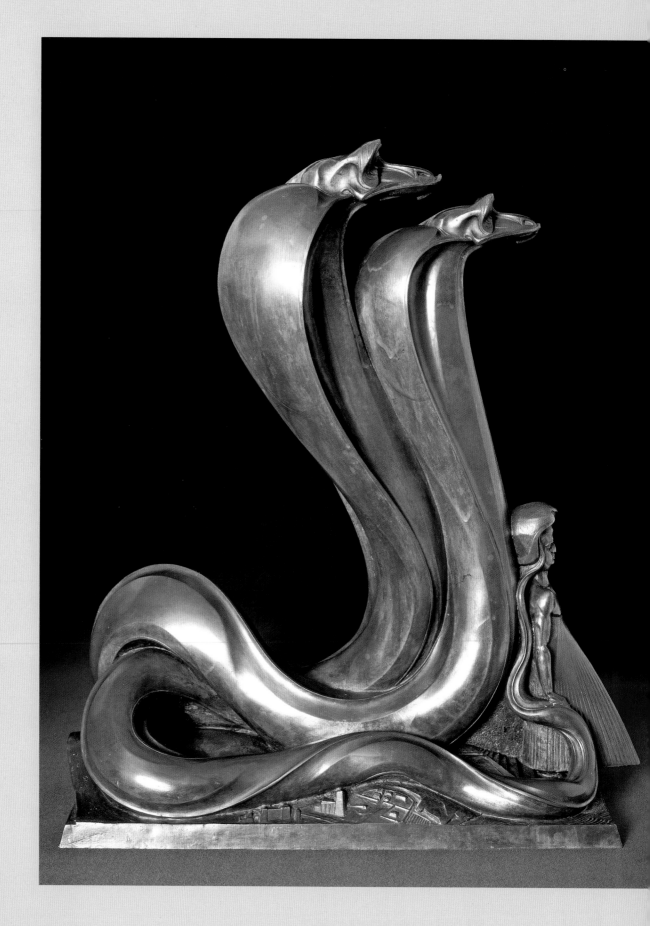

The Prophet

1919

The two snakes represent the wisdom of man.
Each one is a fundamentally different system
of thought. Beside them, Man himself is
insignificant.

Cecora

1927

This sculpture was done in a large piece of alabaster that I found in a stone cutter's yard while living in May-en-Multien near Paris, where I had a home. Without a previous sketch or model in clay or plaster, I carved this work directly in the stone, working as close to the original shape so as to not lose its dimension.

The subject matter commemorates one of the most tragic instances in early Polish history. The frequent attacks on the Polish borders by Tartars, Turks and others made vigilance a vital duty for every patriot. The country never had a standing army, but depended solely on the popular rise to the emergency. Thus, the term for war was potrzeba or "necessity."

On one such occasion, Stanisław Żołkiewski, one of the greatest generals Poland produced, asked for a military force. The nobles, resenting his extraordinary importance to the country, refused to help him. He went with a small army of ten thousand to fight against the chronic invaders. The vast enemy, having all of Asia behind them, surrounded his patriotic followers.

The army of Żołkiewski formed an oblong of wagons chained together, the horses inside, and began to push back towards the center of Poland. Their plight was hopeless. Nobility still did not come to their aid, and at a place called *Cecora* (pron. *tseh-tsoh-ra*), the whole army of ten thousand was wiped out. The head of Żołkiewski was carried away by a galloping Tartar to be thrown at the feet of the Asian leaders.

Here, in this life-size sculpture, a warrior drinks his own blood which drains from the wound on his forehead. It is mixed with the open-eyed tears an angel on his cheek directs into his mouth.

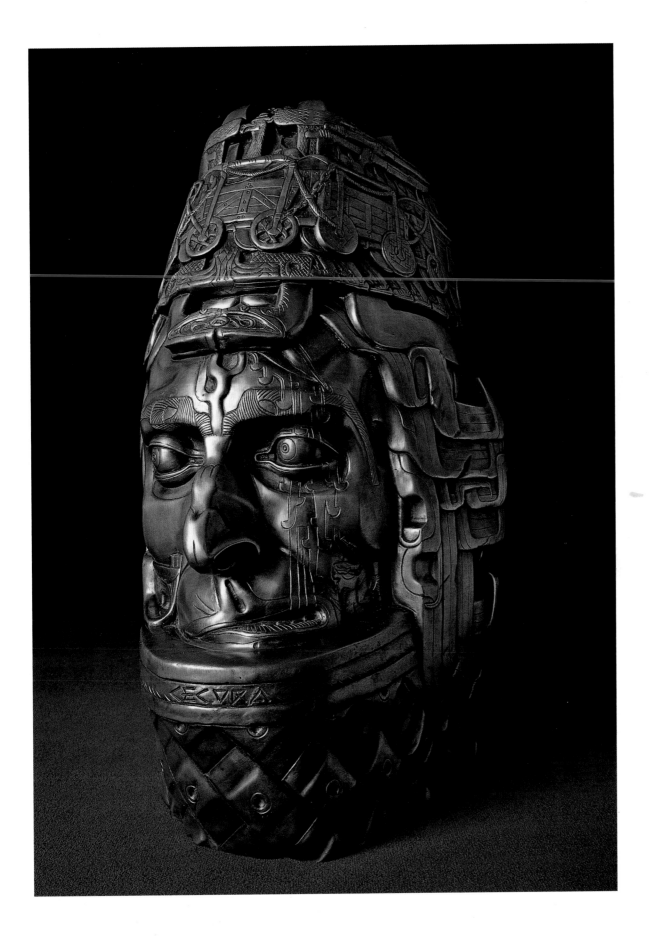

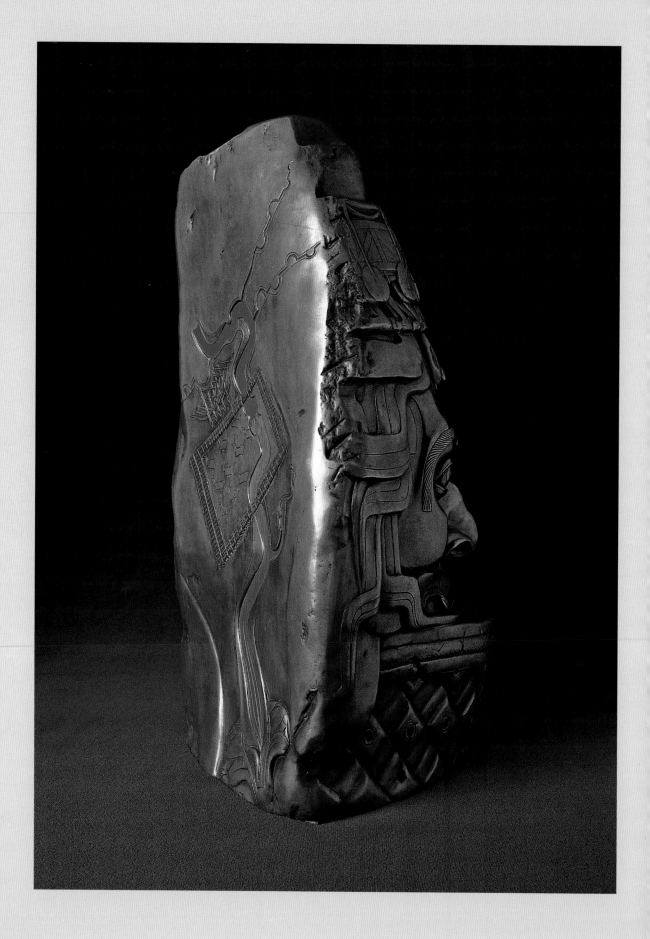

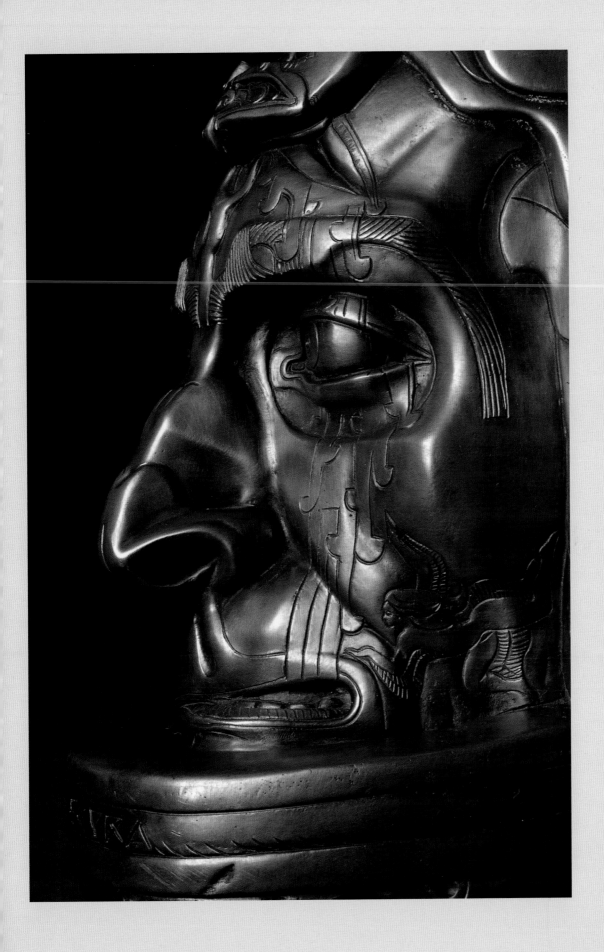

Promerica

A Sculpture to Pan-American Union to Be Erected on Pan-American Highway

1933

An Aztec priest, walking in the rabbit moccasins of peaceful intent, steps upon the altar of Amity to bless the blueprint plans for road-laying and irrigation which are presented by the youthful American engineer (Civilization) who reverently kneels. Atop his head is an aviation helmet with a transit for surveying.

Behind the venerable Priest peers a child, shyly sizing up the foreign visitor. The masks on its head are for the curiosity of a crowd of children.

The great arch behind the two central figures is the Pan-American Highway which terminates with the dual heads of the ancient and modern Dragons. One is Aztec, the other a North American steam shovel that, by blowing hot steam from its mechanical nostrils, awakens to life the tongue of the other ancient head of the Highway.

The conical base is a colossal ear of corn. On each vertically aligned grain will be inscribed the cities and villages of all the American countries.

On the highway arch there are imprints of seven feet. Starting from the left, the first one carries the Gammadion (left-turning Swastika) for the agricultural motivations of all Civilization-builders. The second, a butterfly for the metamorphosis of Instinct into Thought; the third a bird of Action; next a horseshoe for the Movement which follows Thought; then the automobile wheel for Communication which brings Civilization to the backwoods population; then the book, or Enlightenment and the resultant well-being; and finally, a honeycomb as the symbol of Sweet Reward for all creative effort.

This is a singing instrument, in that the slightest passage of wind would give the monument a very deep humming sound, forever proclaiming the Pan-American Unity. This vocal monument I call "Windeterna."

On the reverse side, I placed the national totems, the Eagles of Mexico and the United States. The notion for the Mexican Eagle, wherein the great bird is entangled with a Serpent, was inherited by Mexico from the Aztecs.

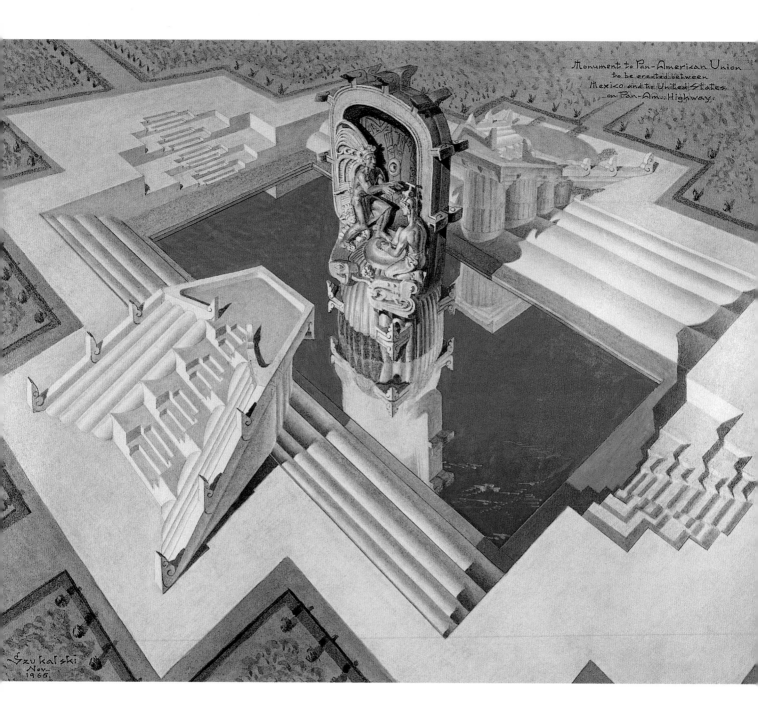

Monument to Pan-American Union
to be erected between
Mexico and the United States
on Pan-Am. Highway.

Szukalski
Nov.
1965.

The Significance of the Eagle
The Eagle was the symbol for "Messenger of the Dawn God." In Egypt he was localized into a Hawk, in Scandinavia into a Raven. Zeus of the Greeks had the Eagle sitting at his feet, awaiting commands. The Aztecs used the Eagle to represent priesthood. The Polish Eagle is white, for he announces the White God, daylight.

This country has as yet no heraldic form of its Eagle. Every commercial artist makes his Eagle as he pleases: wings open, wings folded, head in any direction, up or down. "Heraldic" means: preconceived and not to be modified;

146]

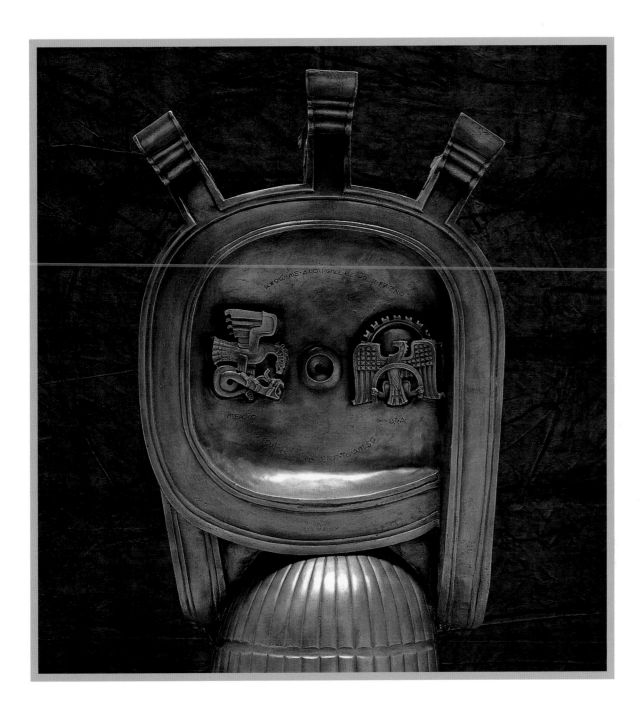

feathers, movement, direction, all are pre-scribed and unalterable. I propose, since prior to Roosevelt America was the Dream of Mankind, the Hope of Enslaved and Tyrannized Mankind, that our Eagle has its wings made of red and white feathers, while the shoulders are covered with white stars.

In his taloned feet he would hold the arching Rainbow, the primordial symbol of Hope (for the storm terminates with the sudden appearance of the rainbow).

Above and below the Twin Eagles, I placed my saying, *Know Me and I Will Be Your Friend*, in Spanish and English. In back of the Ameri-

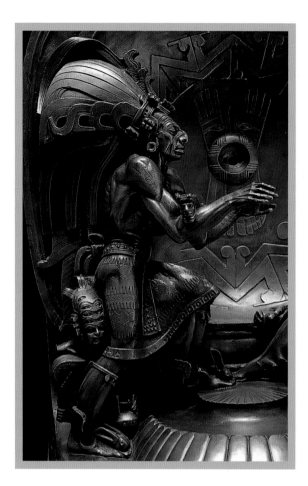
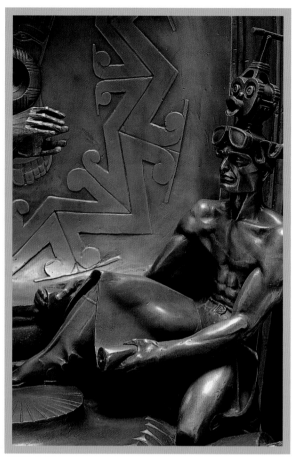

can Eagle, I placed the Rising Sun, which triggers the appearance of the Rainbow.

The monument of *Promerica* would be set in the center of the Pan-American Highway, within an architectural crater.

This project was exhibited in Los Angeles years ago, but true to my description of Southern California as the "cultural Siberia of America," nothing has been done toward its realization, because this is a non-historical, totally unforeseeing nation. Yes, we "made history," but we never plan it. We were "born yesterday," and as Barnum said, a fool is born every day.

Promerica is part of a vaster plan. I would propose—if there was a king, tyrant or manager wise enough in this country—to found a university town on the Pan American Highway between Mexico and the United States, where Texas touches upon it.

The University/Polytech combination would be dedicated to the advancement of Inter-American Monolithism; the youth of both Americas (including Canada) would gather to work diligently for this dual-continent's good. There would also be a Military Academy, so as to monolithize both Americas into one supreme power, radiating the universal concept of Freedom to all nations through cultural, political, economical and military co-ordination. The town would be called Unimerica (in Latin).

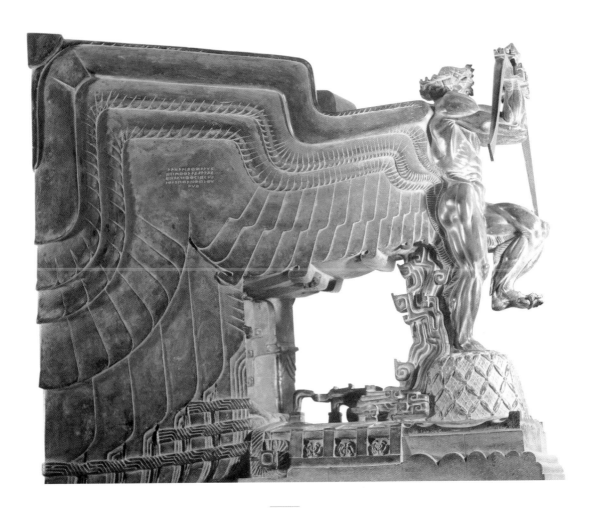

Yaltantal

1945

(FROM ORIGINAL NEGATIVE – MISSING WORK)

I named my sculpture of the Caucasian parallel version of Prometheus *Yaltantal*, to commemorate the criminal betrayal of half of Europe by the Anglomericans conspiring with the parasitic Moscovites at the Yalta Convention. There, a procession of eleven nations was signed away into Communist slavery, which was ratified by the American Senate and Congress.

Tantalus of Yalta stands atop the Navel of the Motherland. It is covered with the traditional cloth strips tied into a netting. The Motherland is sinking in the deluge of misfortunes. *Yaltantal* wishes to cry out but his mouth is taped so that his protest is not heard. He raises his bow and seeks the bowstring with his foot to release his Arrow-of-Indignation heavenwards, but he cannot find a footing, for there is no string nor arrow to his bow, and the bow itself has trapped his wrists into a shackle of nullification. His fists remain clenched, however, in a symbol of never-ending Indignation that will ripen into vengeful revolt.

Behind him rises the smoke of the extermination ovens, to which are roped the wings of the Divinity of Sunrise, which will thus be unable to shine upon the enslaved world.

Krak, Carried Away

1940

When Ptolemy's *Mare Longum* (the "Long Sea") was migrating elsewhere, islets began to appear above the present plains of Poland, in the proximity of Hungary and Bohemia, at the foot of the Tatra Mountains.

One such islet emerged where it is now encircled by the Polish city of Kraków. It had a cavern on its top, which was occupied by a venturesome shaman, who proclaimed it as a temple dedicated to the god Ra ("Dawn").

In this cavern, the people dwelling on nearby isles centered their worship on the god Ra, sending their prayers and the aromatic fragrance of burnt offerings *Ka Ra* ("Towards Ra, the Dawn"). But since humans cannot imagine any of nature's phenomena in abstract form, they began to regard Ra as a youth and consequently added the letter k to "K Ra" thus making the concept into a person called "Krak".

Here I show the youthful Krak being lifted from the islet by an eagle who will take him towards the sun.

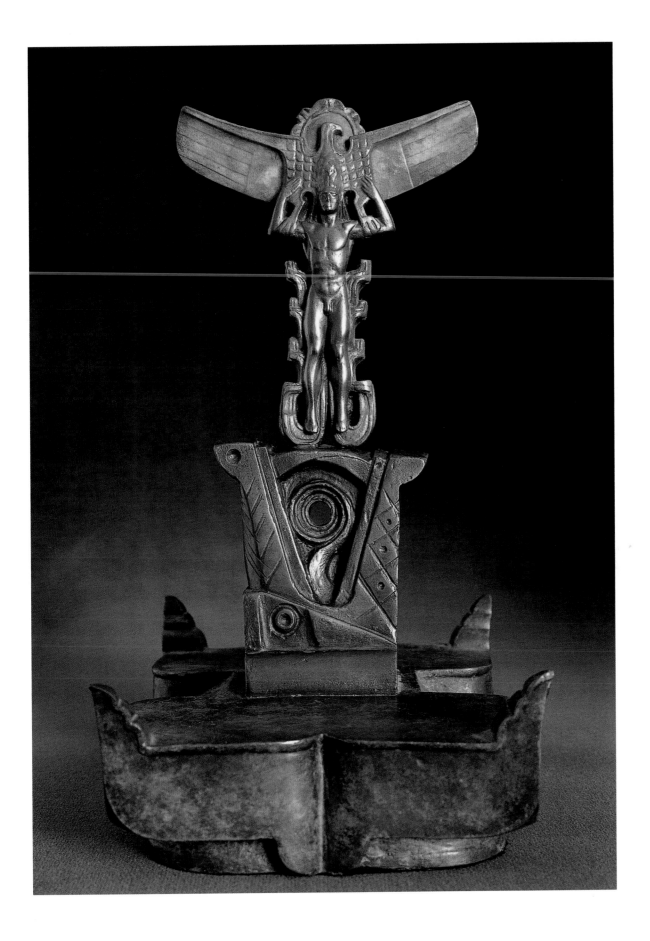

Frozen Youth

3RD VERSION

1940S

Youth frozen in the moment of its flight.
A monument for those who die too young in life.
(first version, in stone: 1920; second version:
1922; see also pp. 31 and 32)

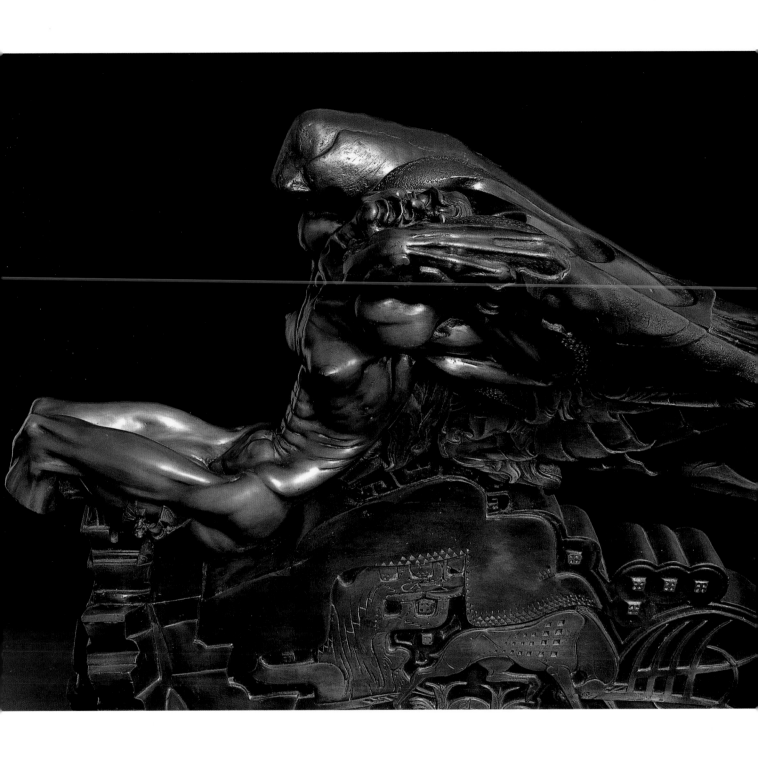

Stuart Holmes
a.k.a. *The Astrologer*

1948

We knew each other for many years while I lived in California. He was an actor* who had played in early motion pictures with Pearl White and had gone on to many roles in sound movies. Being of pleasant disposition, he was very companionable, and full of anecdotes. His wife Bianca was a well known astrologer and he too became apt in the pseudo-science.

He stood for me while I began to model him in clay in the outdoors, which was a new experience for me. I found it to be ideal, for the sunlight came from directly above. I needed him to pose for about an hour, then finished the sculpture from memory.

His interest in Astrology was one of his special charms. He and his wife had many extravagant things to tell about me as a Sagittarius. I believed only the things I liked, and what I didn't like I regarded as the mistakes that astrologers make. Since he was born under the sign of the Pisces, I gave him two fish at the base of the neck.

* Joseph Liebchen, Chicago 1884 – Hollywood 1971

STUART HOLMES

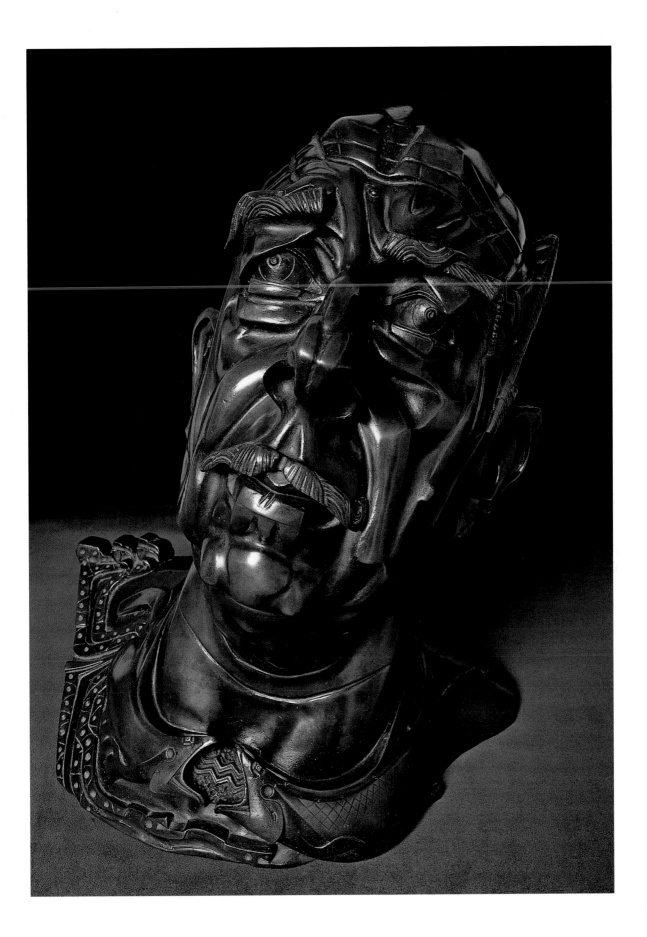

Deluge (20th Century)

1954

In the center of the seas floats the almost sinking kufa (the reed-woven basket-boat of the Mesopotamians) in which sits the Great Lioness of the Pacific, the personification of the Motherland of our mutual ancestors.

The rim of the kufa is already sunken to the level of the rising waters of the globe. On three sides the kufa is squeezed by the two-headed Flood Serpent. One head consists of the Hammer and Sickle, the Hammer serving as the weight that tightens the hanging noose. The Sickle has perforations in its arching blade, from which dangle the totemic nine yak-tails of Dzengis Khan, the first prototype and the greatest of the parasitic empire-builders. The head at the other end consists of the whirling, serpent-headed Swastika. (Hitler and his Yetin-syny did not know that the Swastika—turning to the right—means Sunset, the end of the day's span, while the same sign turning to the left, the Gammadion, means Pre-Morning.)

The kufa is about to sink and our Civilization is about to perish from the onslaught on Mankind by the *predatory* species. The churning whirls, symbols for "Diluvial Sinkage,"

threaten to drown the Great Lioness.

According to the traditions of all great peoples on this earth, the Great Lioness (Easter Island) gave birth to the Dawn God. She was the one whom the Etruscan sculptor, who had never seen a lioness, gave the likeness of a She-Wolf. Here she breast-feeds the twin boys Europe and America. The latter is well fed and exuberantly punches her breast in order to get even more milk, while the other twin is skin and bones and hangs from the European breast, from which air bubbles rise, because it was shot through and emptied by the two arrows of two World Wars.

The Great Lioness was awakened by the crowing of the *Rooster of Gaul* and the Eagle-axe of Poland which was within her grasp—but to no avail, because Anglomerican Civilization lacked the capacity for *resolution.*

Made in a chicken house in Tarzana, California, the state where Art is betrayed and lowered to the level of depravity of Picasso, Lipschitz and Henry Moore.

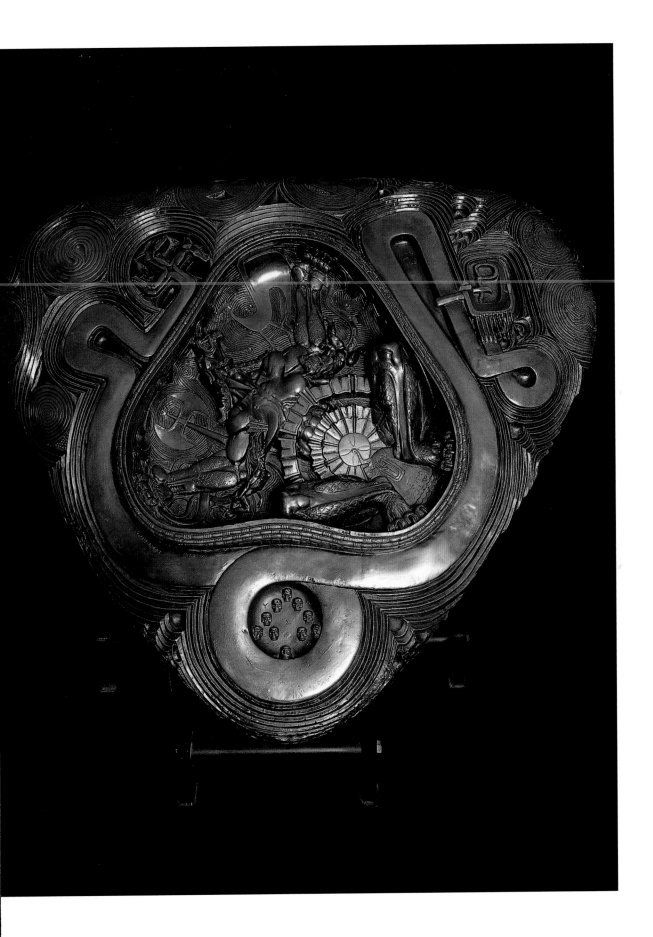

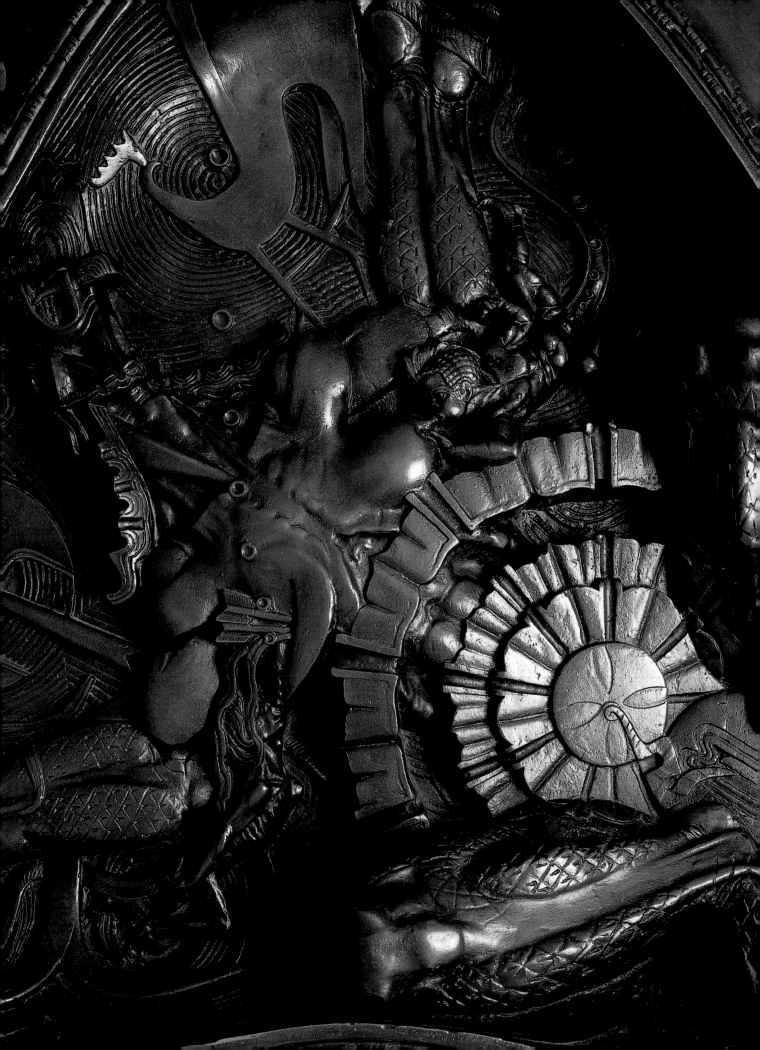

Le Coq Gaulois

a.k.a. Rooster of Gaul

Le Coq Gaulois
a.k.a. *Rooster of Gaul*

In 1886 the French sculptor Frédéric-Auguste Bartholdi proposed to his Government that France make a present to the young American nation of the Statue of Liberty. The Government was in the hands of culturally intelligent men who were wise in materializing such a dream of a creative individual. The United States has never reciprocated in kind and given an expression of similarly generous thoughtfulness. I, therefore, have designed such a project to be given to France and have evolved the architectural setting for its location in Paris. It would be a gift to the French nation by the American nation.

■ ■ ■

Firstly, I wished to underline the linking of the two names of Gaul, the ancient name of France, and De Gaulle, the most singularly individual of contemporary Europe (who, unfortunately for France and Europe, was destroyed by subversive elements in America and France.)

Secondly, as an anthropologist who has devised a new science of pictography,

Zermatism, I have learned why the rooster became the totemic coat of arms of the people of Gaul. The rooster is the first of the domesticated animals to awake in the farmyard. He is the one who, on perceiving the glow of the birth of Dawn below the horizon, rejoices for Man by crowing repeatedly, thus awakening the sleeping Worshippers of the Dawn God, so that they be up and dressed, their eyes be washed and bright, their hands clean and hair combed, when the Lord who brings *light*, undoes the all-pervading blackness of the Universe.

Thus Chanticleer (the French *chant éclair* means "announcer of light") was picked as the national emblem of France. The name of the country itself evolved from the Protong word Wrance, which actually means Worshippers.

■ ■ ■

Before I ever begin a sculpture, I "create" the concept in every detail in the darkness of night, when my mind is so frantically busy that I cannot sleep at all. When I begin the modeling in clay or plastina, I work from memory only,

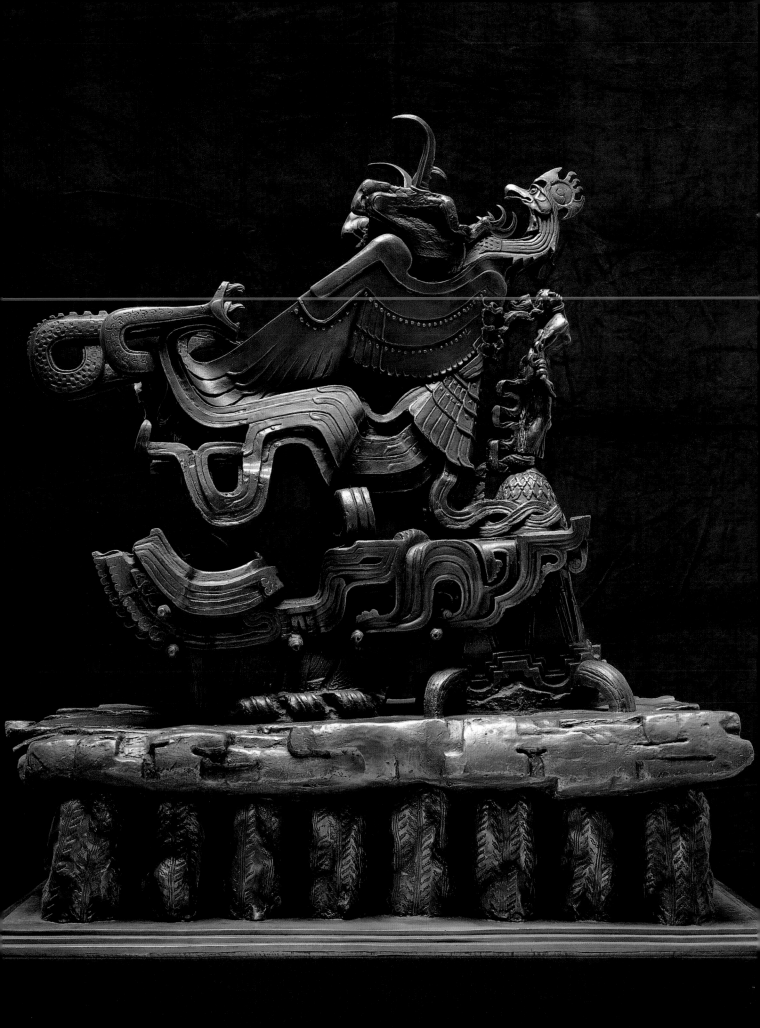

SERPENT (DETAIL) DRAWING, 1960

EXIT FROM THE DOLMEN DRAWING, C. 1968

never altering a single detail in what I imagined in these sleepness nights. For that reason, there is never any hesitation and I finish the sculpture in one tenth the time it would take another—no matter how professional—sculptor.

■ ■ ■

This, then, is the concept converted into sculpture.

There are three Serpents—originally symbols of Flood, but here associated with utmost Evil and Calamity—about to attack Marianne, a peasant girl who in popular imagery personifies France. Their tails are sneaking up on her, winding about her ankles, wrists and now, her throat. She is breathless and about to faint. But suddenly the Anthropomorphic Rooster, the awakener of the nation, throws himself between the encroaching Evil Calamities and Marianne, thus saving her life and altering the course of history.

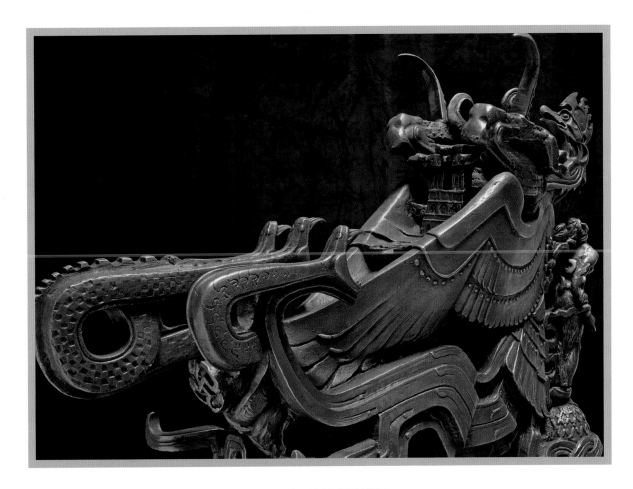

GRASPING THE CATHEDRAL OF NOTRE DAME FROM THE SERPENTS

She stands on top of the *Omphalos* (the classical symbol for "navel," hence Motherland), higher than the clouds, beneath which the cluttered skyscrapers of Modern Civilization and the waves of red (glazed ceramic) vapors of Cosmopolitan Subversion and Communist Treason.

The Rooster is in the air, raising his gigantic claws to strike at the Serpents. To save the greatest treasure of the "Worshippers," the Cathedral of Notre Dame, he lifts the small replica of it between his wings, away from the murderour reptilians.

The clouds float above the prehistoric Dolmen, the temple of the ancient Gauls.

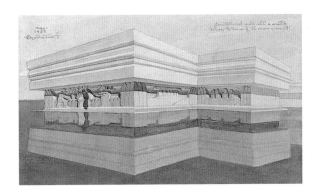

SCULPTURED WALL WITH A WALK BELOW THE BASE
OF THE MONUMENT

DRAWING, 1960

[163

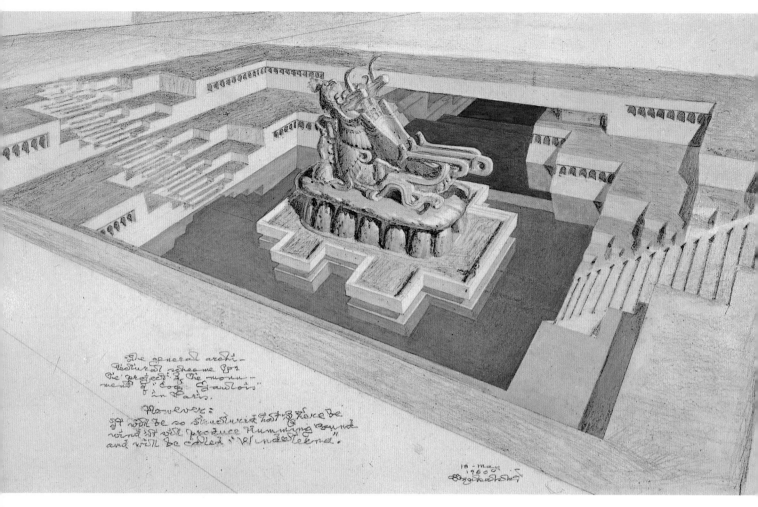

The general archi-
tectural scheme of
the project of the monu-
ment of "Cock Gaulois"
in Paris.

However:
It will be so structural that there be
wind it will produce Humming sound
and will be called "Windstband".

18-May
1960

SETTING, SHOWING INTENDED SIZE DRAWING, 1960

THE PARVIS OF NOTRE DAME
CATHEDRAL, PARIS

The pillars would be assembled out of ceramic fragments filled with concrete. The base, on which there would be 25 reliefs, showing the earliest temples of Brittany up to the earliest churches, would be in the shape of the Cross of Lorraine. This base in itself would house a small museum.

The whole monument would be erected on the parvis opposite the Notre Dame, embedded in an architectural crater filled with water. The monument, and the sculpture on top in particular, are narrow (lengthwise), so that the view of the architectural beauty of the Cathedral would not be obstructed.

To enter the "Beehive of France" inside,

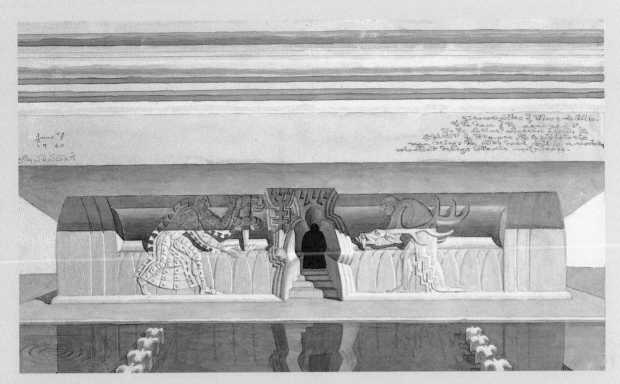

ENTRANCE TO THE "BEEHIVE OF FRANCE" WITH QUEEN'S DOORWAY DRAWING, 1960

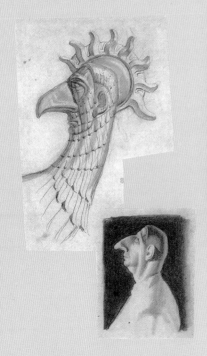

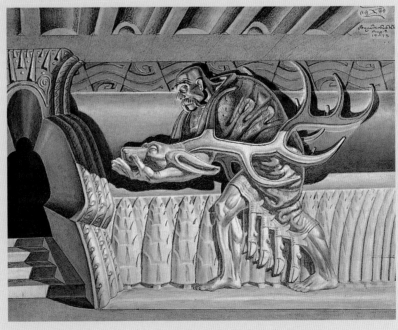

DE GAULLE

UNDATED SKETCH

RELIEF NEAR THE ENTRANCE TO THE MONUMENT. THE STAG'S HEAD IS
THE SYMBOL OF ALL SUNKEN CIVILIZATIONS.

DRAWING, 1973

ÉCHELLE À CIEL (STAIRS TO THE SUN)

DRAWING, 1970

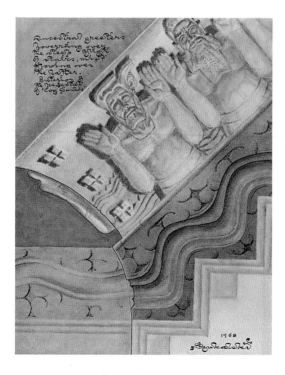

people would have to walk over stepping stones in the water in the form of fleurs-de-lis. The doorway is shaped like a sitting silhouette, representing the Queen of France, with crown and scepter. At her right is a high relief of an ancient Gaul bringing her the head of the Totemic Stag; at her left De Gaulle presents her with the Hydrogen Bomb.

Entering the Queen's Doorway, people will face a never before devised kind of stairs, for though they look very steep, they are comfortable to climb when they place their right foot on the right steps and their left foot on the left ones. These "Stairs to the Sun" would be cast in glass blocks, emulating the morning mists rising to the Sun.

As people walk up the Stairs to the Sun, over them will hover the Ancestral Greeters formed out of the morning mist, cast in smokey glass, sandblasted and polished on protrusions.

Inside, they would face the central pillar, which alone supports the weight of the bronze sculpture. In the narrow end of the pillar is a deep niche, within which a *Pietà* ("*Mother France*") is sculptured.

(see also pp. 59–62).

ANCESTRAL GREETERS (1968)

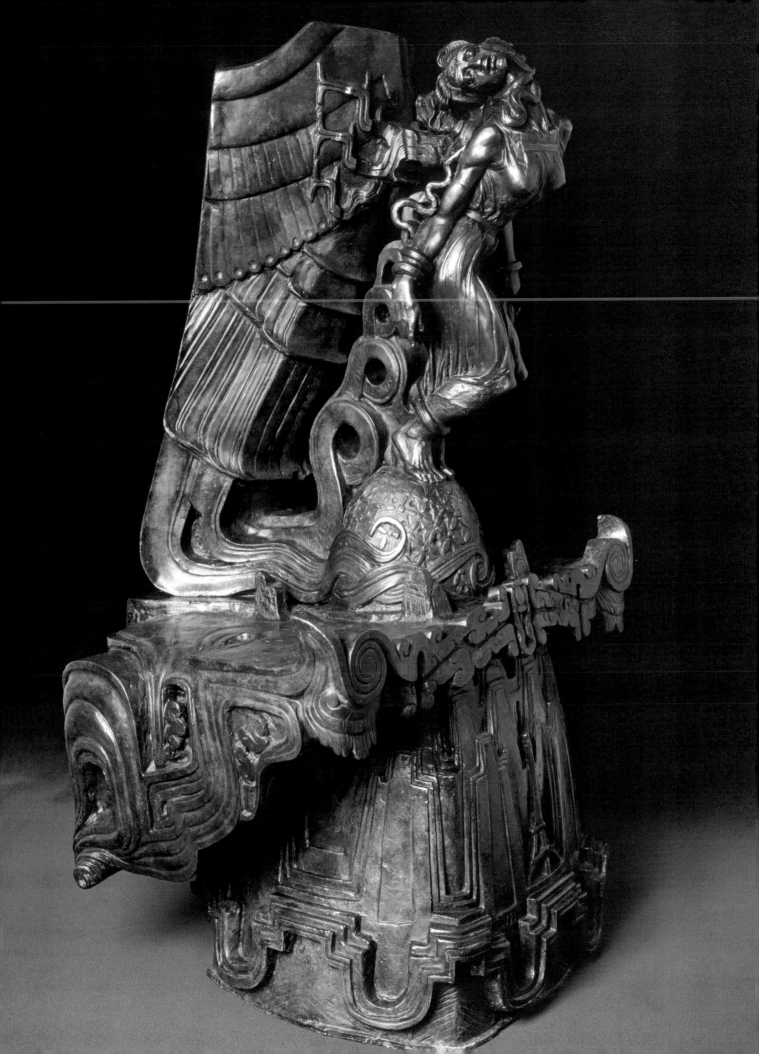

Bor Komorowski, Son of the Merman

1955

Bor Komorowski was the leader of the Warsaw uprising against the German invaders who assembled an underground army in the sewers of the Polish capital. Like frogs, the uprisers had to duck in the sewage filth, hence the stylized frogs around the neckline, the scumlines on the face.

On the back of the head, the Mermaid, universal representative of our first common Civilization on Easter Island (and still featured in Warsaw's coat-of-arms) holds up the dawn-greeting mirror to welcome her son, the New Day.

Easter Island was anciently called Mata Weri. From the description-phrase *Mata Weri* in Protong we learn that it was regarded by prehistoric peoples all over the world as the "Mother of Worship." "Worship" always means "Dawn" (as reveals the now meaningless name of Dover; after resegmentation to Do Wer, it can be translated as "〚Where is〛 Given Worship" or "Where the Sun Rises

〚to the British〛"). Thus I modeled the two first rays emanating from the solar disc, rising from behind the isle.

The island is surrounded by a ring of seawaves. The ring-shaped disc anciently called *Bi* means "Killed," i.e. "Dead by Deluge." Beneath the watery *Bi* I placed the Mermaid, pregnant with the next Morning's Dawn. She slips her arm from under the seas, holding her Dawn-greeting mirror in which is reflected the light of Yesterday's Dawn, her firstborn child, from the distant Atlantic Ocean.

Beneath the lower watery *Bi*, one can see the ducking frogs, hiding from the Germans. Above the island one sees two eyes of "Oce On," which was the ancient name of the lavaic continent in the Atlantic Ocean which, in prehistoric times, was universally regarded as the Father who copulates with the Mermaid to sire yet another Morning.

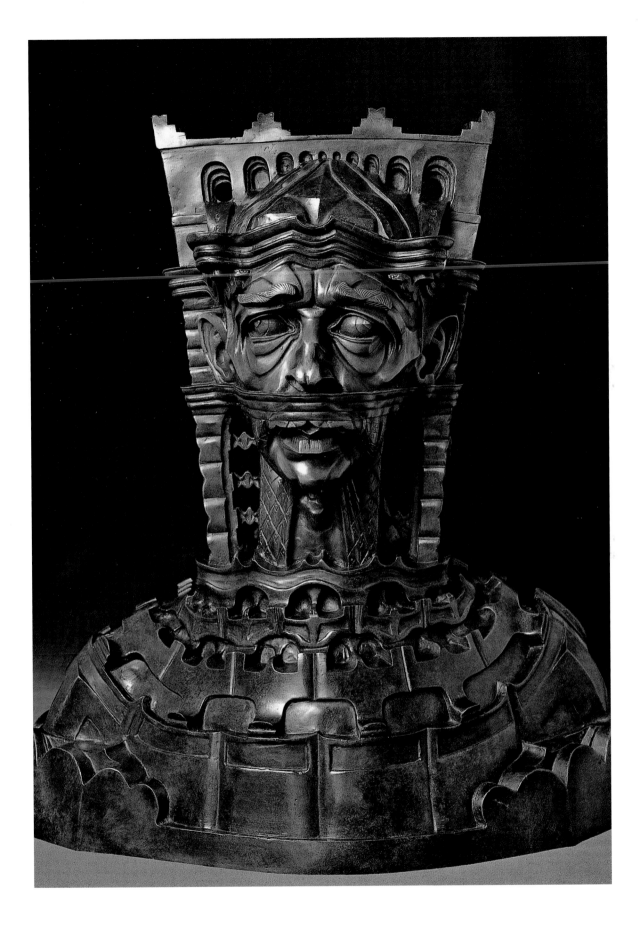

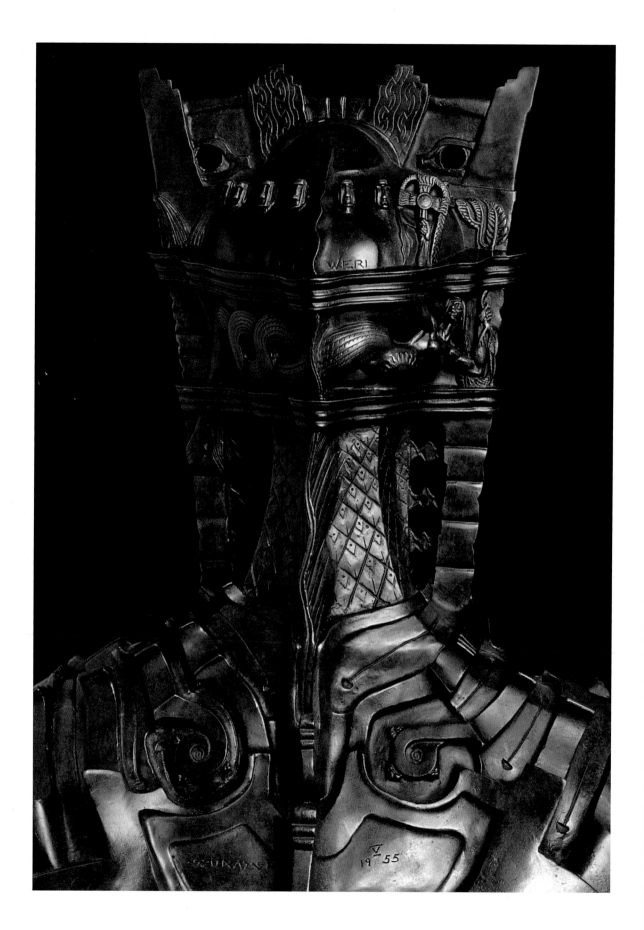

Aspiral
(a.k.a. *Spire / Aspire / Inspire*)

Aspiral

(a.k.a. *Spire / Aspire / Inspire*)

1965

Out of the footprints of history, Man's snail-paced Thought evolves and rises to beautiful Inspiration.

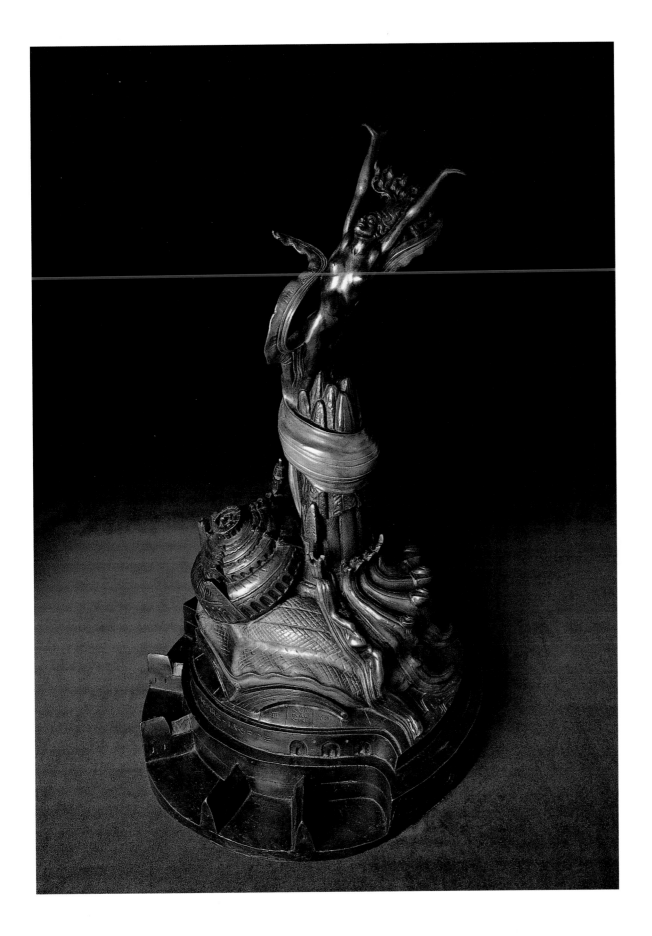

Katyn

(a.k.a. *The Last Breath*; *Human and A-Human*)

1979

■ by Lena Zwalve ■

The mark of a true artist—as opposed to someone catering to art critic-invented trends—is that he *has* to make art. He just can't help himself. Wherever you put him, no matter how miserable his circumstances, he cannot do anything else but say what has to be said, for the world to know.

Glenn and I consider ourselves very fortunate to have seen Szukalski sculpt *Katyn*. Stas was already 85 at the time, always working, reluctantly taking out time to eat and sleep. Since he could never afford to rent a studio, *Katyn* was entirely sculpted on his kitchen counter, under artificial light.

At first it was impossible to imagine what this thing was going be. One day there was an armature made out of wire coat hangers and styrofoam cups, held together with wooden clothespins. The next time we visited, this was covered by a huge blob of the hardened Hydrocal that Glenn had bought him, which he would carve, cut, grind, and polish over the next few weeks. (Szukalski insisted he had the entire sculpture and its details in his head when he started; the actual making of it was the boring part for him, because it kept him from researching other projects.)

In the first version, the Head of Communism had a gorilla face. One evening about a year after he had completed the work, we noticed that the head now had the face of a hyena. At a market checkout Stas had seen a copy of *Weekly World News* with that image and thought it much more devious-looking.

Katyn tells the story of the thousands of Polish intellectuals who were executed during ww ii in the Katyn forest. The Communist (part hyena, part octopus) is executing the "God's Eagle" (defender of the country) by a hammer blow to the head and a revolver shot to the brain. The predator has entwined the victim with his octopus legs which also stretch out over the prostrate body of Europe, who can only witness the atrocities, being shackled herself. The crimes were committed at night, therefore the tentacles rest on the crescent of the moon.

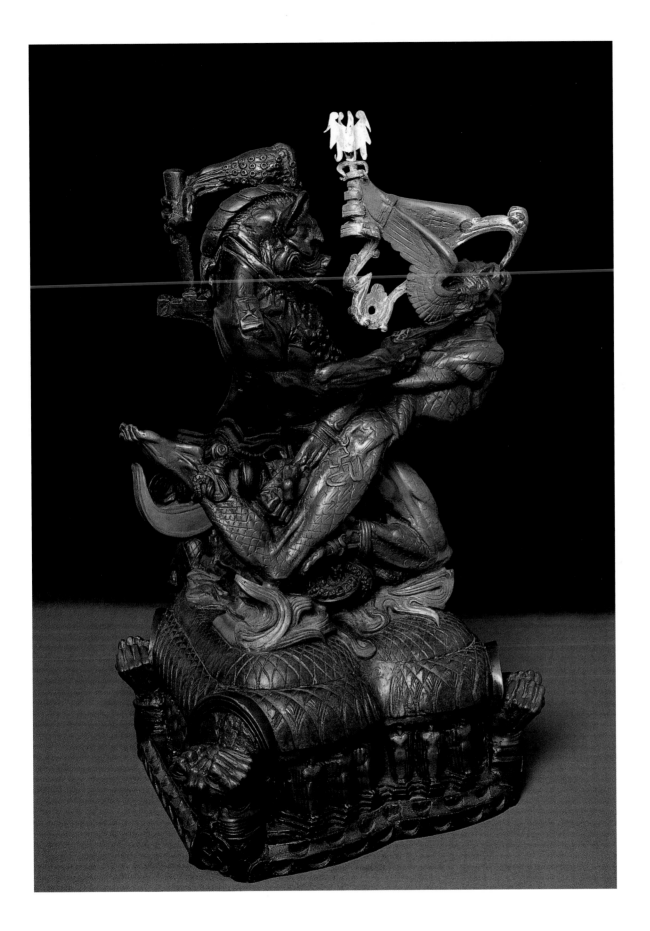

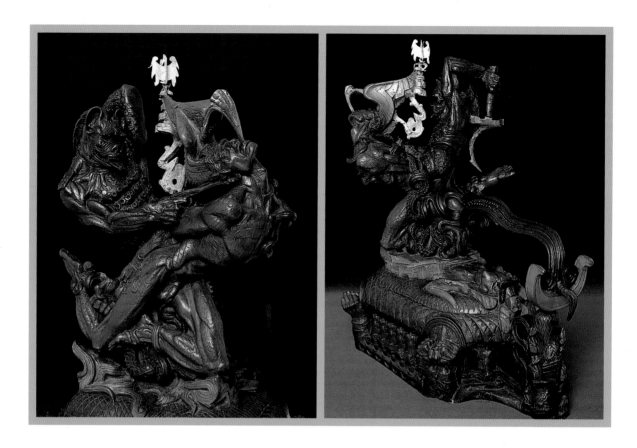

At the time, before the fall of the Berlin wall and Communist regimes all over Eastern Europe, the official opinion was that the Nazis, our enemies, had been the executors. But Stas knew all along that it had been the "vile, never-to-be-trusted" Communist Russians, our and the Poles' allies, no less, for whom the thinking crème de la crème of the Polish nation formed a great danger. Stas has been vindicated.

(For Szukalski's own description of *Katyn*, see his book *Behold!!! The Protong*.)

SZUKALSKI'S
Goddess
SCULPTURE

■ by Glenn Bray ■

ONE night in 1985 at his apartment in Burbank, Stas mentioned wanting to find a small piece of driftwood to use as a pedestal for a work he had in mind about a mermaid. I knew of a place not far away and the next week we made a daytime trip out to Sepulveda to Balboa Brick & Supply.

We drove into the dusty parking lot and got out of the car. I exited the driver's side and behind me, about 10 yards away was a cluster of miscellaneous sizes of driftwood, about a 20 foot circle full. Stas looked over my shoulder and shouted: "Look! There's a lady over there!" I tried to look past the stack of wood where he was pointing, but saw no one.

Stas understood my confusion and said, "No! In the woodpile!" I refocused my attention to the pile and still didn't get it. We walked nearer to the stack and about 12 feet away from the pile I saw what he meant. There it was, a 5ft. piece of driftwood that—loosely—resembled a figure of a headless woman.

We bought the piece and drove it to his apart-

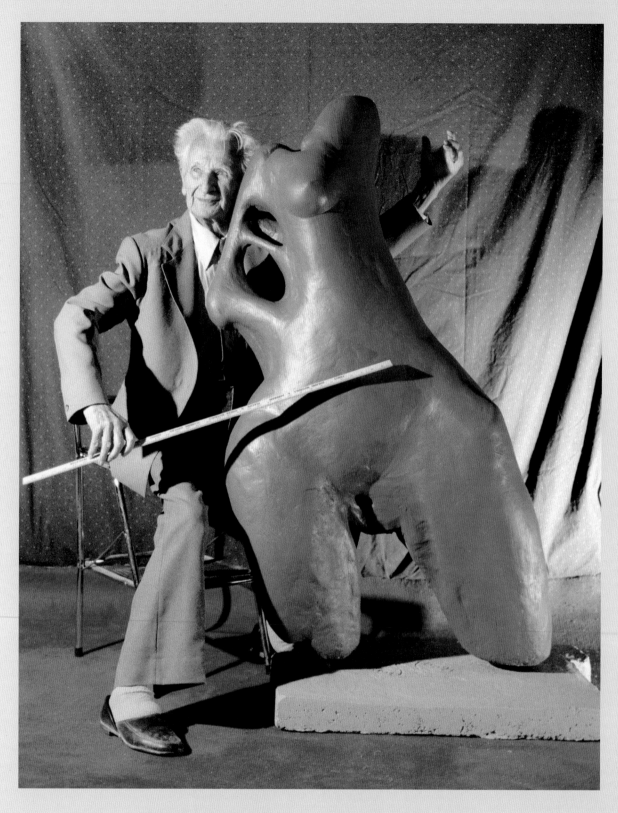

SZUKALSKI "PLAYING" THE FINISHED *Goddess* SCULPTURE
APRIL 19, 1987

PHOTOS BY GLENN BRAY

3
ZERMATISM

SAMPLES

MERMAID STONE CARVING FROM FOUSSAIS, VENDÉE DISTRICT, FRANCE

A preserved head discovered in Peru.
Lips are spiked together to resemble
serpent fangs, in allusion to the Flood-
origin (descent) of the deceased.
Am: Mus. Nat. His.

Legendary White Immigrant
called "Ambat", whose pate (Sac-
red Isle" shaped) is Flood-water-
marked. South Malekula. Malanesia.
"Jam Bat" (Polish)
"I-am Terrified."

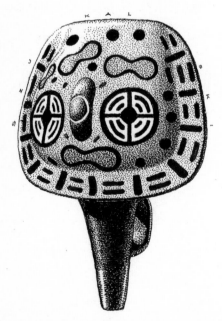

Water buttle (upsidown while drinking).
Within Great-Turtle circle are Oce and Ma.
Chimu cultur. Peru.

Head-jar from Glozel.
France.
"Glo Ze L": "Hungry From Flooded."

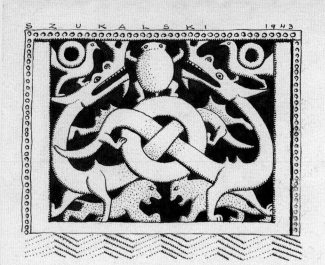

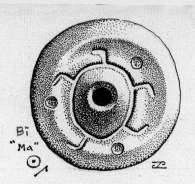

"(Great) Turtle" on spin-whorl. Prehistoric Troya.

Twin-Dragons about to devour Great Turtle while their tails interlock the sign "Ma", making incidentally "SunFaith" out of it. Lion-cubs are temporarily overcome by the Dual-Flood. Birds (Eagles?) carry away safely, the "models" of "Ma", her spiritual Culture. China.

"Six Dynasties" grave.
now in Stockholm.

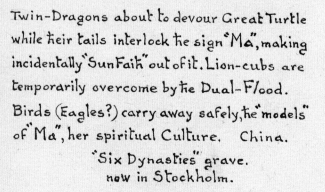

"(Great) Turtle". Aztec. Cortezan Codex.

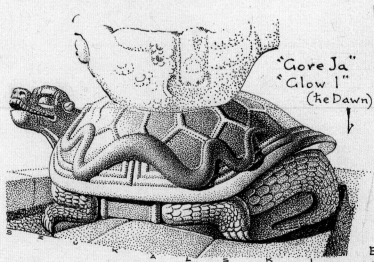

"Gore Ja"
"Glow 1"
(the Dawn)

The "Great Turtle" flanked by Twin-Serpents | Soul. Korea.

Early Chinese pictogr..
"Kuei" (turtle) "Gł JeJi"
"Destroyed Is Her". (Polish)

ZERMATISM #460: "GREAT TURTLE" IMAGERY FROM CHINA, GREECE, PERU, AND KOREA

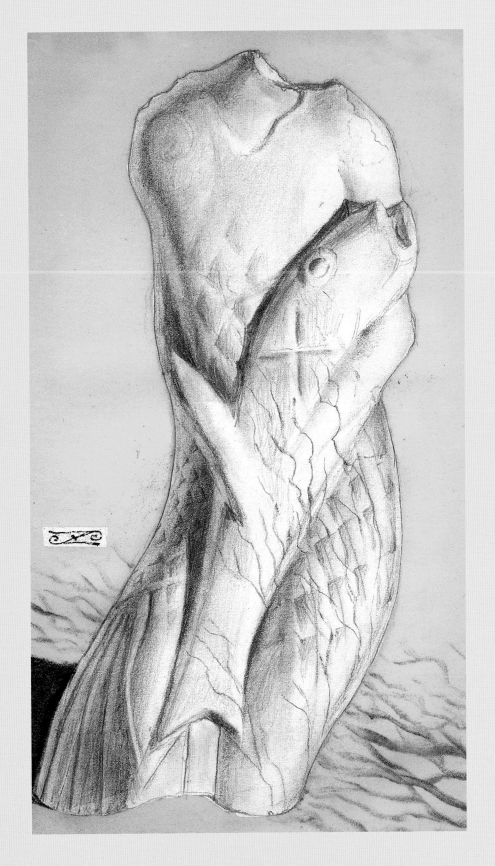

"DELUGED CONTINENT" – BREASTLESS MOTHERLAND HOLDING A FISH (SOBOTKA, POLAND)

186] REMAINS OF THE SABEAN GOD BAR-AN (POLISH "BARAN" MEANS RAM)

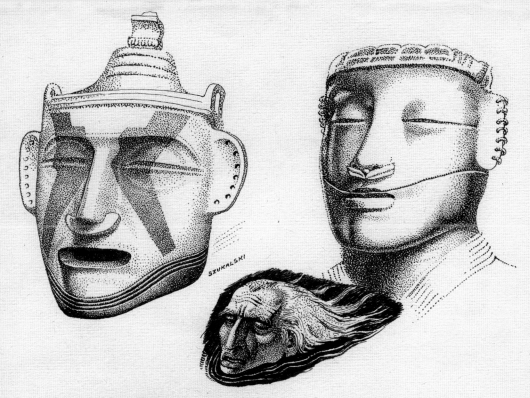

Flood-scum watermark, tatooed on ħe faces of Gony.
Dual-continent mark on his face. Columbia

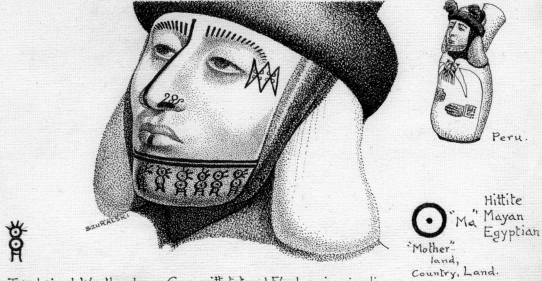

Tow-haired Wadlandean Gon, with tatooed Flood-swimming line
beneath which float the drowned "fellow-Countrymen", marked as
"dotted circles". Peru

Peru.

Hittite
"Ma" Mayan
Egyptian
"Mother"-
land,
Country, Land.

(Polish "Mat")
"Mother".

TOMB OF HO CH·II·PING (SHANSI, CHINA)

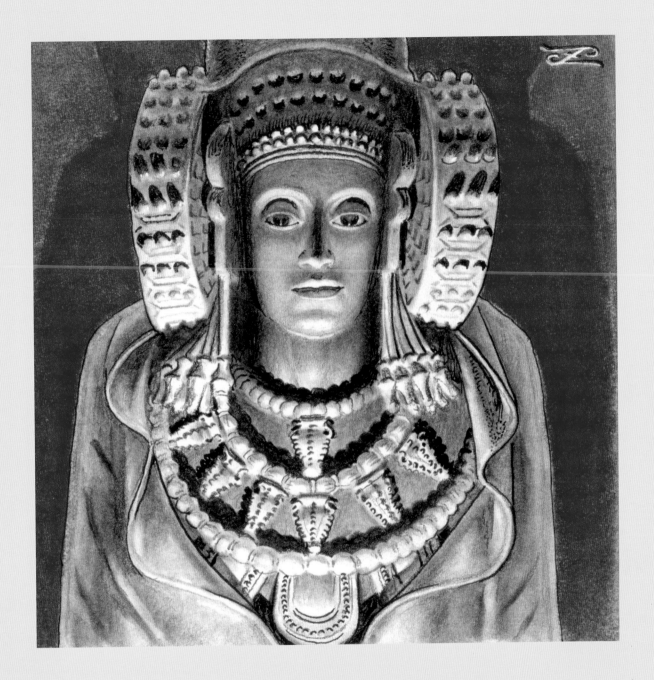

(SPAIN)

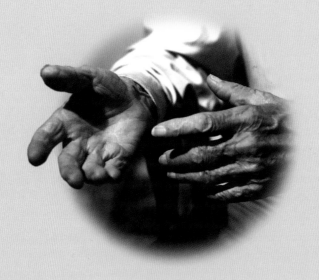

STRUGGLE

■ by Glenn Bray ■

ARCHIVES SZUKALSKI

STANISLAV Szukalski died in a Burbank hospital on May 19th, 1987, knowing that over half his life's work was either looted or destroyed in Poland during the siege of Warsaw in 1939. Many other works: sculptures, bronzes, writings, drawings, photographs, personal collections of important artworks, were all "lost" during that time. Much of the work is known to have been burned and destroyed by Nazi troops. There are several bronzes that still exist, surviving the melting-for-armaments with bullet holes in their chest, meant for Szukalski himself. Szukalski had information from correspondents in Poland who had heard of rooms filled with his works hidden from the public since the end of the War.

Among those pieces looted was one of his most recognizable works, the sculpture *Struggle*.

After returning from Poland with his wife and two small suitcases, Mr. Szukalski started a campaign to request his work back that survived the War. There are copies of numerous such requests to the U.S. State Department—all unanswered.

In 1997 we were alerted that the original bronze of *Struggle* was up for auction in Warsaw. With the help of supporters, Archives Szukalski was able to purchase the original 1917 casting from

its unidentified "owner." It is of interest to know that the laws of Poland will not prosecute thieves of artwork after 50 years. It is also unlawful for works of pre-WWII art to leave the country.

Five years after Mr. Szukalski's passing, an original casting of *The Prophet* surfaced from an estate in New York. In 1999, copies of *Imploration* and *Labor* appeared from a collection in Mexico.

With the help of Mr. Szukalski's nephew, Roman Romanowicz, who lives in Warsaw, we are able to export and exhibit the original *Struggle* with certification from the Ministry of Culture.

A number of castings have been made directly from the original work which are now in the hands of collectors around the world.

It is our hope that more of Szukalski's lost works will be found and shared, as this book comprises only a segment of one man's life of artistic harvest.

THANKS

Archives Szukalski extends its appreciation of involvement to:

Gene Bray; Jack Brown; Sabine & Danny Carey;
Sandy Decker and the people of Decker Studios; Cam DeLeon;
Leonardo, Peggy & George DiCaprio; Jose Fernandez; Ernst Fuchs;
the late Rick Griffin; Trigg Ison; Camella Grace & Adam Jones;
Eva & Donat Kirsch; Michael Messner; Jill Tipping & Edwin Pouncey;
Roman Romanowicz; Piet Schreuders; Jeff Vaughan;
Suzanne & Robert Williams; Jim Woodring; and Ray Zone.

Szukalski: A Select Bibliography

I. BOOKS

The Work of Szukalski
Chicago: Covici-McGee, 1923
Limited, numbered edition of 1000 copies
(Advertised as "The Most Beautiful and Unusual
Volume Ever Published in the United States")

Max Bodenheim, *The Sardonic Arm*
Chicago: Covici-McGee, 1923
(cover lettering and interior illustrations
by Szukalski)

Sheldon Cheney, *A Primer of Modern Art*
New York: Horace Liveright, 1924

Burton Rascoe, *A Bookman's Daybook*
New York: Horace Liveright, 1929
(contains review of 1923 Work of Szukalski book)

Szukalski: Projects in Design
Chicago: University of Chicago Press, 1929
Limited edition of 1000 (unnumbered) copies plus

an additional 100 copies with special binding and
signed woodblock, unpaginated
With architectural drawings and photographs
(taken by Szukalski) of his sculptures.

Marie Armstrong Hecht, *My Husband by His
First Wife*
New York: Greenberg Publishers, 1932

*Official Catalogue of the Polish Pavilion at the
World's Fair in New York, 1939*
Warsaw: Arkady, 1939 / New York, 1939
(medal with portrait of Copernicus)

Alson J. Smith, *Chicago's Left Bank*
Chicago: Henry Regnery Co., 1953
(photo of Szukalski with several references)

Bernard Duffey, *The Chicago Renaissance in
American Letters: A Critical History*
Michigan State College Press, 1954

[193

Ben Hecht, *A Child of the Century*
New York: Simon & Schuster, 1954
Autobiography.
(Recollections of Szukalski in Chicago in the
1920s/'30s)

Vincent Starrett, *Born in a Bookshop: Chapters from
the Chicago Renascence*
Norman: University of Oklahoma Press, 1965

Stanislav Szukalski, *Troughful of Pearls /
Behold!!! The Protong*
Sylmar, Ca.: Glenn Bray, 1980
Edition of 1000 copies (softcover) plus 100 signed
and numbered copies (hardcover)

Stanislav Szukalski, *Inner Portraits by Szukalski*
Sylmar, Ca.: Glenn Bray, 1982

Jay Robert Nash, *Zanies: The World's Greatest
Eccentrics*
Piscataway, N.J.: New Century Publishers, 1982
(The chapter "Stanislaus Szukalski" contains mostly
erroneous information)

Stanislav Szukalski, *Behold!!! The Protong*
Sylmar, Ca.: Archives Szukalski, 1989
(partial reprint of 1980 edition)

Andrezej K. Olszewski, *Polish Art and Architecture,
1890–1980*
Warsaw: Interpress Publishers, 1989
(Szukalski mentioned on p. 38)

Bob Black and Adam Parfrey, *Rants and Incendiary
Tracts*. New York: Amok Press, 1989
"The Anthropolitical Motivations" by Szukalski
(9 pages)

*The Lost Tune: Early Works (1913–1930)
as photographed by the artist*
Sylmar/Chicago: Archives Szukalski /
Polish Museum of America, 1990

Sue Ann Prince (ed.), *The Old Guard and the
Avant-Garde: Modernism in Chicago, 1910–1940*
Chicago: University of Chicago Press, 1990

Thomas Rain Crowe, *The Personified Street:
Poems, 1974–1978*
Cullowhee, N.C.: New Native Press, 1993
(cover illustration: Death)

Constance Katherine Campbell Poore, *The Prophets
of Modernism: Art in Chicago, 1900–1924* (thesis)
The University of New Mexico, 1994

Roger Manley, Stephen Jay Gould, Howard Finster,
Adam Parfrey, The Dalai Lama, John the Divine,
*The End is Near! Visions of Apocalypse, Millennium
and Utopia*
Los Angeles: Dilettante Press, 1998
(Szukalski mentioned on pp. 68–71)

Stanley S. Sokol, *The Artists of Poland: A Biographical
Disctionary from the 14th Century to the Present*
Jefferson, N.C.: McFarland & Co., 2000
(Szukalski mentioned on pp. 102, 214)

Vanity Fair, June, 1917
"Stanislaw Szukalski, Chicago's Seismic Sculptor"
(credited to Ben Hecht)

The Little Review (Margaret Anderson, ed.), June, 1918
"Drawings by Stanislaw Szukalski" (7 pages)

The International Studio #291, June 1921
New York: John Lane Co.
(cover: *Prophet*)

The Chicago Literary Times (Ben Hecht, ed.),
April 15, 1923
"Largo Fortissimo: Three Rounds with Stanis.
Szukalski"

Los Angeles Herald-Express, Tuesday, July 19, 1932
"Olympic Art Controversy Rages"
(photograph of Szukalski with *Remussolini* statue)

The Public Works of Art Project (WPA)
14th Region, Southern California
Los Angeles Museum, Exposition Park, March, 1934
(foldout pamphlet with a heraldic design by
Szukalski on front cover)

American Weekly, Sunday, June 3, 1934
"Striking Sculptures by a Polish Artist"

*Robert Breckinridge Announces an Exhibition of
Drawings by the Pupils of Stanislaw Szukalski
Monday, Nov. 12, 1934, 912 No. Michigan Avenue*

*The New American. A Monthly Digest of Polish-
American Life and Culture*, Sept. 1935, Vol. 11, No. 10
"Stanislaw Szukalski: Painter, Sculptor, Architect,
Philosopher" by Blanche Gambon.

Chicago Herald-American, November 30, 1939
"Sculptor Back Sans Art, Country, Money"

Helena Modjeska Memorial Program, May 25, 1955
(Hollywood, Harout's Ivar Theatre)
(cover illustration: *Modjeska Players*)

The Atlantic, July 1964
"The Mute Singer" by Szukalski (6 pages)

The Cornhill No. 1043, Spring 1965
John Murray, London
"The Mute Singer" by Szukalski

Literary Times, Feb.–March 1966
"The Return of Szukalski" by J.R.N.

The Quarterly Review, July-Sept. 1972
"A.D. 1972: The Year of Copernicus" by Prof. Ludwik
Krzyanowski

Ward Ritchie, *Adventures with Authors*
Laguna Beach, Ca.: Laguna Verde Imprenta, 1978
Privately printed by the author in a limited edition of
c. 50 copies as a vehicle to show some initial letters
designed by Szukalski. Text based on a talk given to
members of the Zamorano Club of Los Angeles.

Furore #15 (Piet Schreuders, ed.), April 1980
(cover: *Longing* by Szukalski)
"Leven & Werk van de Beeldhouwer, Schilder,
Man van de Wetenschap, Uitgeweken Pool en
Geniaal Denker Stanislav Szukalski" (15 pages) by
Piet Schreuders; "When Wright Was Wrong"
(chapter from autobiography, 4 pages) by Szukalski

Fanfare magazine #3 (Bill Spicer, ed.), Spring 1980
"Szukalski" (2 pages); "When Wright Was Wrong"
(chapter from autobiography) by Szukalski

L.A. Weekly, Dec. 25–31, 1981 (Vol. 4, #4)
"The Great Szukalski" by Ray Zone (cover and 3
pages)

Escape #18, Summer 1989
"Szukalski" by Paul Gravett (2 pages)

Weirdo #1, Spring 1981 (Robert Crumb, ed.)
"Szukalski" (6 pages)

Tapes for Dying [catalogue]. Willem de Ridder,
Holland, 1985
(cover & various drawings)

The Comics Journal #117, Sept. 1987
"Death of a Polish Sculptor" (1 page) by Ray Zone

Whole Earth Review, Fall 1988
"The Neglected Genius of Stanislav Szukalski"
by Jim Woodring

Jacæber Kastor and Carlo McCormick (ed.),
Szukalski: Song of the Mute Singer
New York: Psy-Sol Word Press, 1989
(Includes a brief biography, fiction, and essays by
Szukalski, and 29 drawings)

Bronzes of Szukalski (catalogue)
Sylmar, Ca.: Archives Szukalski, 1989

Downtown Scluptors' Foundry (newsletter),
April 24, 1989
"Profile: A Colorful Biographical Sketch"

Stanislav Szukalski, The Mute Singer
Sylmar, Ca.: Archives Szukalski, 1989
(One chapter of the unpublished autobiography)

Shred, Sept. 1989
"Szukalski" by John Hutchinson (9 pages)
with color reproduction of Mermaid of Warsaw

Chicago: The Modernist Vision, Robert Henry Adams
Fine Art (Summer 1990)
(Szukalski mentioned in article "Chicago Modernism"
by Robert Adams)

Chicago Sun-Times, Aug. 24, 1990
"Polish Master" by Mary Gillespie

Chicago History, Spring and Summer 1991
"Stanislav Szukalski's Lost Tune" (20 pages)

Concrete: Fragile Creature
Dark Horse Comics, Aug. 1994
"Introduction" by Paul Chadwick; various Szukalski
re-drawings

Juxtapoz, Vol.3, #2, Spring 1997
"Echo of a Parallel Century: The Paradox of
Szukalski" by Eva and Donat Kirsch (11 pages)

Fortean Times #125, September, 1999
"New World Disorder" by Rod Perkins and Breck
Outland

[Los Angeles] *Daily News,* April 30, 2000
"Works of Famed Artist on Display" by Diana Peyton

Los Angeles Times, August 19, 2000
"DiCaprio Boosts Artist's Show" by Vivian Letran

Stanisław Szukalski, *Atak Kraka*
Kraków: Gebethner i Wolf, 1929

Marian Rużamski, *Kto to jest Szukalski?*
Warszawa, 1934

Stanisław Szukalski, *Wykaz prac Szukalskiego
i Szczepu Rogate Serce.*
Kraków, 1936

Stanisław Szukalski, *Krak*
Katowice, 1937

Stanisław Szukalski, *Krak Syn Ludoli*
Śląsk, 1938

Tygodnik Polski (The Polish Weekly), Sept. 2, 1945
(cover: *Copernicus* by Szukalski)
"Rzeźby Stanisława Szukalskiego" (2 pages)

*Polacy w Toronto: W Stulecie Śmierci Adama
Mickiewicza, 1855–1955*
(Photos of Szukalski's monument and medallion
for Adam Mickiewicz)

Wiadomości, London 1955, nr. 15/16
"Myś lowinieta rzeźbą, Uwagi o dziele i sprawie
Szukalskiego" by Aleksander Janta-Połczyński

The Culture. Paris, 1965
"Sprawa Szukalskiego" by Aleksander Janta-
Połczyński

Biuletyn Historii Sztuki Nr. 4, Warszawa 1976
"Stanisław Szukalski—Życie i Twórczość" (21 pages)
by Lechosław Lameński

Stanisław Szukalski: Artysta Niepokorny
Warta: Muzeum Miasta i Rzeki Warty, 1976
12 page exhibition catalogue

*Szukalski i Szczep Rogate Serce: Retrospecktywna
Wystawa Prac 1930–1939*
Kraków, Rzeszów, Maj 1970

Perspektywy, January 1, 1985
"Rzeźbiarz i Heretyk" by Olgierd Budrewicz
(interview with Szukalski)

Przekròj, July 5, 1987 (Kraków, Poland)
"To Koło Na Orlim Ogonie" by Szukalski (open letter)

Rzeźba Polska, Centrum Rzeźby Polskiej w Orońsku-
Rocznik, 1987
"Pro Memoria" by Lechosław Lameński

Stanisław Szukalski: Artysta Niepokorny
Warta: Muzeum Miasta i Rzeki Warty, Pttk, 1988

Marian Konarski "Marzyn" (exhibition catalogue),
Warszawa/Chicago, 1989/90
"A Self-Portrait in a Cracked Mirror: Marian Konarski
and His Art" by Lechosław Lameński

Kaleidoskop nr. 37/83 , Sept. 14, 1990
"Stanisław Szukalski Samorodny Przeciwko
Wspólnemu Mianownikowi" by C.K. Norwid
(3 pages); "Stanisław Szukalski" by Krzysztof
Kamyszew (2 pages). Cover photo: *Bor Komorowski*

*Między Polską a Światem: Kultura emigracyjna po 1939
roku* Warszawa: Wydawnictwo Krąg, 1992
"Wielki Przegrany, Rzecz o Stanisławie Szukalskim"
by Lechosław Lameński

Index of Works

PRINTS BY SZUKALSKI

varnishfineartshop.bigcartel.com

■

INQUIRIES RE: AVAILABILITY OF
BRONZES BY SZUKALSKI

Decker Studios Fine Arts Foundry
Please contact Sanford Decker:
sdfinearts@gmail.com

ALSO AVAILABLE

Inner Portraits by Szukalski
ISBN 978-0-86719-494-4

Behold!!! The Protong
ISBN 978-0-86719-876-8

LAST GASP │ SAN FRANCISCO